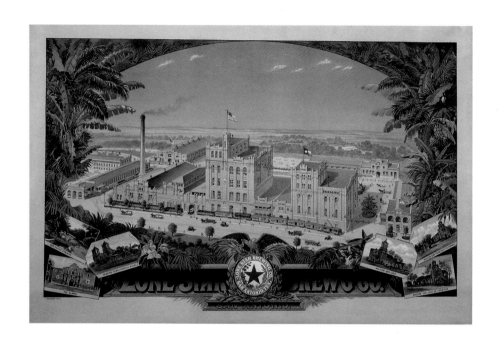

THE SAN ANTONIO MUSEUM OF ART
Guide to the Collection

THE SAN ANTONIO MUSEUM OF ART
Guide to the Collection

This publication was made possible by generous support from the Robert J. Kleberg, Jr., and Helen C. Kleberg Foundation.

Published by the San Antonio Museum of Art
200 West Jones Ave.
San Antonio, TX 78215
samuseum.org

Editors: Jessica Powers and John Johnston
Copy editor: Susan Shaw
Principal photographer: Peggy Tenison

Produced by Marquand Books, Seattle
marquand.com

Designed by Tina Kim
Typeset in Whitman by Maggie Lee
Proofread by Carrie Wicks
Color management by iocolor, Seattle
Printed and bound in China at C&C Offset Printing Co.

Library of Congress Cataloging-in-Publication Data
San Antonio Museum of Art.
 The San Antonio Museum of Art: guide to the collection.
 pages cm
 Editors: Jessica Powers and John Johnston.
 Includes index.
 ISBN 978-0-615-67865-8 (alk. paper)
 1. Art—Texas—San Antonio—Catalogs. 2. San Antonio Museum of Art—Catalogs. I. Title.
 N736.5.A66 2013
 708.164'351—dc23 2012033761

Cover: Martin Johnson Heade, *Passion Flowers with Three Hummingbirds* (detail, see p. 159)
Half-title: The Milwaukee Litho Company, *Lone Star Brewing Co., San Antonio,* color lithograph on paper, h. 27 in. (68.6 cm), w. 41½ in. (105.4 cm), Museum purchase, 74.93

For identification of detail photographs, see p. 219.

Contents

DIRECTOR'S
FOREWORD

IN JUST OVER THIRTY YEARS, the San Antonio Museum of Art, with a modest seed collection and the potent vision of its founders, has grown to become a world-class fine arts institution with outstanding strengths in numerous collecting areas. The Museum takes a comprehensive approach to the visual arts and displays the great achievements of artists from ancient to contemporary times.

A walk through our beautiful and varied galleries allows our visitors to marvel at ancient works of art from the Mediterranean region, Asia, and Latin America, as well as modern and contemporary works from Europe and the Americas. One of the most rewarding aspects of viewing art from diverse traditions and time periods is discovering the incredible aesthetic and thematic parallels that transcend cultural and temporal boundaries. Visitors who come to the San Antonio Museum of Art embark on a visual journey around the world through our collections. This handbook will serve as a guide to highlights of these rich and engaging collections.

Frank Lloyd Wright said that the price of success is "dedication, hard work, and an unremitting devotion to the things you want to see happen." The Museum's Board of Trustees has demonstrated those qualities and has unswervingly believed in the importance of having an encyclopedic museum in the city of San Antonio for its citizens and visitors. More specifically, I would like to thank the Robert J. Kleberg, Jr., and Helen C. Kleberg Foundation for the generous financial support of this first and much-needed guide to SAMA's collections and for their ongoing support of the Museum.

I would like to commend the editors, Jessica Powers, the Gilbert M. Denman, Jr., Curator of Art of the Ancient Mediterranean World, and John Johnston, the Coates-Cowden-Brown Curator of Asian Art, for their diligent efforts on this highly anticipated publication. Many other SAMA staff members contributed to this publication, and I particularly thank The Brown Foundation Curator of Contemporary Art, David Rubin, and Curator of Latin American Art, Marion Oettinger, Jr., for their contributions in their respective areas of expertise. Additional thanks are

due to Dr. Oettinger for writing the introduction to the Museum and its collections. Assistant Registrar Leona Scull-Hons worked tirelessly to coordinate photography for the project, in collaboration with Associate Registrar Kia Dorman. Director of Special Projects Emily Jones and Registrar Karen Baker contributed their knowledge of the Museum's history. I also thank Peggy Tenison, who provided most of the photography, and Susan Shaw, who copy-edited the text, for their outstanding efforts. Curatorial Assistants Erin Keelin, Allyson Walsh, and Christin Johnson also contributed in many ways to the preparation of the volume.

In compiling this guide, we have relied on expertise from outside the Museum to select and present numerous works in SAMA's extensive permanent collection. We are grateful to Richard R. Brettell, Donna Corbin, Yuka Kadoi, Lisa B. Reitzes, and Virginia-Lee Webb for the fine research and writing appearing in their entries. And I would also like to thank the design team and everyone at Marquand Books for preparing such a lovely volume.

Pablo Picasso famously said that "the purpose of art is washing the dust of daily life off our souls." Hopefully this guide will help you chart a refreshing and inspiring journey through the collections of our young, but ambitious and growing museum.

Katherine C. Luber
The Kelso Director

INTRODUCTION
TO THE COLLECTION

WHEN THE SAN ANTONIO MUSEUM OF ART opened to the public in spring 1981, the galleries in its newly renovated industrial space were sparsely installed with a small but select collection of American paintings, Latin American art, and contemporary works and an abundance of loans from dozens of generous patrons. The Museum's founders, many of whom were collectors themselves, were committed to sharing the art that inspired them for the benefit and enjoyment of the South Texas community and beyond. In the thirty years since then, that vision has become a reality: from its modest beginnings, the Museum has developed into an encyclopedic institution with a permanent collection comprising nearly twenty-five thousand works of art representing cultures from around the world (fig. 1). This *Guide to the Collection* celebrates the Museum's growth by presenting a selection of highlights from the permanent collection.

The Museum's history began in 1926, when the San Antonio Museum Association established the Witte Memorial Museum to house collections related to Texas history and natural history, transportation, and art. Gifts from San Antonio residents in the following years sowed the seeds of the growing art collection. Notable early acquisitions included the bequest of William Adolphe Bouguereau's masterpiece *Admiration* and American and European paintings donated by the Oppenheimer family. San Antonio's proximity to Latin America and its strong historical and cultural ties to Mexico fed the Latin American collection. Individuals whose families had fled the Mexican Revolution and others who moved to San Antonio during the early twentieth century brought colonial paintings, silverware, and furniture that eventually made their way to the Museum. Later, in the 1970s, grants from The Brown Foundation and the National Endowment for the Arts supported the purchase of several works by prominent contemporary painters, including Frank Stella, Wayne Thiebaud, Philip Guston and Richard Diebenkorn.

By this period, it had become increasingly apparent that the burgeoning collection would need a freestanding museum devoted solely to art. Jack McGregor, then Director of the San Antonio Museum Association,

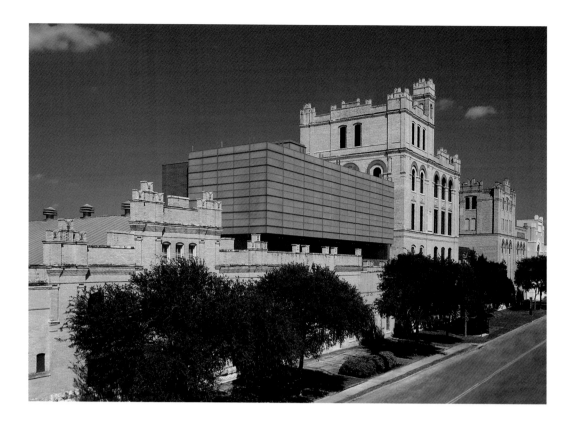

FIG. 1. The San Antonio
Museum of Art today.

strongly recommended that the Association purchase a dilapidated complex of buildings that formerly served as the Lone Star Brewery for this purpose. McGregor shared his vision for a new San Antonio Museum of Art with Chair of the Association's Board Thomas Drought and trustees Nancy Brown Negley, Elizabeth Huth Coates, Gilbert M. Denman, Jr., and others, and by 1971 the Association had agreed to purchase the former brewery.

Built in 1884 and expanded in the 1890s, the Lone Star Brewery was designed in the grand style often associated with nineteenth-century breweries in America. The massive four-story pale brick building, situated on the banks of the San Antonio River, rises above the pecan and live oak trees behind it like a castle, complete with two great towers and crenellated parapets. The Lone Star Brewery touted itself as the largest brewery in Texas, and its campus included cooper and blacksmith shops, bottling facilities, horse stables, and other outbuildings. Local owners partnered with the legendary Adolphus A. Busch of St. Louis, and the brewery thrived. When Prohibition was adopted, however, the Lone Star Brewery, like hundreds of other breweries throughout the country, dramatically declined. For a brief time, the brewery produced a non-alcoholic beverage called *Tango*, advertised to make the palate "dance with joy." That venture was doomed to failure, and over the next several

decades the campus was used as a cotton mill (fig. 2), an ice factory, an auto repair shop, a uniform storage business, and as a venue for other brief commercial endeavors. By 1970 the once-impressive brewery of decades past was in disrepair, and the San Antonio River was polluted, its banks overgrown.

The conversion of the brewhouse into museum space was accomplished by Cambridge Seven Architects, in association with architects Chumney, Jones, and Kell. The Economic Development Administration, the City of San Antonio, local and national foundations, corporations, and individual donors made major contributions toward the project. The brewhouse's two soaring towers were renamed in honor of benefactors Nancy Brown Negley and Elizabeth Huth Coates, whose support was fundamental to the transformation of the campus. In 1977, Mayor Lila Cockrell christened the new San Antonio Museum of Art by smashing a bottle of beer against the facade, and the much-anticipated Museum welcomed its first visitors on March 1, 1981, to great fanfare.

With the enthusiastic support of the San Antonio community, the Museum's holdings grew rapidly throughout the 1980s. In 1985 the Museum received two large collections of Mexican folk art from the families of the late Vice President Nelson A. Rockefeller and of local artist, teacher, and collector Robert K. Winn. These gifts, spearheaded by Patsy Steves, Edith McAllister, and others, established the foundation of what

FIG. 2. The former brewery served as the Lone Star Cotton Mills between 1921 and 1925.

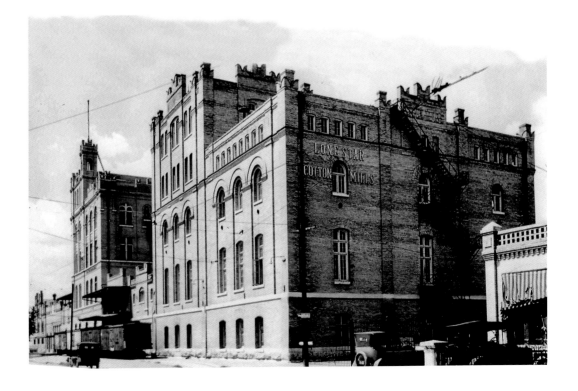

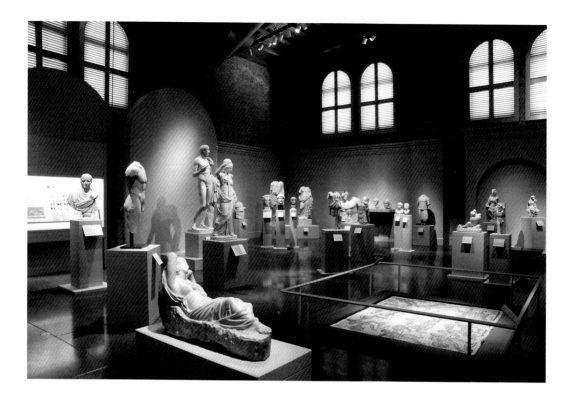

FIG. 3. Roman sculptures in the Gilbert M. Denman Gallery of the Ewing Halsell Wing.

would become one of the most important collections of Latin American folk art in the United States. Also in these years, trustees Lenora and Walter F. Brown made the first in a series of donations that would create the Museum's widely acclaimed collection of Chinese ceramics, and the Robert J. Kleberg, Jr., and Helen C. Kleberg Foundation generously supported the purchase of important nineteenth-century American paintings. In 1986 trustee Gilbert M. Denman, Jr., established the collection of art of the ancient Mediterranean world with the first of several large gifts of ancient Egyptian, Greek, and Roman art. In the same year, with generous support from Robert and Margaret Pace Willson, the Museum purchased more than eight hundred antiquities—primarily Egyptian artifacts and Roman glass—acquired in the late 1920s by the Stark family of Orange, Texas.

The expanding collection rapidly began to outgrow the Museum's new home, which initially consisted only of the Great Hall flanked by the Negley Tower to the west and the Coates Tower to the east. Over the next thirty years, additional adaptations and renovations accommodated the increasingly diverse collection and allowed the Museum to become a major cultural institution serving the region. In 1990 the refurbished boiler and engine rooms adjoining the Negley Tower opened as galleries for the newly acquired collection of Greek and Roman art. Named in honor of the Ewing Halsell Foundation, which supported this renovation,

the wing now houses one of the most spectacular spaces for the display of Roman sculpture in this country (fig. 3). In response to a growing need for temporary exhibition space, the large warehouse building immediately behind the Great Hall was renovated into an elegant gallery. This new space, made possible mainly through a generous grant from the Cowden family, was inaugurated in 1991. Shortly afterward, the brewery's former cooper shop, perched on the banks of the river, was stabilized and renovated. Known as the Beretta Hops House, it now serves as the museum's café and educational space. After thirteen years of rapid expansion, the San Antonio Museum Association was dissolved in 1994, and the San Antonio Museum of Art became an independent nonprofit organization with its own Board of Trustees.

In the 1990s, the Museum embarked on a major capital campaign to build a new wing dedicated to Latin American art. Located on the eastern end of the campus and designed by Overland Partners, this 30,000-square-foot wing opened to the public in fall 1998. This addition, named the Nelson A. Rockefeller Center for Latin American Art in honor of the late vice president's lifelong interest in the region's arts, was underwritten with funds from a city bond initiative and generous gifts from local and national foundations, corporations, and individuals. In addition to folk art from the Rockefeller and Winn collections, the new wing houses pre-Columbian material (fig. 4), much of it donated by

FIG. 4. The Pre-Columbian Gallery in the Nelson A. Rockefeller Center for Latin American Art.

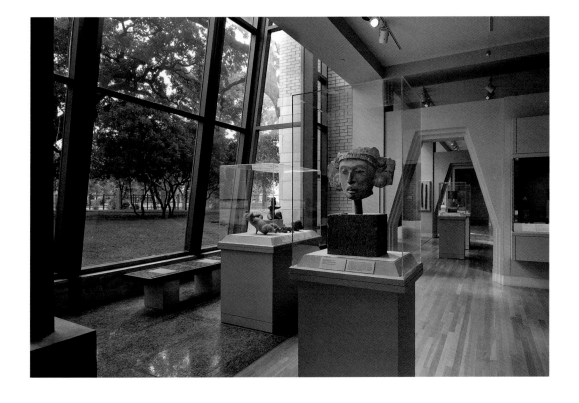

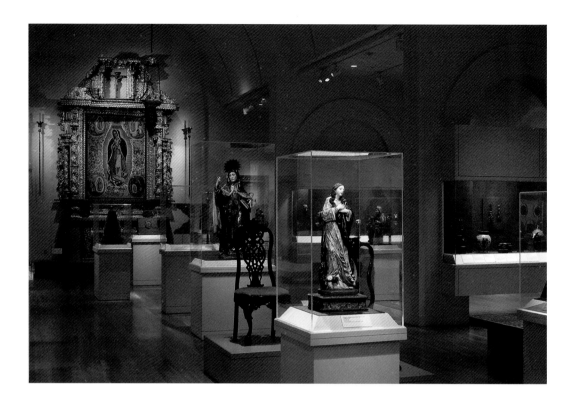

FIG. 5. The Spanish Colonial Gallery in the Nelson A. Rockefeller Center for Latin American Art.

Museum patrons Elizabeth Huth Coates and Mrs. A. A. Seeligson, Sr., as well as the Duff family. The holdings of Spanish Colonial and Republican art have grown steadily over the years (fig. 5), and with the inauguration of the new galleries, the Museum also began to acquire Modern and Contemporary Latin American art. Many of these acquisitions have been sponsored by the Robert J. Kleberg, Jr., and Helen C. Kleberg Foundation. This remarkable collection representing the diverse cultures of Latin America, past and present, continues to expand: among recent additions was the 2006 gift of more than three hundred eighteenth- through early twentieth-century Spanish and Latin American objects from folk art collector Peter P. Cecere.

Soon after the opening of the new Latin American galleries, the trustees' attention turned to the pressing need for a suitable home for the Asian art collection. Largely through the vision and generosity of trustees Lenora and Walter F. Brown, the Museum has developed an Asian art collection of remarkable quality, with particularly extensive holdings of Chinese ceramics (fig. 6). Gifts from the Browns and other donors have also included major works of Japanese, Indian, Korean, Tibetan, and Vietnamese art. In 2005 the Museum opened a new 15,000-square-foot state-of-the-art wing dedicated to the arts of Asia, designed by Overland Partners and adjacent to the second and third floors of the Negley Tower. The Lenora and Walter F. Brown Asian Art Wing, named in recognition of the

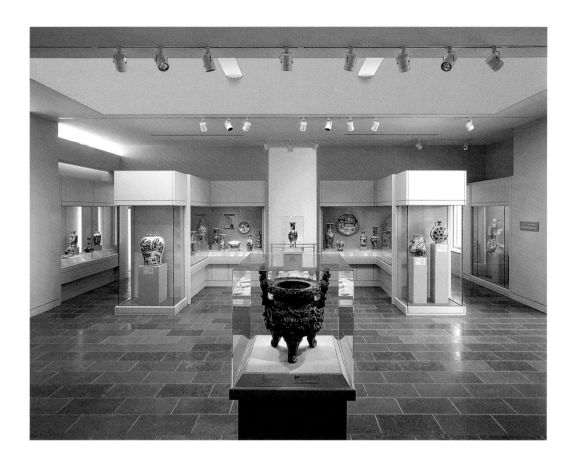

FIG. 6. The Peggy and Lowry Mays Imperial Chinese Art Gallery in the Lenora and Walter F. Brown Asian Art Wing.

Browns' long-standing support of the Museum and its collection of Asian art, was made possible by major gifts from the Ewing Halsell Foundation, the Mays Family Foundation, the Kronkosky Charitable Foundation, the Forrest C. Lattner Foundation, and other benefactors. The new wing continues to inspire visitors and donors alike. These generous donors allow the Museum to provide visitors with a rich and multifaceted experience of Asian art and support the continued growth of the collection.

In addition to the construction of these two wings, which built on existing strengths of the Museum's holdings, the last fifteen years have seen the collection expand in new directions, as well. Gifts from Frances and Frederick Wilkins in 1996 and 1999 initiated the Museum's collection of Islamic ceramics and metalwork. Two important donations enriched the European decorative arts: in 2001 Kittie Nelson Ferguson and Henry Rugeley Ferguson gave the Museum their collection of Wedgwood ceramics, and three years later, John V. Rowan, Jr., bequeathed the Museum more than 250 pieces of seventeenth- and eighteenth-century Irish silver, one of the finest such collections outside Ireland. The European collection was further enhanced in 2005 through the Gilbert M. Denman, Jr., bequest of French paintings and works on paper,

most notably Pierre Puvis de Chavannes's *The Woodcutters*. In addition, the contemporary art collection has been the focus of renewed growth in recent years, with acquisitions concentrating on artists who have gained prominence since the 1980s. The collection also reflects San Antonio's vibrant community of artists and recognizes the roles many artists from this area have played in shaping the trajectory of contemporary art. The contemporary collection has expanded, too, into such currently developing fields as digital photography and new media.

A series of forward-looking decisions by the Museum's trustees, resulting in the acquisition of two sizable tracts of land on the south side of Jones Avenue, ensured that the campus continued to grow along with the collection and individual buildings. These purchases doubled the size of the Museum's campus to nearly fourteen acres and gave it the longest stretch of riverfront property in San Antonio. The 2009 extension of the famed River Walk north from downtown to the Pearl Brewery complex was named the Museum Reach in recognition of the San Antonio Museum of Art's central position in this riverfront neighborhood. The Museum responded to this expansion of the River Walk by constructing a new river-facing entrance complete with a boat landing, covered pavilion, and terraces overlooking the river (fig. 7). Designed by Overland Partners and supported by generous contributions from the Goldsbury Foundation, Rose Marie Hendry and John L. Hendry, III,

and others, these structures integrate the Museum's campus with the river. The new river landing was inaugurated in May 2009. Today, visitors walking along the Museum Reach can discover a whole new world, more tranquil than the faster-paced downtown segment of the River Walk. It is a walk through mixed-use neighborhoods, filled with runners and cyclists, engaging water features, birds, and verdant plants, many in colorful bloom. Exciting installations of sound, color, and form created by local and international contemporary artists enliven the bridges. With the completion of the Museum Reach, the Museum is now at the heart of San Antonio's new cultural corridor along the river.

The Museum enters its fourth decade poised to seize the new opportunities arising from the revitalization of its neighborhood. The Museum and its collections continue to benefit from the dedication and generosity of its many donors, not only those mentioned here, but also other individuals and foundations, too numerous to name, whose support has been essential to the institution's growth and success. This *Guide* offers a taste of the Museum's broad collections, and we hope that both regular visitors and those new to the Museum will find in these pages works of art that awe, delight, and inspire.

Marion Oettinger, Jr.
Curator of Latin American Art

ART OF THE ANCIENT
MEDITERRANEAN WORLD

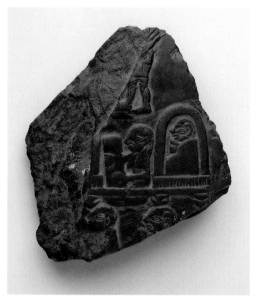

Front

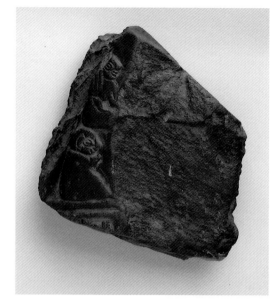

Back

CEREMONIAL PALETTE
FRAGMENT
Egyptian, Predynastic
Period–Early Dynastic Period,
circa 3000 BC
Slate
h. 3 in. (7.6 cm); w. 2¾ in.
(6.9 cm); d. ¾ in. (1.8 cm)
Museum Purchase: Stark-
Willson Collection, 86.138.62

This intricately carved fragment once belonged to an elaborately deco-
rated oblong palette, with figures carved in low relief surrounding a
round depression on one side for grinding cosmetics. The few such pal-
ettes that survive all date to the period of Egypt's unification in the late
fourth millennium BC and appear to commemorate military conquests or
ceremonial occasions. Several examples have been found in or near tem-
ples, and they may have played a role in religious rituals that celebrated
the king's reign and achievements. Despite their very early date, these
palettes' decoration already incorporates features that remained typical
of Egyptian art for thousands of years, especially the use of horizontal
registers to structure the composition and the combination of profile and
frontal views to represent human figures.

On the front of this fragment, a figure wrapped in a garment sits
beneath the canopy of a carrying chair. The identity of the figure is uncer-
tain, but it may represent a woman of elite status. A woman sits next to
the chair, and part of a second carrying chair remains to the left. The
upper register preserves the legs and kilt of a man striding to the left,
while two male heads remain from the bottom register. A woman and
another draped figure appear on the back of the palette fragment. The
complete palette may have depicted a ceremony at which the two women
served as attendants to the more important, clothed figures.

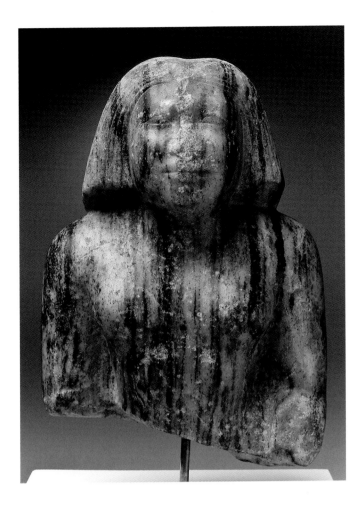

This bust is remarkable, not only because few portraits of women from the Old Kingdom survive, but more particularly because of the rare and distinctive stone from which it was carved. Known as gneiss, the gray stone with pronounced black veins came from a distant quarry near Abu Simbel in northern Nubia. The royal government controlled access to the quarry for this prized material, and the statue is therefore likely the product of a royal workshop. The bust, probably made for the woman's tomb, is not inscribed, so her identity remains unknown, but she must have been a member of the ruling family—perhaps the mother, wife, sister, or daughter of one of the Fourth Dynasty kings.

The bust formed the upper part of a statue that depicted the woman seated, with her forearms resting on her thighs. The statue was just under half life-size when complete. The woman wears a thick, finely striated wig that falls below her broad shoulders. Her wide face is slightly upturned. The woman's delicate eyes and mouth, as well as the carefully polished surface of the face and torso, reflect the ancient sculptor's skill in working the very hard stone.

BUST OF A WOMAN
Egyptian, Old Kingdom,
Dynasty 4, circa 2613–2494 BC
Gneiss
h. 10 in. (25.4 cm); w. 7¼ in.
(18.4 cm); d. 5 in. (12.7 cm)
Gift of Gilbert M. Denman, Jr.,
91.80.126

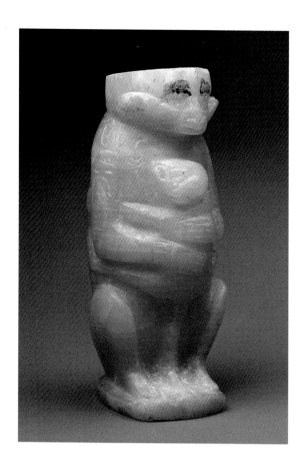

VASE IN THE FORM OF
A FEMALE MONKEY WITH
HER YOUNG
Egyptian, Old Kingdom,
Dynasty 6, reign of Pepy II,
circa 2278–2184 BC
Calcite (Egyptian alabaster)
h. 5½ in. (14.0 cm); w. 2¼ in.
(6.0 cm); d. 2½ in. (6.3 cm)
Museum Purchase: Stark-
Willson Collection, 86.138.61

A female monkey cradling her young lends a whimsical shape to this vase, which once served as a container for oil or perfume. The baby in turn rests its head on the mother's breast and wraps both arms and legs around her. The two monkeys are vervets, long-tailed primates that live in eastern Africa south of the Sahara and were imported into Egypt from the area of modern Sudan and Ethiopia. The monkeys may have alluded to the vase's contents, since the ingredients for the scented oil were procured from the vervets' native region. The Egyptians sometimes kept monkeys as pets, and the bracelets on the mother's wrists indicate that she has been tamed.

The mother monkey's right arm bears an inscription with the name of Pepy II. Having ascended to the throne as a young child, Pepy II ruled for more than ninety years, longer than any other Egyptian king. Similar vases, including two in the Metropolitan Museum of Art in New York, are inscribed with the names of Pepy I and of Pepy II's brother and predecessor, Merenra. These vases of scented oil were probably precious gifts given by the respective kings to members of their courts.

SEKHMET
Egyptian, New Kingdom,
Dynasty 18, reign of
Amenhotep III,
circa 1390–1352 BC
Granodiorite
h. 71 in. (180.5 cm); w. 21 in.
(53.0 cm); d. 40 in. (101.5 cm)
Bequest of Gilbert M. Denman,
Jr., 2005.1.28

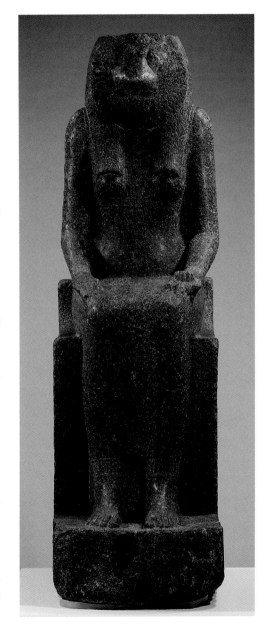

The powerful goddess Sekhmet, daughter of the sun god Ra, offered protection from Egypt's enemies and healing from illness, but if angered she could be deadly. Sekhmet was depicted with the head of a lioness, as in this imposing statue of the goddess seated on a low-backed throne. She wears a close-fitting dress and a long wig beneath the lioness's ruff. Her jewelry consists of a broad collar, just visible between the lappets of the wig, and striped bracelets and anklets. The goddess holds an ankh, a symbol of life, in her left hand. A headdress in the form of a sun disk and uraeus serpent, all carved from a separate block of stone and now missing, completed her original appearance.

Many statues of Sekhmet similar to this one were made during the reign of Amenhotep III for his funerary temple complex, located on the west bank of the Nile across from Thebes. Hundreds of these Sekhmet figures were later moved across the river to the Temple of Mut at Karnak, where this statue was probably discovered. Some of the seated Sekhmet statues, including this example, have hieroglyphic inscriptions on either side of the goddess's legs. The inscriptions give the name and titles of Amenhotep III and assert his close relationship with the goddess by describing him as "beloved of Sekhmet."

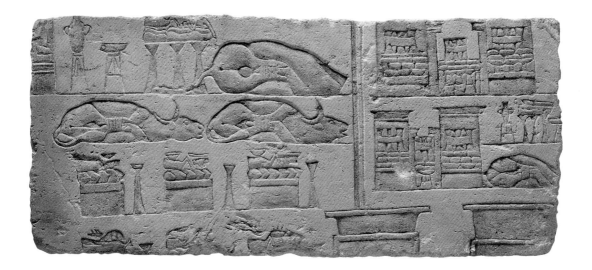

OFFERINGS IN THE GREAT
TEMPLE OF ATEN
Egyptian, New Kingdom,
Dynasty 18, reign
of Akhenaten, circa
1352–1336 BC
Painted limestone
h. 9½ in. (24.0 cm); w. 22 in.
(55.5 cm); d. 1¼ in. (3.3 cm)
Gift of Gilbert M. Denman, Jr.,
91.80.162

Amenhotep IV made a radical departure from worshipping the traditional Egyptian gods to focus on the cult of the sun disk, or Aten. The king changed his name to Akhenaten and built a new capital city, Akhetaten, now known as Amarna. Following Akhenaten's death, both his religious changes and Amarna were soon abandoned. Later kings reused stone from the city's buildings for their own construction projects, including a temple Ramesses II built at Hermopolis, just across the Nile. This relief is one of more than two dozen Amarna blocks reused in Hermopolis that are now in the Museum's collection.

This block represents part of the Great Temple of Aten at Amarna and provides a combination of bird's-eye and frontal views. At bottom right is the top of one of the temple's pylons, or monumental gateways, and the vertical line rising from its left tower indicates the wall separating two courtyards. Both courtyards are full of offerings to Aten, including rectangular altars piled high with haunches of beef and loaves of bread as well as jars of wine on stands. Three trussed bulls, two awaiting slaughter and one with its head and a foreleg already removed, lie in the left courtyard, while another bull and two shrines in the form of small pylons occupy the courtyard to the right. Once presented to the god, these abundant temple offerings were distributed among the temple's clergy and their families.

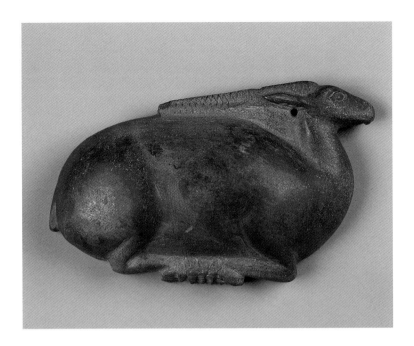

Among the ancient Egyptians, both men and women used a variety of cosmetics to ensure cleanliness, protect their hair and skin, and enhance their appearance. Derived from minerals, plants and trees, and animal fat, cosmetics formed an important part of everyday life for many Egyptians and were also placed in tombs for use in the afterlife. Oils and lotions prevented the hair and skin from drying and cracking in the hot climate, while perfumes masked undesirable odors. Cosmetics including kohl and henna added attractive color to the eyes, cheeks, and lips, as well as hair and fingernails. The Egyptians used an array of jars, palettes, spoons, dishes, and utensils for the storage, preparation, and application of these valuable substances.

This cosmetic dish takes the shape of an oryx (a type of antelope) with bound legs, a form that became popular in the Eighteenth Dynasty (1550–1295 BC). Working in steatite, a soft stone, the craftsman has attentively captured the texture of the oryx's long horns. The upper side of the dish is hollowed in a large oval, following the animal's shape, to hold the cosmetic substance. The oryx forms the bottom of the dish, and its pleasingly rounded contours would have fitted comfortably into its owner's hand while he or she applied the contents.

COSMETIC DISH IN THE
FORM OF AN ORYX
Egyptian, New Kingdom,
Dynasty 18–20, circa 1550–
1069 BC
Steatite
h. 3 in. (7.6 cm); w. 5¼ in.
(13.5 cm); d. 1¼ in. (3.2 cm)
Purchased with the Grace
Fortner Rider Fund, 88.2

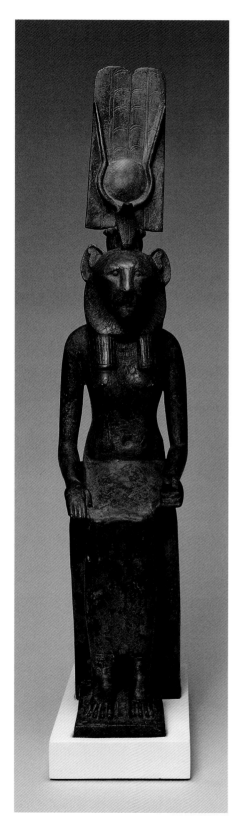

LIONESS-HEADED GODDESS
Egyptian, Late Period,
664–332 BC
Bronze
h. 25½ in. (63.7 cm); w. 5 in.
(12.5 cm); d. 5 in. (12.5 cm)
Museum Purchase: Stark-
Willson Collection, 86.138.223

This dignified lioness-headed goddess seated on a low-backed throne is probably Wadjet, the patron deity of Lower Egypt. Although several Egyptian goddesses could be depicted with leonine heads, inscriptions on similar large bronze figures confirm that they represent Wadjet. The goddess wears a close-fitting dress, a broad collar necklace, and an elaborate headdress consisting of two tall feathers, cow's horns, and a solar disk on a platform crown with a uraeus, or cobra, at its front. The fine rendering of the headdress and leonine features reflects the high level of skill attained by Egyptian bronze workers in the Late Period. Engraved scenes on the sides of the throne, now only partly visible, show Wadjet seated amid emblems of Lower Egypt and receiving offerings.

The Late Period witnessed a significant shift in Egyptian religious practices, as temples increasingly received votive dedications to the gods from private individuals. Petitioners often dedicated bronze statuettes or mummified animals in hopes that these gifts would encourage the gods to look favorably on their requests. This statuette almost certainly served as such a votive offering to Wadjet. The hollow throne may originally have held an animal mummy: remains of ichneumons, a type of mongoose native to Egypt, have been found inside similar statuettes.

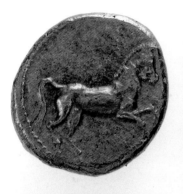

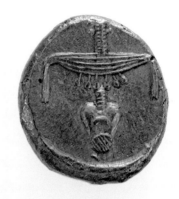

Obverse Reverse

Egyptian kings began minting their own coins only during the fourth century BC, considerably later than their Greek and Persian neighbors. The kings of Dynasties Twenty-Nine and Thirty struck coins primarily to pay Greek mercenaries, whom they hired in an effort to protect Egypt from the threat of Persian conquest. This rare stater is one of a small number of surviving gold coins issued by Nectanebo II, the last native ruler of Egypt until modern times. Nectanebo repulsed an attempted Persian invasion early in his reign, but his efforts to defend Egypt were ultimately unsuccessful, and he was defeated and driven from the country by the Persians in 343 BC.

Nectanebo's gold staters differ markedly from earlier pharaonic coins, which imitated the widely circulated coins of Athens and their depictions of Athena and her owl. Here, instead, the obverse shows a spirited horse prancing to the right. An explicitly Egyptian image, in the form of two superimposed hieroglyphs, occupies the reverse. The heart and windpipe represent the word *nefer*, or "good," while the pectoral with six pendants stands for *nub*, literally, "gold." The expression "good gold" asserts the genuine gold content, and thus the validity, of the coin.

STATER OF NECTANEBO II
Egyptian, Dynasty 30, reign of Nectanebo II, 361–343 BC
Gold
diam. ⅝ in. (1.5 cm)
Purchased with the W. C. Maverick Fund, 93.95.6

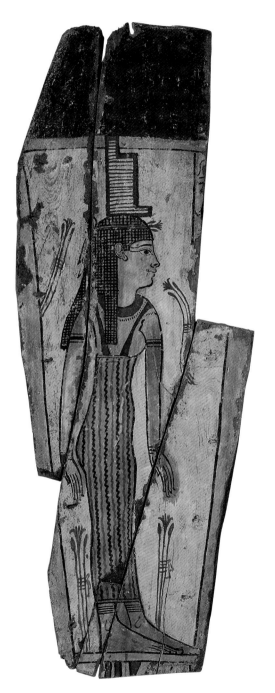

COFFIN PANEL WITH ISIS
Egyptian, Late Ptolemaic
Period–early Roman Period,
mid-1st century BC–
early 2nd century AD
Painted wood
h. 51 in. (131.0 cm);
w. 19¼ in. (48.5 cm);
d. ½ in. (1.5 cm)
Gift of Gilbert M. Denman, Jr.,
91.80.118

The Egyptians believed that those who lived justly would be rewarded with a life after death. Reaching this afterlife required preserving the body through mummification and an appropriate burial, as well as securing the gods' protection through the proper images and spells. This coffin panel depicting Isis reflects the continuity of these long-standing beliefs even as a succession of foreign rulers, including the Greek-speaking Ptolemies and the Romans, took control of Egypt. The powerful goddess's image served to protect the deceased on the potentially dangerous journey to the afterlife. The upper right part of the panel is now lost, but the area opposite Isis's headdress once bore a hieroglyphic inscription containing a prayer uttered by the goddess on behalf of the deceased.

Isis wears a brightly colored, light blue dress with red stripes and black zigzags and narrow red shoulder straps. Her tall headdress takes the shape of a throne. Figures with similar proportions and features appear in the painted decoration of coffins and tombs from cemeteries in Middle Egypt, and a workshop in this region may have made this coffin. The panel, which formed the coffin's floor, was assembled from three irregularly shaped planks that were carefully fitted together and attached with wooden pegs. Its size suggests that this panel may have belonged to the coffin of a child.

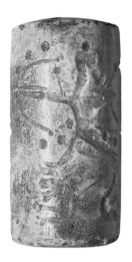

For more than three thousand years, cylinder-shaped seals, engraved with geometric or figural designs, served as a means of identification for individuals and institutions throughout the ancient Near East. The impressions left by rolling the seals across clay tablets inscribed with legal, economic, or administrative texts attested to the individuals present at these transactions and ensured the documents' authenticity. Seals were also impressed on lumps of clay affixed to storeroom doors and containers for goods to guarantee the security and the ownership of their contents. Carved from a variety of stones, as well as other materials such as wood, ivory, and faience, cylinder seals were often pierced lengthwise so that they could easily be attached to the owner's garments or worn around the wrist or neck.

The images on this seal may depict an episode drawn from Mesopotamian creation myths, in which the warlike god Ninurta defeats a series of monsters who threaten the gods. Ninurta stands on the back of a winged, scorpion-tailed creature and takes aim with his bow and arrow at a winged lion. The winged lion may represent Anzu, a monster who stole the Tablet of Destinies from the supreme god Enlil. By defeating Anzu and returning the tablet to Enlil, Ninurta ensured the stability of Enlil's rule. To the left of this scene are a beardless worshipper and a spade representing the god Marduk.

CYLINDER SEAL
Neo-Assyrian, circa 700 BC
Chalcedony
h. 1½ in. (3.6 cm);
diam. ¾ in. (1.8 cm)
Museum Purchase: Stark-
Willson Collection, 86.138.636

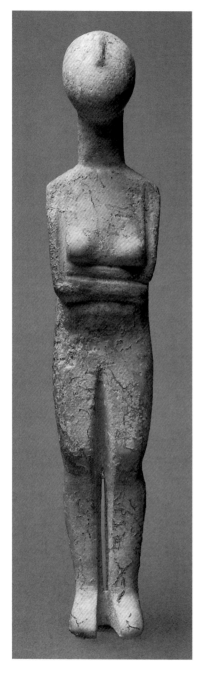

FEMALE FIGURE
Cycladic, Early Cycladic II,
circa 2700–2500 BC
Marble
h. 8¼ in. (21.0 cm); w. 1½ in.
(3.9 cm); d. 1½ in. (3.7 cm)
Gift of Gilbert M. Denman, Jr.,
86.134.2

Early Bronze Age sculptors on the Cycladic Islands in the Aegean Sea fashioned a series of marble figures remarkable for their abstracted forms. Marble occurs naturally on several of the islands, and the sculptors worked this material with stone or bronze tools. The resulting figures range in height from several inches to nearly life-size. While the majority of the figures, including this statuette, represent nude women, male musicians and warriors were also created. Such marble figures have been found in both cemeteries and settlements. Although their function and meaning remain uncertain, they may represent deities, ancestors, or companions or servants of the deceased.

Cycladic figures have long been admired for the sculptors' skillful reduction of the human form to its most essential elements. This figure's rounded head, narrow shoulders and nearly flat feet are typical of the Kapsala variety, so-named after a cemetery on the island of Amorgos where an early example of the type was discovered. The woman's long, slender arms are folded beneath her drooping breasts, and the folds of her abdomen are indicated by horizontal grooves. The prominent nose is the only feature on her tilted-back head, though her other features may have been added in paint. Black, red, and blue pigments were sometimes used for the female figures' hair, eyes, and pubic triangle, as well as decorative patterns on the skin.

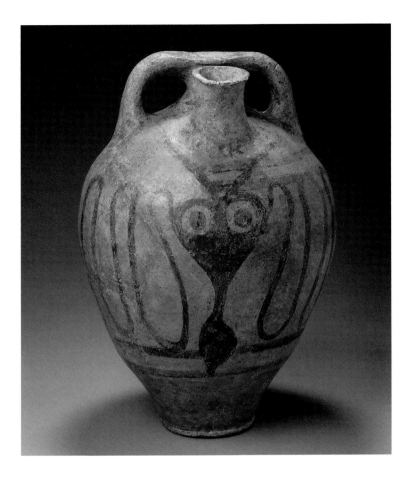

This sturdy vessel is one of a group of stirrup jars that were made from a coarse clay fabric and used as containers for transporting liquids, primarily olive oil and wine. The jars take their name from the two stirrup-shaped handles. The octopus had long been a popular motif on Minoan ceramic vessels, and this jar features a stylized specimen with large, staring eyes. Two of the creature's tentacles encircle the body of the vessel, while another two emerge from its head and flank the spout.

Transport stirrup jars provide evidence for the extensive trade networks linking Late Bronze Age civilizations. Manufactured on Crete, they were exported widely around the eastern and central Mediterranean: similar vessels have been found in mainland Greece, coastal Anatolia, Cyprus, Egypt, and the Levant, as well as in southern Italy and Sicily. Incised into each of this jar's handles is a sign related to the Cypro-Minoan script. Such marks were used by Cypriot traders, and their presence indicates that this jar was probably shipped from Crete to Cyprus or another destination in the eastern Mediterranean. Although the precise meaning of the marks is unknown, they probably recorded the source, destination, or ownership of the jar's contents.

STIRRUP JAR
Minoan, Late Minoan III,
circa 1300–1200 BC
Terracotta
h. 14 in. (35.8 cm);
diam. 10 in. (25.2 cm)
Gift of Gilbert M. Denman, Jr.,
86.134.17

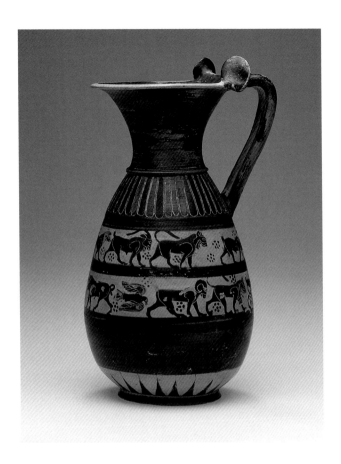

OLPE (PITCHER) WITH
ANIMAL FRIEZES
Greek, Corinthian, circa 650–
625 BC
Terracotta
h. 10½ in. (26.4 cm);
diam. 5¼ in. (13.5 cm)
Purchased with the Grace
Fortner Rider Fund, 93.17

In the seventh century BC the pottery workshops of Corinth produced vases decorated with animals and floral designs, like this *olpe*, or pitcher. Lions, goats, boars, a panther, a bull, a ram, and a flying bird parade around the body of the vase in two registers. Such compositions reflect the influence of the animal friezes popular in Near Eastern art, which Greek artisans probably encountered on imported objects in metal, terracotta, and ivory. Dotted rosettes, typical of Corinthian vase painting, occupy the empty spaces between the animals' legs and above their backs. A row of tongues on the shoulder in black, red, and white and a set of rays emerging from the base complete the vase's decoration.

Details of the animals' heads and bodies are rendered in the "black-figure" technique, that is, by lines incised through their dark silhouettes into the buff-colored ground of the vase. The incised lines give greater clarity to the animals' anatomy, while red paint accentuates their manes and the bird's wings. Developed in Corinth, the black-figure technique was subsequently adopted by vase painters in other cities, most notably Athens, where it flourished in the sixth century. Corinthian vases in this style, including pitchers like this example and smaller perfume containers, were widely exported around the Mediterranean region.

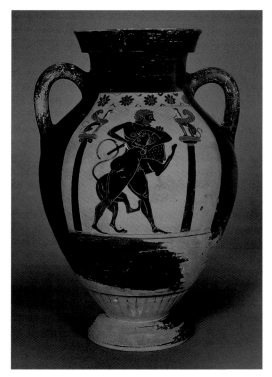

Front

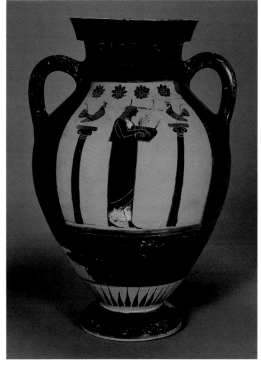

Back

The painter of this amphora, or jar, juxtaposed two scenes of contest. On the front, the Greek hero Herakles struggles with a great lion that terrorized Nemea and the surrounding countryside in the northeastern Peloponnese. The first of Herakles's twelve Labors, the combat with the Nemean Lion was one of the most frequently represented subjects on Athenian vases of the sixth century BC. The vase-painter has captured the intensity of the fight: grasping the writhing lion by the head, Herakles has struck it with his sword, but the blow will prove futile against the beast's impervious hide. Herakles ultimately emerged victorious by strangling the lion. Herakles' contest with the Nemean Lion is a frequent subject on vases attributed to Group E, a workshop of black-figure painters named after their famous protégé, Exekias.

This story's popularity and its depiction here may have been inspired by the establishment of the Nemean Games in 573 BC. The man playing a lyre on the reverse side likewise calls to mind the Nemean Games and other Greek festivals. On these occasions competitions were held in music and poetry as well as in athletics, and the lyre-player here is probably a contestant. The paired columns that frame each scene, topped by sphinxes on the front of the vase and by cocks on the back, serve to emphasize further the connection between the mythical conflict and the human contest.

AMPHORA (JAR) WITH HERAKLES AND THE NEMEAN LION
Attributed to Group E
Greek, Athenian, circa 550–540 BC
Terracotta
h. 14 in. (35.4 cm);
diam. 9¼ in. (23.3 cm)
Gift of Gilbert M. Denman, Jr., 86.134.40

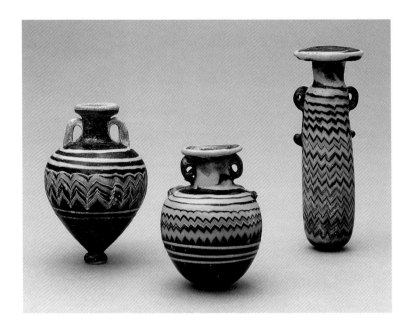

THREE PERFUME OR
COSMETIC BOTTLES
Greek, Eastern Mediterranean,
late 6th–5th century BC
Dark blue, yellow, and
turquoise glass
left: h. 2¾ in. (7.2 cm);
diam. 2 in. (5 cm)
middle: h. 2¼ in. (5.9 cm);
diam. 1¾ in. (4.4 cm)
right: h. 3¾ in. (9.6 cm);
diam. 1¼ in. (3.4 cm)
Museum Purchase:
Stark-Willson Collection,
86.138.276, 86.138.299,
and 86.138.288

These small glass bottles imitate the shapes used for larger Greek vessels made of metal and terracotta: from left to right, they are an *amphoriskos* or miniature amphora, a globular *aryballos*, and a slender *alabastron*. They were produced by a technique introduced into the eastern Mediterranean from the Near East. The dark blue ground was formed around a core of clay and other materials. The glassmaker then wound threads of yellow and turquoise glass around the vessel and dragged a sharp tool through these threads to create the zigzag patterns that decorate each bottle. The handles and flaring rims, as well as the foot of the amphoriskos, were fashioned separately and applied after the rest of the vessel was completed. The round-bottomed aryballos and alabastron may have had metal or glass supports, or they could have been suspended from a cord passed through the handles.

Core-formed bottles like these served as pretty containers for small amounts of costly perfumes, scented oils, or cosmetics. The discovery of such bottles at sites around the Mediterranean and Black Seas attests to the demand for their valuable contents. These bottles were not only for personal use, but could also be dedicated in sanctuaries as offerings to the gods. In addition, bottles of perfume or oil were sometimes placed in graves, a practice that enabled the survival of such fragile glass vessels.

A single-handled vessel, the *oinochoe* was used to serve wine. Such vases saw use during *symposia*, the drinking parties that formed an important part of the social life of aristocratic Greek men, and the encounter painted on this oinochoe was particularly suited to that setting. A young man wearing a wreath gazes intently at the flower he offers to a seated woman, while she touches his garment provocatively with a flowering branch. The young man's coin purse reveals the occasion for their meeting: the woman is almost certainly a *hetaira*, or prostitute, whose services the youth hopes to secure. The mirror hanging on the wall above the woman's head indicates that the scene takes place in her living quarters. Skilled in music and conversation, hetairai were often hired as entertainers for symposia. The depiction of this negotiation scene on a serving vessel reminded symposium guests of their host's efforts to plan the evening's pleasures.

This vase has been attributed to the Berlin Painter, one of the outstanding vase-painters working in Athens in the early fifth century BC. The finely drawn figures are typical of the Berlin Painter's work. His composition, carefully arranged to suit the shape of the vessel, elegantly conveys the tension of the meeting between the hesitant, seemingly inexperienced youth and the self-assured hetaira.

OINOCHOE (PITCHER)
WITH A YOUNG MAN AND
A WOMAN
Attributed to the Berlin Painter
Greek, Athenian, circa 490–
480 BC
Terracotta
h. 11½ in. (28.9 cm);
diam. 5 in. (12.9 cm)
Gift of Gilbert M. Denman, Jr.,
86.134.59

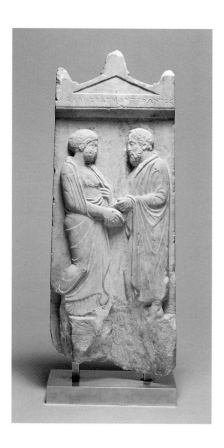

GRAVE STELE OF
KALLISTRATE
Greek, Athenian, circa 420–
400 BC
Marble
h. 33¼ in. (84.7 cm);
w. 13½ in. (34.0 cm);
d. 4 in. (10.0 cm)
Gift of Gilbert M. Denman, Jr.,
86.134.8

A youthful woman and an elderly man poignantly gaze at each other while clasping hands on this stele, or upright stone slab, that served as a grave marker. The Greek inscription names the woman, Kallistrate, as the deceased and identifies her as the daughter of Antiphon. Kallistrate wears a himation or mantle over a thin dress called a chiton, and her hair is gathered at the back of her head under an *opisthosphendone*, a wide cloth band. A row of short locks frames her face, and she wears a round earring. Antiphon is clothed in a himation, and his long beard and the sagging flesh of his cheeks indicate his advanced age. Both figures wear sandals.

Stone grave markers came into wider use in Athens in the late fifth century BC after limited production during the middle of the century, perhaps on account of laws restricting expenditure on funerary monuments. Like many grave stelae from this period, this example has an architectural form, with a pediment topped by three projecting *acroteria*. Its carving reflects the sensitive treatment of drapery and anatomy characteristic of Greek sculpture of the Classical period. Family scenes depicting two or more relatives often appear on grave stelae from this period. The handshake, a common motif in these scenes, may be a gesture of farewell between the living and the dead or of reunion as the newly deceased greets family members in the afterlife.

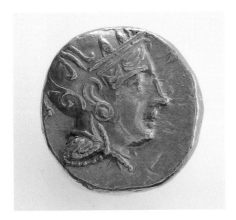

Obverse

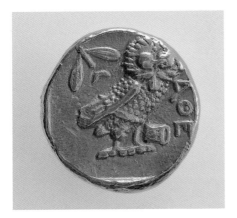

Reverse

Following the death of Alexander the Great in 323 BC, a period of political upheaval ensued as his commanders and their successors vied for control of his former empire. This small gold coin attests to the turmoil experienced by the city of Athens during these years. Under siege and cut off from the Laurion silver mines, the Athenian tyrant Lachares had to find alternative sources of metal for the coins needed to pay his troops. As a last resort, he stripped the gold from the famous cult statue of Athena in the Parthenon and melted down other dedications from the Acropolis. This stater is one of the few surviving gold coins minted by Lachares from these extraordinary sources.

The images on the obverse and reverse of the stater had appeared on the city's widely circulated silver coins since the late sixth century BC. On the obverse is Athena, patron goddess of the city, wearing a helmet decorated with olive leaves, a round earring, and a beaded necklace. Standing beneath an olive branch on the reverse is an owl, sacred to Athena. The wool basket near the owl's feet represents the crafts over which the goddess presided. The legend AΘE on the reverse gives the first three letters of Athens' name.

STATER OF ATHENS
Greek, Athenian, circa 296 BC
Gold
diam. ⅝ in. (1.5 cm)
Purchased with the W. C. Maverick Fund, 93.95.5

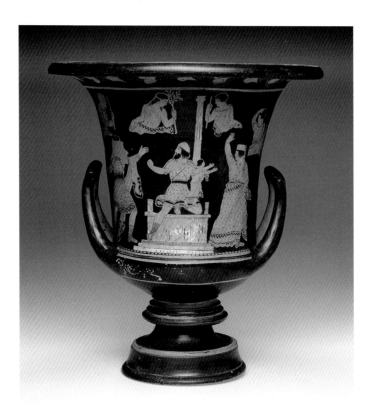

CALYX-KRATER (MIXING
BOWL) WITH TELEPHOS
AND ORESTES
Signed by Asteas
South Italian, Paestan,
circa 340 BC
Terracotta
h. 22¼ in. (56.5 cm);
diam. 19¾ in. (50 cm)
Gift of Gilbert M. Denman, Jr.,
86.134.167

The scene on the front of this large krater is drawn from the Greek myths surrounding the Trojan War. At center is the Mysian king Telephos, who kneels on an altar while clutching the infant Orestes. Injured in the leg by the hero Achilles during the Greeks' first, unsuccessful assault on Troy, Telephos learned from an oracle that only the weapon that caused the wound could heal it. Here Telephos threatens to kill Orestes unless Agamemnon, Orestes's father and the Greeks' leader, persuades Achilles to heal the wounded leg. Orestes's mother, Clytemnestra, reacts in horror while the seer Calchas, Apollo, Hermes, and a woman named Thrisa look on from above. The emotional moment was pivotal to the success of the Greeks' campaign: once healed, Telephos agreed to lead the Greek army back to Troy to renew their attack.

This krater, a vessel for mixing wine with water, is one of a dozen surviving vases signed by the painter Asteas, who worked in the South Italian town of Poseidonia (later Paestum) in the mid-fourth century BC. Remarkable both in its size and in its elaborate mythological imagery, this vessel would have formed an impressive focal point for a *symposium* or banquet. Several of Asteas's other signed vases have been found in large painted tombs outfitted with a rich array of grave goods, and this krater, too, may have ultimately formed part of the burial equipment of one of the region's wealthy inhabitants.

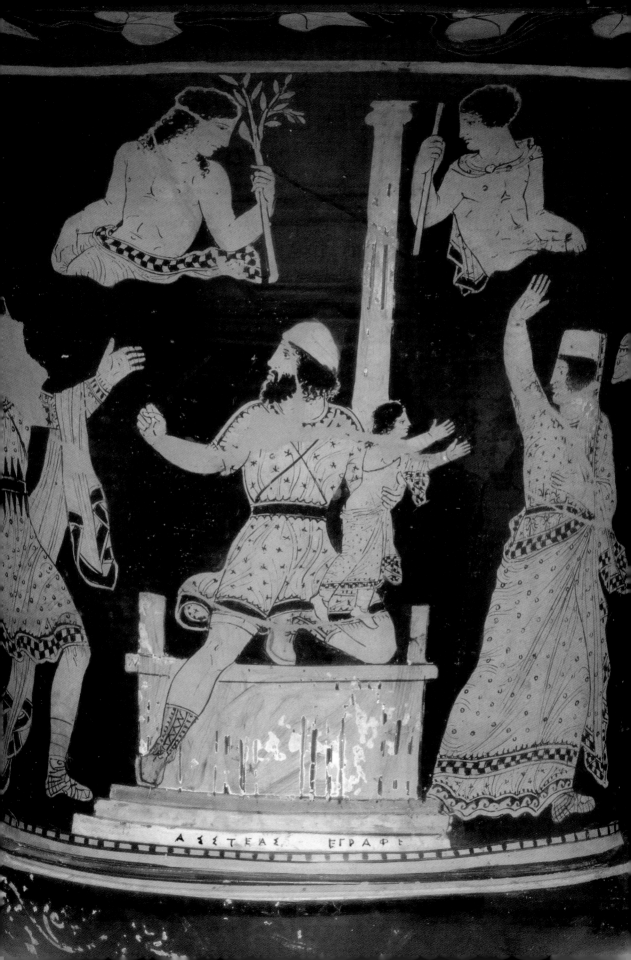

ΑΣΣΤΕΑΣ ΕΓΡΑΦΕ

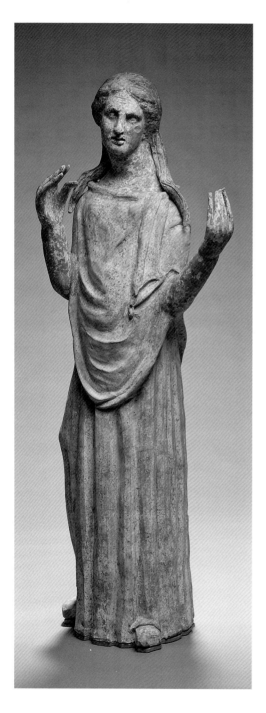

MOURNING WOMAN
South Italian, Canosan,
3rd century BC
Painted terracotta
h. 35½ in. (90.5 cm);
w. 13 in. (33.0 cm);
d. 11¾ in. (30.0 cm)
Gift of Gilbert M. Denman, Jr.,
95.18.2

This haunting female figure evokes the depths of grief. Her expression of anguish, with deeply furrowed brows and partly open mouth, is reinforced by the dramatic gesture of her upraised hands with their elongated fingers. Similar figures have been found in the underground chamber tombs, or *hypogea*, of Canosa, a town in southeastern Italy. Canosa's residents had long been in contact with the Greek colonies of southern Italy, though by the late fourth century BC the city had allied itself with the expanding Roman state. The distinctive mourning figures reflect the continuation of local artistic traditions despite this shifting political landscape.

The Canosan figures appear to have been made in pairs or sets. Technical studies have shown that their draped torsos were constructed from coils of clay with further pieces of clay added for details such as the folds of the long chiton and the shorter himation, or mantle, worn over it. The head and arms, as well as the long locks of hair on the shoulders, were fashioned separately and attached before firing. The figures were richly painted, and extensive traces of this one's original polychromy survive: dark red for the hair, yellow and red for the eyes, bright red on the lips, and bright pink for the two stripes running down the skirt of the chiton in front.

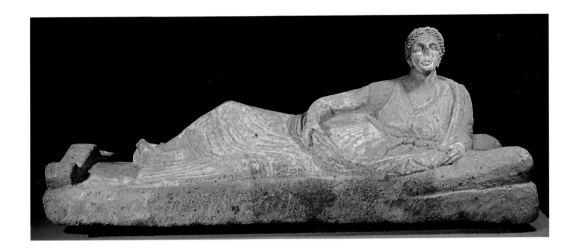

The deceased woman depicted on this lid from a sarcophagus, or coffin, lies on a couch with a gabled footboard and rests her left arm on a pillow, as if she is reclining at a banquet. Although images of banqueters appear frequently in Etruscan funerary sculpture and tomb painting, their meaning is uncertain. They may represent feasts held by the living in honor of the deceased or the departed enjoying the pleasures of the afterlife. This woman is finely attired for the occasion: she wears a diadem in her hair and a pair of pendant earrings. Her chiton, or dress, belted under her breasts, falls in fine folds beneath the heavier mantle draped around her legs and over her left shoulder. The woman lifts her head with an expectant gaze, as if waiting to greet visitors to the tomb.

The Etruscans, famed as metalworkers, made relatively little sculpture in stone. This lid is carved from a soft, gray volcanic stone known by the Italian name *nenfro*, and it would have covered a rectangular chest made from the same material. Nenfro was employed for sarcophagi produced in several cities of southern Etruria from the late fourth to early second centuries BC. The coarse surface of the stone was originally painted: red pigment survives on the woman's hair and on the footboard, while traces of pink remain on her skin.

LID FROM A SARCOPHAGUS
Etruscan, 3rd century BC
Nenfro (volcanic stone) and pigment
h. 32½ in (82.4 cm);
w. 85¾ in. (218.0 cm);
d. 26¾ in. (68.2 cm)
Bequest of Gilbert M. Denman, Jr., 2005.1.50

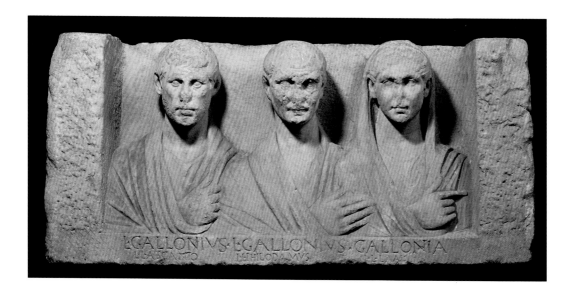

FUNERARY RELIEF FOR
THREE FORMER SLAVES
Roman, Augustan period,
late 1st century BC–
early 1st century AD
Marble
h. 25 in. (63.4 cm);
w. 54¾ in. (139.2 cm);
d. 17 in. (43.4 cm)
Purchased with funds provided
by Gilbert M. Denman, Jr.,
2001.11.2

This funerary relief commemorates three former slaves, whose names are inscribed below their portraits: Lucius Gallonius Ascanio, Lucius Gallonius Philodamus, and Gallonia Lais. All three had been the slaves of a Lucius Gallonius, and, as was customary, upon emancipation they took their former master's name in addition to their slave names. Like their names, the clothes the figures wear emphasize their new social status. The two men wear togas, a garment reserved for Roman citizens. Lais's veiled head, a symbol of modesty and chastity, alludes to virtues associated with the ideal Roman matron. Although the inscription gives no information about the relationship between the three figures, Philodamus and Lais may have been married: they turn toward each other slightly, and his hand rests gently on her arm.

Funerary reliefs like this one, with bust-length portraits of the deceased, were popular in Rome and the surrounding area from the middle of the first century BC through the early first century AD. The Romans buried their dead in cemeteries along the roads leading out of the city, and funerary reliefs decorated the street-facing sides of the tombs. The reliefs thus served as a lasting reminder of the deceased to all passersby. In the 1600s this relief was displayed in a villa just outside Rome's walls on the via Nomentana. It may have originally belonged to one of the many tombs that lined this ancient road.

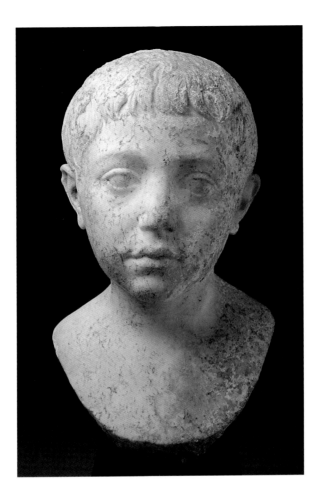

This sensitive portrait depicts a young boy who is probably between five and eight years of age. He wears a serious, pensive expression, with raised brows and slightly pursed lips. Like his facial features, the boy's hair is delicately carved. The arrangement of his hair, and in particular the series of short, comma-shaped locks across the forehead, emulates the hairstyles worn by Augustus, the Julio-Claudian emperors who followed him, and their male relatives. This portrait reflects the growing fashion by which private individuals adopted the styles worn by imperial family members.

Images of children in the imperial family appeared on numerous public monuments and coins in the late first century BC and early first century AD, as Augustus and his successors sought to establish the legitimacy of their heirs. Perhaps inspired by depictions of imperial children, private portraits of children became much more common in this period. Such portraits were most often commissioned by parents to commemorate a child who had died. This portrait may have been displayed either in the family's home or at the child's tomb as a memorial for a life that ended too soon.

PORTRAIT OF A BOY
Roman, Julio-Claudian period, early 1st century AD
Marble
h. 12½ in. (32.0 cm); w. 7 in. (18.0 cm); d. 6¾ in. (16.9 cm)
Gift of Gilbert M. Denman, Jr., 86.134.97

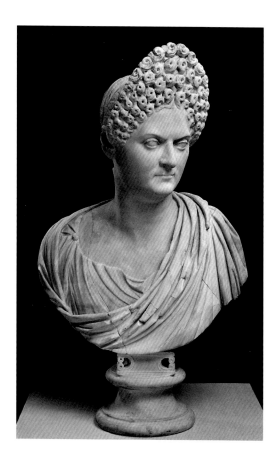

PORTRAIT OF A WOMAN
Roman, Trajanic period, early
2nd century AD
Marble
h. with pedestal 29½ in.
(75.3 cm); w. 18 in. (45.6 cm);
d. 11¾ in. (29.7 cm)
Gift of Gilbert M. Denman, Jr.,
86.134.99

This imposing portrait bust depicts a rather formidable-looking woman. The sagging flesh of her cheeks and neck indicates her mature age. Her hair, in a tour de force of the Roman sculptor's skill, is piled high in four tiers of curls above her forehead, while the rest is worked in fine braids gathered in a bun around her crown. This dramatic hairstyle first became popular during the Flavian dynasty (AD 69–96), but the extensive drilling of the curls indicates that this bust was probably carved early in the following century. The woman, in other words, is shown with a coiffure that came into fashion during her youth.

On the basis of her hairstyle and facial profile, the woman has been tentatively identified as Domitia Longina, wife of Domitian, the last of the Flavian emperors. Domitia was reputedly involved in the plot that resulted in her husband's assassination. This portrait may be one of several created after Domitian's death to commemorate her role in eliminating this unpopular emperor. Acquired in the 1760s or 1770s by the Earl of Shelburne for his growing sculpture collection, the portrait was displayed for many years in the library of Lansdowne House, London. The bust has minor eighteenth-century restorations, including the nose and the center of the top tier of curls.

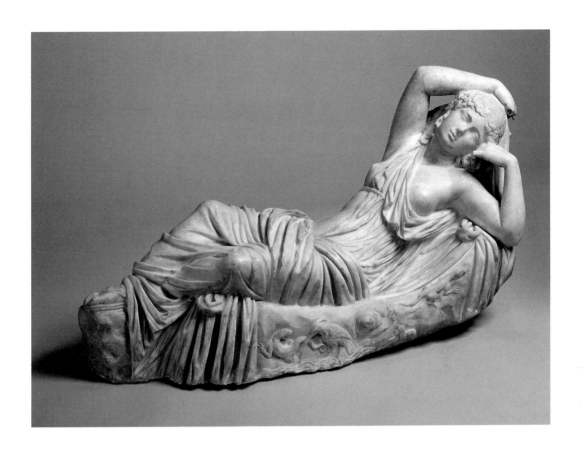

SLEEPING ARIADNE
Roman, 2nd century AD
Marble
h. 18 in. (46.2 cm); w. 34 in.
(86.7 cm); d. 12¼ in.
(31.2 cm)
Gift of Gilbert M. Denman, Jr.,
86.134.149

This charming statue of a sleeping girl depicts Ariadne, daughter of the mythical King Minos of Crete. Ariadne fell in love with the Athenian hero Theseus, who had arrived in Crete among a group of youths intended as victims of the Minotaur, the monstrous offspring of Minos's wife and a bull. Ariadne secretly aided Theseus in killing the Minotaur and escaped from Crete with him, but on their journey to Athens, Theseus abandoned her on the island of Naxos. This statue shows Ariadne sleeping peacefully, before she awakens to discover Theseus's betrayal. Her story had a happy ending, however: the god Dionysos soon arrived on the island, discovered Ariadne, and made her his consort.

Ariadne's adventure was immensely popular in Roman art and literature: in addition to marble sculptures, she is also represented in wall paintings and floor mosaics and on gems and coins. In this statue, a small-scale variation on a type that also survives in several over-life-size versions, the girl reclines with legs crossed and head cradled in her arms. During her slumber, her garment has slipped, leaving both breasts exposed. The size of the statue would have made it suitable for display in a Roman house or villa garden. The aquatic creatures that decorate the plinth, including a heron, a duck, two lizards, and a snail, suggest that it may have been placed near a pool or fountain.

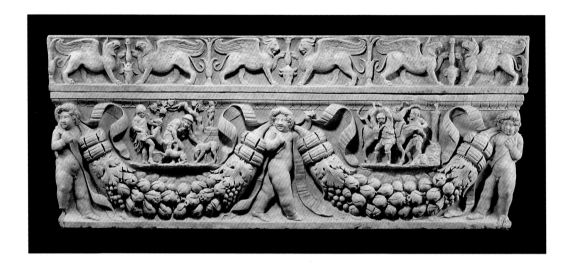

GARLAND SARCOPHAGUS
WITH HUNTING SCENES
Roman, circa AD 130–150
Marble
h. including lid 29 in.
(74.0 cm); w. 76¾ in.
(194.7 cm); d. 29½ in.
(75.0 cm)
Purchased with funds provided
by Gilbert M. Denman, Jr.,
90.17.a-b

Garlands laden with fruit and supported by three chubby cupids span the front of this marble sarcophagus, or coffin. Hunting scenes occupy the spaces above the garlands. On the left, two hunters collect their dogs, and at right they prepare to load a donkey with the deer and boar they have killed. Sarcophagi decorated with garlands of fruit, flowers, and leaves in this manner became popular in the first half of the second century AD. Although hunting scenes often appear on later Roman sarcophagi, this chest is one of only a few that combine bucolic images with the garlands.

Pairs of griffins, alternately eagle- and lion-headed, adorn the front flange of the lid. Three coffers are carved into the lid's upper surface. This block, coffered side down, must originally have served as part of the cornice of a public building. The fine carving of the moldings in the coffers places the creation of the architectural block in the late first or early second century AD, that is, not long before its reuse as the sarcophagus's lid.

The deep undercutting and unusually crisp surfaces on the front of the chest, as well as several anomalous details of the figural scenes on both chest and lid, have led some scholars to suspect that the front of the sarcophagus may have been recarved in the twentieth century.

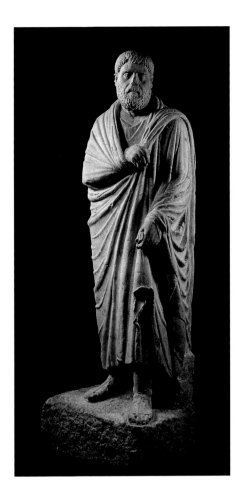

This solemn, bearded fellow wears the usual formal attire of a Greek citizen. The himation, worn over a chiton, continued to be the dress of choice for portraits of men in the Greek-speaking eastern provinces under Roman rule. The himation covers the man's right arm so completely that only the hand is visible. In his left hand he holds a scroll, an allusion to his literary education. A pair of leather sandals, tied neatly in front of the ankles, completes his outfit.

The statue is unusual in being carved of a kind of limestone called travertine rather than from marble, which was generally preferred for sculpture. Travertine was widely used in the Roman world as a building material but was rarely employed for statuary. This portrait may have been made in a provincial area where marble was not readily available. The rough plinth seems unfinished, as does the support behind the left leg, which may have been intended to take the form of a scroll box. The statue was probably destined for an architectural setting, perhaps a niche on the facade of a public building or tomb, where the sketchily worked back and the buttress behind the neck would not be visible.

PORTRAIT OF A MAN
Roman, mid 2nd–
3rd century AD
Travertine
h. including plinth 85 in.
(216 cm); w. 29½ in. (75 cm);
d. 20½ in. (52 cm)
Bequest of Gilbert M.
Denman, Jr., 2005.1.93

PORTRAIT OF MARCUS
AURELIUS
Roman, AD 140–150
Marble
h. 95 in. (241.0 cm);
w. 32½ in. (82.5 cm);
d. 26½ in. (67.0 cm)
Gift of Gilbert M. Denman, Jr.,
85.136.1

As a boy, the young Marcus Aurelius was adopted by the Roman emperor Antoninus Pius and selected as his successor. This over-life-size portrait shows the young man in the early stages of adulthood, with wispy traces of a moustache and beard. It was probably carved in the 140s, when Marcus was in his twenties. Many portraits of Marcus were created in these years to emphasize his important position as heir to the imperial throne. In this statue, the powerful nude torso likens the future emperor to heroes of Greek mythology, who were usually depicted unclothed. The cloak—a type worn by Roman generals—and sword allude to Marcus's military authority, while his scepter is an emblem of imperial power. Marcus succeeded Antoninus in 161 and ruled for nearly twenty years, until his death in 180.

This portrait, together with several other statues depicting mythological and athletic subjects, was discovered in 1771 at a villa a few miles outside Rome on the via Appia. The excavator, Gavin Hamilton, arranged for the statue's restoration in Rome, including reattaching the head to the torso and undertaking repairs to the arms, sword, scepter, and left leg. He then sold the portrait for £300 to the future Marquess of Lansdowne, who assembled a large collection of Greek and Roman sculptures at his house in London.

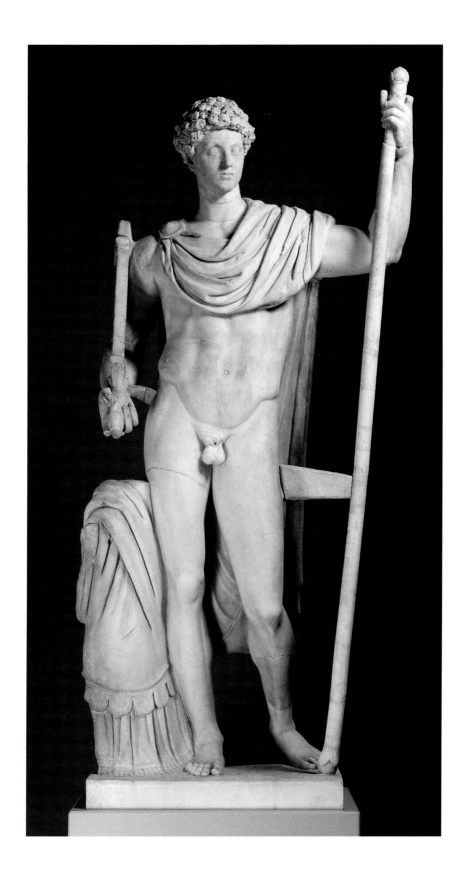

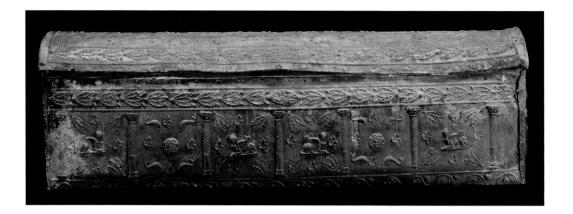

SARCOPHAGUS
Roman, probably from Tyre,
2nd–3rd century AD
Lead
h. 22¾ in. (57.8 cm);
w. 72 in. (183.0 cm);
d. 16¼ in. (41.3 cm)
Purchased with funds provided
by the L. E. Bruni Family
Charitable Trust of the San
Antonio Area Foundation,
89.63.1

Sphinxes, dolphins, and heads of the Gorgon Medusa, surrounded by laurel leaves and grapevines, decorate the sides of this remarkably well-preserved lead sarcophagus, or coffin. Arranged in six panels separated by spirally fluted columns, the sphinxes and Medusa heads serve as guardians of the deceased, while the dolphins and grapevines evoke the realm of Dionysos, the god of wine, who was also associated with rebirth into a life after death. An intricate temple facade occupies one end of the sarcophagus. Its pediment, with an arch between the center columns, echoes a feature typical of Syrian architecture in the second and third centuries AD. The opposite end presents an eight-spoked star, and more grapevines wind across the lid.

This sarcophagus is one of a group of lead coffins thought to have been produced in the area of Tyre, a coastal city in Roman Syria (modern Lebanon). The chest and lid were cast in molds made of wet sand or unfired clay, into which individual stamps had been pressed to create the images raised in relief on the finished sarcophagus. The chest was cast as a single flat sheet: after casting, the sides and ends of the chest were folded upward and soldered at the corners, with thin strips of lead covering the joins for added strength. Because lead is easily deformed, the coffin may have been encased in stone or wood before placement in the tomb.

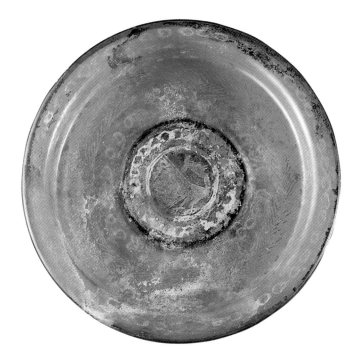

This extraordinary platter finds few parallels among surviving Roman glass vessels. Free-blown in yellowish-green glass, it is remarkable both for its large size and unusual decoration. The shallow platter has a wide rim and stands on a low foot fashioned from a separate piece of glass. The images on the rim and the interior were created by using a copper wheel and an abrasive to cut the glass. A peacock with partly opened tail and tall crest occupies the center of the dish within a border of two concentric circles. A palm- or feather-like ring of chevrons and two bands of circles surround the central emblem, while a third band of circles adorns the rim.

Sacred to the goddess Juno, peacocks were admired in antiquity for their beauty. The Romans bred peacocks in captivity, and the roast fowl was considered a delicacy. A recurring motif in Roman wall paintings and mosaics, where it evoked the splendor of lush gardens, the peacock also appeared in early Christian art as a symbol of immortality, on account of the regeneration of its spectacular tail feathers each spring. The presence of the peacock here perhaps emphasized the sumptuousness of the costly platter itself as well as the refined taste of its owner.

PLATTER WITH A PEACOCK
Roman, 4th century AD
Glass
h. 2¾ in. (7 cm);
diam. 17¼ in. (44 cm)
Museum Purchase: Stark-
Willson Collection, 86.138.726

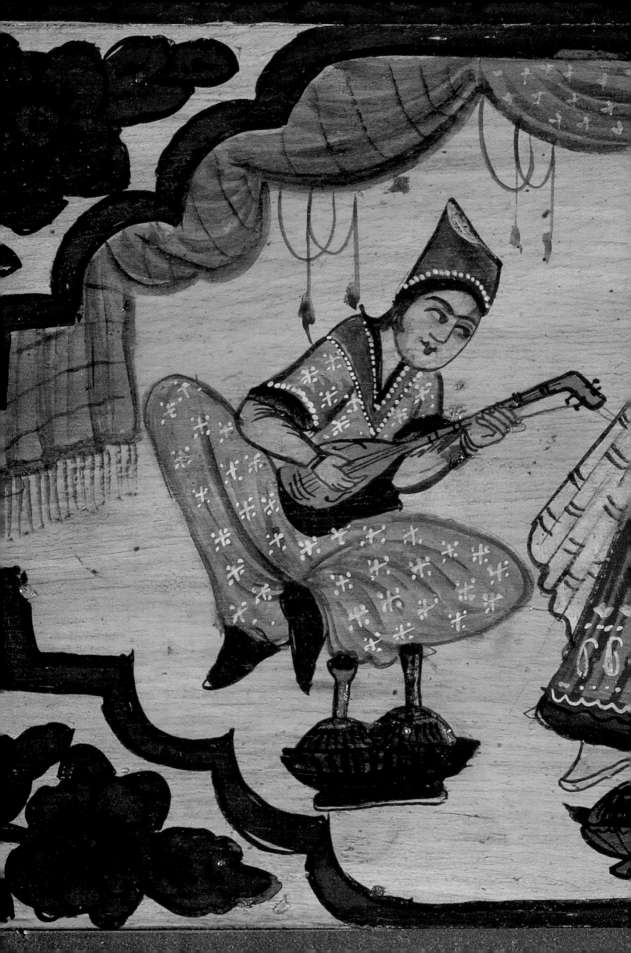

ISLAMIC ART

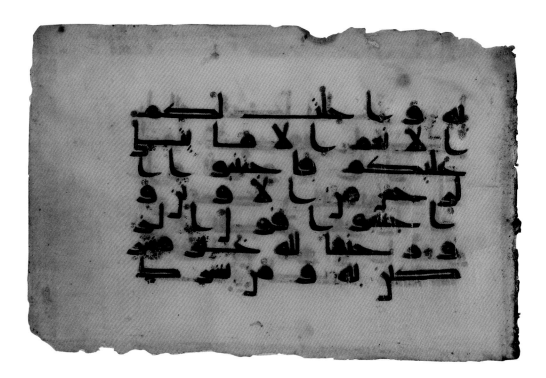

PAGE FROM A QUR'AN
Near East or North Africa,
9th–10th century
Ink, opaque pigment,
and gold on parchment
h. 4¾ in. (12.0 cm);
w. 7¼ in. (18.4 cm)
Gift of Frances and Frederick
Wilkins, 96.1.105

As the holy book of Islam, the Qur'an (meaning "recitation") is believed to contain the word of God, sent from heaven to the Prophet Muhammad. Because of its spiritual significance in the Islamic world, great care has been given to the production of the Qur'an throughout the ages, especially before the introduction of printing in modern times. The copying of the Qur'an in itself became a pious act, and, as a result, calligraphy became the most highly esteemed form of Islamic art.

As the production of exquisite Qur'anic manuscripts was actively promoted in the Islamic world, several distinct calligraphic styles evolved. This page, which comes from a parchment copy of the Qur'an produced during the ninth and tenth centuries, is written in a simple, angular script called Kufic, a term derived from the town of Kufa in southern Iraq. The text is accentuated with diacritical marks in red, indicating the placement of vowel sounds. The horizontal format is characteristic of this type of early Qur'an. Although the Kufic script was eventually replaced by more legible, cursive styles of writing, it became widely used for inscriptions and calligraphic designs on buildings, textiles, metalwork, ceramics, and other types of decorative objects. The script remains illustrative of the creativity and inventiveness found in the arts of early Islam.

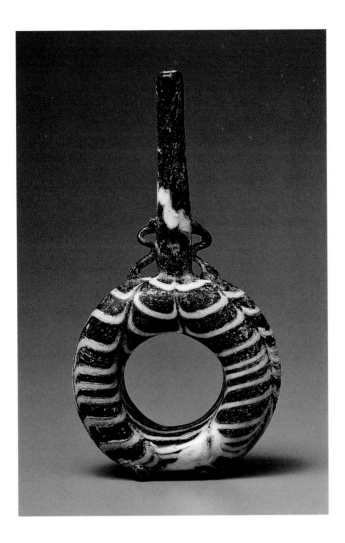

The production of glass vessels, small in scale yet technically challenging and aesthetically appealing, originated in the ancient Near East and Egypt. The tradition of glassmaking continued under Muslim rule, and glassmakers developed innovative techniques and designs.

A number of exquisite glass objects survive from medieval Egyptian and Syrian workshops. Among the most eye-catching of these vessels are perfume sprinklers with a distinctive decoration of white threads on a dark purple or black ground. This effect was achieved by combing the glass to create a festooned pattern and then rolling it on a polished marble or iron slab in a process called marvering. These sprinklers ordinarily have globular bodies with tall, slender necks further accentuated by delicate handles. This example is unusual for the circular opening in the middle of the body. Sprinklers such as this one were used to hold rosewater or aromatic oils, and they reflect the great appreciation of fragrance in the scent-conscious cultures of the Middle East.

QUMQUM (SPRINKLER)
Egypt or Syria,
12th–13th century
Glass
h. 4⅜ in. (11.1 cm);
diam. 2¼ in. (5.8 cm)
Museum Purchase: Stark-
Willson Collection, 86.138.412

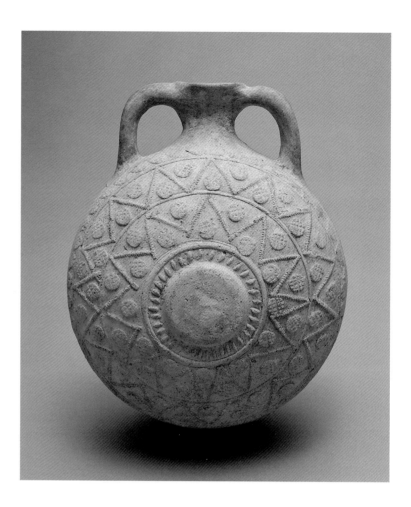

FLASK
Iran, 13th century
Earthenware
h. 10½ in. (26.6 cm);
w. 8¾ in. (22.1 cm);
d. 6¼ in. (16.0 cm)
Gift of Frances and Frederick
Wilkins, 96.1.174

Although colorful, glazed Islamic ceramics are better known today, more modest, unglazed vessels make up the majority of pottery excavated at Islamic sites. Unglazed wares, such as this flask, were predominantly made for utilitarian purposes and are closely associated with daily life. Vessels of this shape, with a circular body and tall handles, are sometimes called "pilgrim flasks" after their use by travelers, including those making pilgrimages. The handles allowed the vessel to be attached to a person's belt or a horse's saddle. Artisans also produced flasks of this distinctive shape in glass and metal, demonstrating the versatility and importance of such vessels in Islamic culture.

The body of the vessel is decorated with dynamic geometric designs in raised relief, which were created by the use of molds. The central medallion features a sun with radiating rays surrounded by two concentric bands containing zigzag and circular motifs.

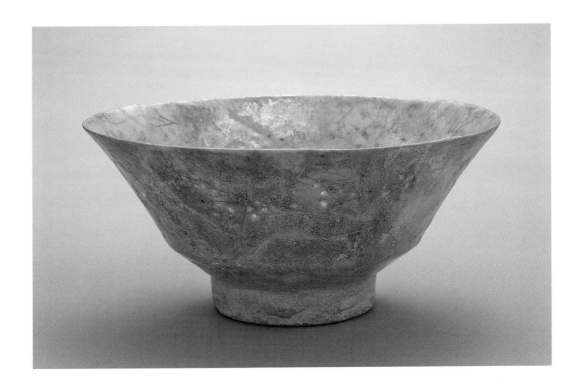

In the twelfth and thirteenth centuries, Iran became the center for the production of some of the most remarkable ceramic wares in the history of Islamic pottery. In an attempt to imitate imported white porcelain from China, Iranian potters developed a ceramic material that included ground quartz, known as frit, which enabled them to create vessels with a hard, porcelain-like texture. This technique ultimately facilitated the production of thinner and more gracefully shaped ceramics than the earthenware vessels of earlier periods.

The outcome of this innovation is clearly reflected in this fine bowl, the angular shape of which is based on prototypes in both ceramic and metal. Its thin walls and subtle color evoke the elegant monochrome wares of Song dynasty China (960–1279). The pierced decoration, however, is an invention of the Iranian potters, rather than a technique adopted from China. The band of glaze-filled openings not only serves as a decorative element, but also emphasizes the translucence of the delicate vessel.

PIERCED BOWL
Iran, 13th century
Fritware with transparent glaze
h. 4 in. (10.1 cm);
diam. 8¾ in. (22.1 cm)
Gift of Frances and Frederick Wilkins, 96.1.127

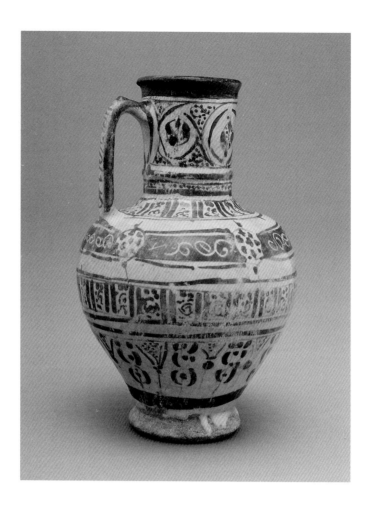

JUG
Iran, 13th century
Fritware with luster over
opaque glaze
h. 7¼ in. (18.7 cm);
diam. 4½ in. (11.4 cm)
Gift of Lenora and Walter F.
Brown, 2006.6.3

This small jug features elaborate designs in luster, a pigment consisting of a mixture of compounds of silver and copper, which was painted on the opaque white glaze after firing. The vessel was then fired a second time to affix the metallic colors to the surface. The luster technique was developed predominantly by potters from Iraq and Egypt, but the production of lusterwares was also well established in Iran from the late twelfth century. The central Iranian town Kashan became the major center of luster pottery. Although luster was most often used to decorate bowls, this technique also appears on medieval Iranian pouring vessels, figurines, and architectural tiles.

Luster-painted pottery can be regarded as a manifestation of conspicuous consumption in medieval Iran, especially among middle-class clients. For those who could not afford precious metal objects, ceramics richly painted in luster, with its attractive metallic sheen, must have been viewed as an ideal alternative. The intricately patterned bands on the exterior of this jug were probably intended to replicate the appearance of chased and inlaid surface decoration on costly metal vessels.

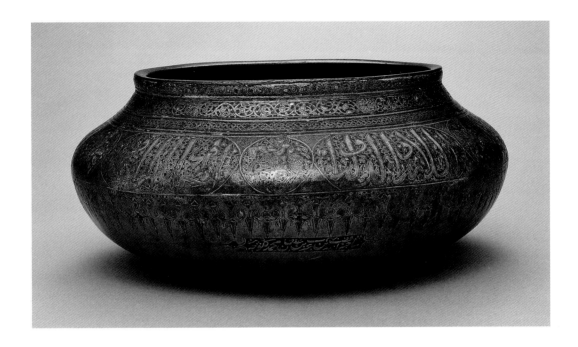

From pre-Islamic times, Iranian craftsmen were renowned for their metalwork. The metalwork industry flourished continuously in the Persian region, especially in Khurasan, located in present-day eastern Iran and western Afghanistan. After the Mongol invasion of Eurasia in the thirteenth century, many metalworkers fled from east to west, thereby spreading technical and stylistic developments throughout a vast area of the Islamic world. In particular, the province of Fars in southern Iran emerged as an important metalworking center under the Muzaffarid (1314–1393) and Inju (circa 1325–1353) dynasties.

Intricate shallow, rounded bowls, like this example, have been attributed to fourteenth-century workshops in Shiraz, a city in southern Iran. The densely ornamented surface is lavishly inlaid with gold and silver. The decorative program around the exterior is composed of men on horseback in six roundels alternating with inscriptions in oval cartouches. The upper and lower portions of the body are covered with geometric motifs. On the interior of the bowl, a group of fish is represented swimming in a whirling pattern.

BOWL
Iran, 14th century
Brass with gold and silver inlay
h. 5 in. (12.5 cm);
diam. 11¼ in. (28.2 cm)
Gift of Lenora and Walter F. Brown, 2006.6.12

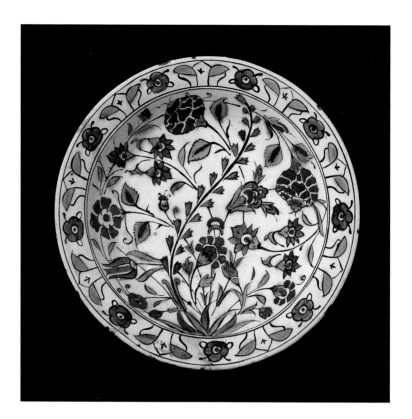

Among the art forms associated with the Ottoman Empire (late thirteenth century–1924), ceramic vessels and tiles produced at Iznik and later in Kütahya, both in northwestern Turkey, stand out for their beauty and elegance. Iznik ware is characterized by a variety of decorative motifs in rich, deep colors against a porcelain-like white ground. The production of Iznik pottery began as early as the late fifteenth century and reached its peak during the sixteenth and early seventeenth centuries.

This plate is quintessentially Iznik in its color scheme and composition. A rich palette of blue, black, green, and red is used to represent flowers, including carnations and tulips. The amazingly bright red color was achieved through the application of a thick slip of iron-rich clay, known as Armenian bole. The asymmetrical arrangement of the flowers on the interior of the plate creates a naturalistic rhythm, while the decoration on the rim consists of a repeating pattern of stylized leaves and flowers.

Iznik pottery evolved within the wider context of Ottoman decorative arts. Rich color schemes and densely composed patterns similar to those found on this plate also appear in contemporary textiles, jewelry, and manuscripts. This common repertoire indicates that Ottoman craftsmen, although working in a wide variety of media, may have shared the same designs as a result of a highly organized workshop system.

DOOR
Iran, 19th century
Painted wood
h. 72¾ in. (185.1 cm);
w. 36 in. (91.5 cm); d. 2 in.
(5.1 cm)
Gift of Frances and Frederick
Wilkins, 96.1.205

The arts of Qajar dynasty Iran (1781–1925) are characterized by indelible European flavors, as artists adopted and adapted Western-style perspective and composition and combined these with indigenously developed ideas about color, space, and iconography. Once thought to have been a period of decline in Iranian art, in contrast with the more celebrated art forms developed under the previous Safavid dynasty, nineteenth-century Iran was nevertheless artistically vigorous.

This lacquer-painted door vividly illustrates the artistic sensibility of Qajar Iran. The design is divided into three sections: the upper panel depicts a dancer and musicians portrayed with typical Qajar-style facial features and costumes; the middle section takes the form of a pair of doors painted with colorful floral and bird images; and the bottom panel has the same flora-and-fauna theme as the middle section, but is painted in dark blue against a yellow ground. These panels are further decorated with intricate borders. The use of ornate wooden doors in both secular and religious architectural settings has a long history in the Islamic world. Most surviving examples of early Islamic wooden doors are carved, but many premodern Iranian wooden doors, such as this example, are painted and lacquered, enhancing their pictorial and decorative quality.

ASIAN ART

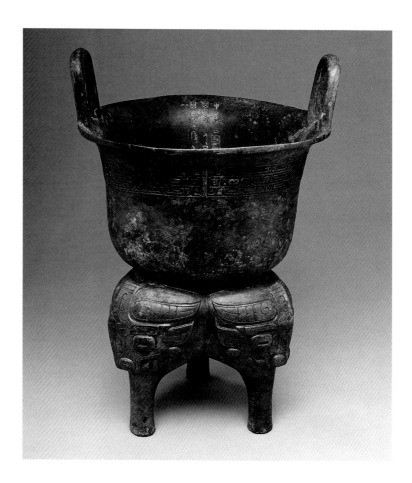

YAN (TRIPOD STEAMER)
Chinese, Shang dynasty,
circa 1600–1050 BC
Bronze
h. 16¼ in. (41.3 cm);
w. 11⅜ in. (28.9 cm);
d. 10½ in. (26.7 cm)
Gift of Lenora and Walter F.
Brown, 2007.20.1

Bronze vessels produced during the Shang dynasty are generally considered to be the greatest artistic achievement of early dynastic China. The highly sophisticated forging techniques of the Shang dynasty, which included the use of three-piece clay molds, allowed for the production of visually complex and technically accomplished objects such as the steamer, or *yan*, in the Museum's collection. The steamer rests on three short legs. A bovine creature with recognizable horns, ears, eyes, and nose is symmetrically positioned above each leg. The upper section of the vessel is of circular form and includes two large loop handles. A band of cloud shapes and geometric forms encircles the vessel below the rim. This band also features a simplified animal mask centered between the handles.

Shang dynasty bronzes were used for elaborate rituals among the political elite and were not intended for daily use. A long inscription written in archaic script is located on the interior of the vessel near the rim. Such inscriptions were increasingly common in the late Shang and Western Zhou (1046–771 BC) periods, when bronze vessels began to serve more secular purposes, such as the recording of land transfers.

STANDING FEMALE
ATTENDANT
Chinese, Western Han dynasty,
206 BC–AD 9
Earthenware with slip
and pigments
h. 29⅛ in. (74.0 cm);
w. 11½ in. (29.2 cm);
d. 5½ in. (14.0 cm)
Gift of Lenora and Walter F.
Brown, 98.15.4.a-b

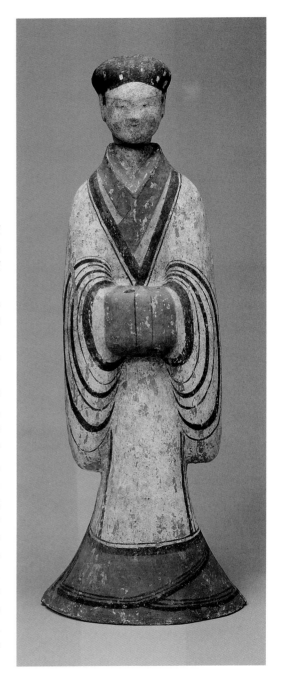

By the Qin dynasty (221–206 BC), the practice of live burial of retainers with their deceased lords had been almost entirely replaced by the burial of earthenware effigies of servants and other figures. These tomb furnishings, known as *mingqi*, were placed in subterranean tombs in large numbers from the Han dynasty (206 BC–AD 220) onward. Mingqi were thought to serve the needs of the deceased in the afterlife.

Ceramic tombware from the Han dynasty is either covered with a lead-based glaze or, as with this example, painted with mineral pigments directly on the earthenware body. An unusually large amount of original pigment is preserved on this graceful figure of a lady. The facial features, including thin wispy eyebrows and a small smiling mouth, are finely painted. The lady wears three robes: the innermost robe is red, the middle blue and tan, and the outer robe is white. The figure's hands are disguised in long-sleeved garments, with the drapery folds painted in dynamic concentric circles outlined in brown pigment. The head of the lady was made separately. A wooden armature, now lost, would have been used to attach the head to the body.

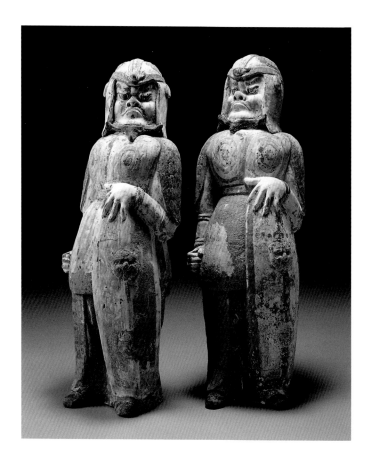

PAIR OF SOLDIER TOMB MODELS
Chinese, Northern Qi dynasty, 550–577
Gray earthenware with white slip and pigment
each: h. 17 in. (43.2 cm); w. 6 in. (15.2 cm); d. 4½ in. (11.4 cm)
Gift of Lenora and Walter F. Brown, 2004.20.5.a-b

The distinctive facial features of the two soldiers, with wide bulging eyes and broad flaring noses, indicate that they are not Chinese and perhaps represent Turkic peoples of Central Asia. The heavy tunics worn by the figures also show that they are foreigners. During the sixth century and extending through the Tang dynasty (618–907), the lands beyond China's northwestern border were an important source of mercenary soldiers. These fearsome soldier models were used to furnish a tomb and were likely intended to provide protection for the deceased in the afterlife.

Both soldiers lean on long shields, each of which is adorned with an animal-head mask. A hole in the lowered right hand of each figure once held a weapon, probably a long spear; the organic material used for the model weapon has long since decomposed. The soldiers wear helmets with long earflaps and a backflap to protect the head. The style of armor worn by the soldiers, with breastplates and backplates composed of round disks and padded shoulder guards, was popular during the Northern Qi dynasty, both as dress for the battlefield and as attire worn by officials. Originally the earthenware figures would have been painted all over in vibrant colors on a white clay slip.

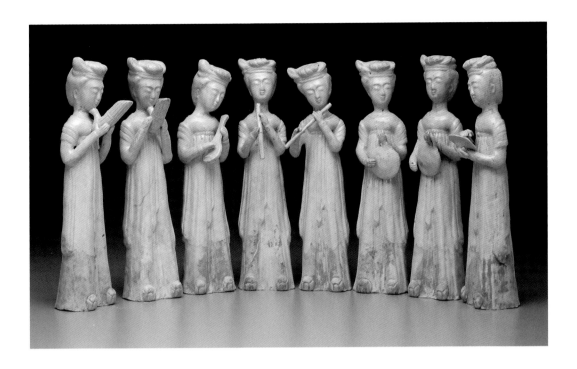

Sculptures of standing female musicians from the Sui dynasty are shown, from left to right, holding the following musical instruments: *sheng*, or mouth organ, held by two figures; *pipa*, or pear-shaped lute; *xiao*, or vertical flute; *dizi*, or transverse flute; *gong*, held by two figures; and *bo*, or cymbals. First imported into China in the fourth or fifth century from the Near East, the pipa was the most popular instrument for entertainment music in the Sui and Tang (618–907) dynasties. In this example the performer holds the pipa to the side, rather than holding the instrument frontally, as became the custom later. The figures playing the small gong would have originally held wooden mallets in their right hands. Small orchestras of female musicians were fashionable among the elite of the Sui and Tang dynasties. These musician figures were created to furnish a tomb and to provide music for the deceased in the afterlife.

The heads and bodies of the ceramic figures were made in molds. The necks, arms, and instruments were hand-built and attached to the figures before their initial firing. The lemon-yellow glaze, which pools to a beautiful emerald green in places, such as in the folds of the drapery, is characteristic of Sui dynasty tomb ceramics.

TOMB MODELS OF
MUSICIANS
Chinese, Sui dynasty, 589–618
Earthenware with slip and lead glaze
average h. 12½ in. (31.8 cm);
w. 3½ in. (8.9 cm); d. 3¼ in. (8.3 cm)
Purchased with funds provided by Faye Langley Cowden,
94.17.1.a-h

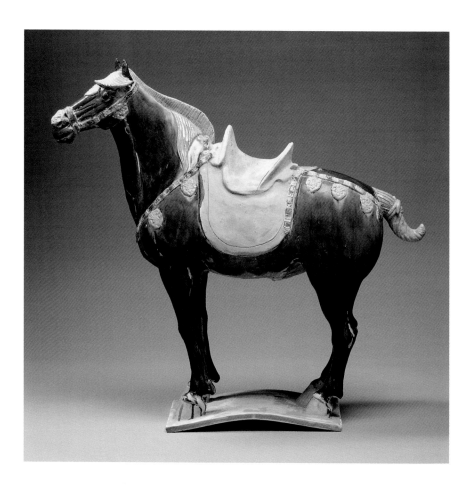

HORSE
Chinese, Tang dynasty,
618–907
Earthenware with *sancai* glaze
h. 24⅜ in. (62 cm); w. 24½ in.
(62.3 cm); d. 7½ in. (19 cm)
Gift of Lenora and Walter F.
Brown, 82.174

This impressive figure of a horse is composed of earthenware covered in a thick multicolored glaze known as *sancai*. The term sancai, or "three colors," refers to the distinctive combination of green, brown, and white found in the glaze. Rarely, blue is also found in sancai. The glaze contains lead as a flux agent that lowers the melting point of the glaze and allows it to fuse to the clay body. While sancai glaze emerged in the Tang dynasty and is most closely associated with that period, it was used for burial wares through the Ming dynasty (1368–1644).

Horses are among the most popular subjects found in tomb furnishings of the Tang dynasty. During this period, the Chinese imported horses from Central Asia. These foreign-sourced horses were more powerful than Chinese horses and thus provided an advantage in battle. Tang emperors were famous horse fanciers and provided a special staff and heated stables for their favorite horses. Tang dynasty sculptures of horses were placed in the tomb to serve the dead in the afterlife. Tang horses, such as this example, are usually shown meticulously groomed and caparisoned. The saddle on this horse was left unglazed and would have originally been painted.

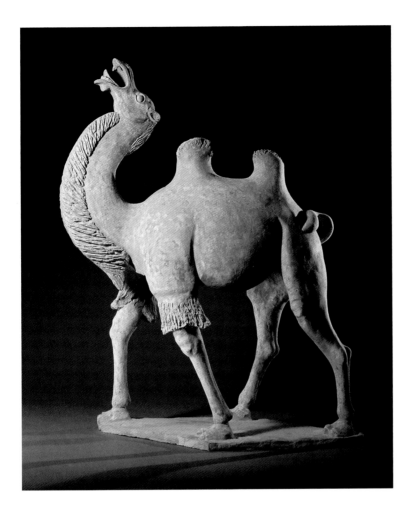

Beginning from at least the Han dynasty (221 BC–AD 206), two-humped Bactrian camels connected China to western lands over the famous Silk Road that traversed the Taklamakan Desert. The sturdy pack animals were perfectly suited to the harsh desert conditions owing to their ability to endure sandstorms and long periods without water. During the Tang dynasty, the Silk Road was secured through a series of watchtowers, limiting the threat of bandits and allowing for increased contact and trade with Central Asia, Persia, and the Mediterranean. Large Tang caravans could include hundreds of Bactrian camels.

This powerfully modeled camel furnished a tomb and was intended to serve the dead in the next life. The camel also indicates the wealth of a tomb occupant who could afford the domesticated animal. This unusually large and muscular camel is shown with head raised, braying. The sculpture is composed of low-fired, refined earthenware and is unglazed, though traces of white slip indicate that it was originally painted.

CAMEL
Chinese, Tang dynasty,
618–907
Earthenware with slip
h. 38 in. (96.5 cm); w. 34 in.
(86.5 cm); d. 14 in. (35.5 cm)
Purchased with funds provided by the Bessie Timon
Endowment, 2000.23

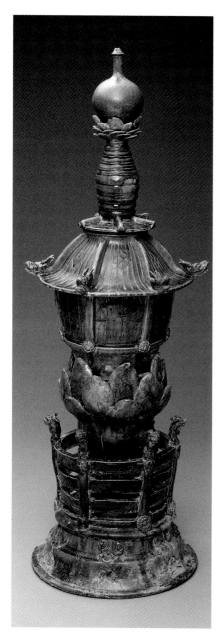

FUNERARY URN
Chinese, Liao dynasty,
907–1125
Stoneware with lead glaze
h. 32 in. (81.3 cm); w. 11¼ in.
(28.6 cm); d. 10½ in.
(26.7 cm)
Gift of Lenora and Walter F.
Brown, 98.15.14.a-c

The Museum is renowned for the outstanding collection of Liao dynasty ceramics from the Brown Collection, the largest such collection in the United States and one of the most important in the world. The Khitan, a proto-Mongolian people distinct from the Han Chinese ethnic majority, founded the Liao dynasty after invading China from their ancestral home in the northeastern borderlands. Though originally shamanistic, the Khitan accepted Buddhism by the tenth century, and combined the religion with their own indigenous traditions. This work is a rare example of Liao Buddhist ceramics.

The large funerary urn was likely used to hold the cremated remains of a prominent Buddhist. The lotuses decorating the sculpture are a Buddhist symbol. A large lotus supports the round container used to hold the cremated remains. The lotus rises from a fenced pond, with each post of the fence topped by an animal figure. Incised geometric designs decorate the surface of the urn. An elaborate cover in the shape of a roof, with the raised eaves terminating in dragon-headed water spouts, surmounts the central circular container. The top of the cover takes the form of a sacred relic container, or *sarira*, that rests on a second lotus. Such containers were used to hold the relics of the Buddha and eminent Buddhists, and thus the sarira is an appropriate addition to this funerary urn.

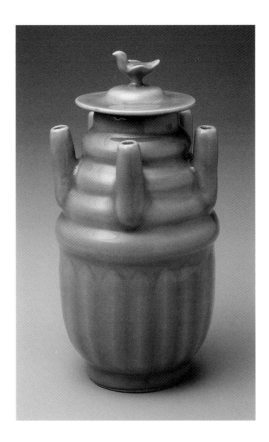

The distinctive glassy, light green glaze that covers this vessel is known as *longquan*, named for the kiln site in present-day Zhejiang province, where such wares were produced from the Five Dynasties period (907–960) through the Ming dynasty (1368–1644). Longquan wares reached the pinnacle of refinement in the Song dynasty (960–1279), and Song longquan celadons are considered among the greatest achievements in the history of Chinese ceramics. Longquan celadon ware also influenced the evolution of light green glazed ceramics in Korea and Japan.

Covered jars with five spouts emerged in the Five Dynasties period. The lower, circular part of the vessel is surrounded by lotus petals carved in low relief, with each petal bearing a raised central rib. Five rounded horizontal lobes of equal height, which are also carved into the clay body, rise from the center of the vessel to the lip, and five short spouts, the shape of which is based on a bamboo rhizome, extend from the shoulder. A small bird forms the knob on the disk-shaped cover. The lotus petals adorning the jar are a Buddhist symbol and suggest the possible funerary use of this vessel. The jar may have been placed on an altar in funerary rituals, with the spouts holding flower offerings.

SPOUTED AND COVERED
FUNERARY JAR
Chinese, Southern Song
dynasty, 1127–1279
Porcelaneous stoneware with
longquan celadon glaze
h. 9½ in. (24.1 cm);
diam. 4⅝ in. (11.7 cm)
Purchased with funds pro-
vided by the Bessie Timon
Endowment, 92.19.2.a-b

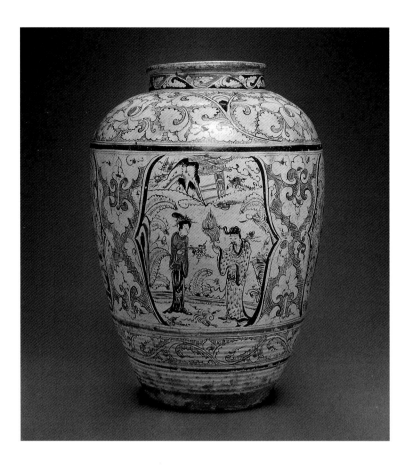

JAR
Chinese, Yuan dynasty,
1279–1368
Glazed and painted
earthenware
h. 23¾ in. (60.2 cm);
diam. 17½ in. (44.2 cm)
Gift of Lenora and Walter F.
Brown, 2004.20.14

Cizhou ware is a broad category of Chinese ceramics primarily comprising brown and white decorated wares. Cizhou ware was largely produced in workshops in Northern China from the Northern Song (960–1127) and Jin (1115–1234) dynasties and extending through the Ming dynasty (1368–1644). The surface decoration of cizhou ware is either carved or, as in this example, painted. The characteristic color scheme is brown glaze appearing on an ivory-colored slip.

Four scenes of unidentified figures are evenly spaced around the surface of this large vessel. The vignettes are likely based on woodblock prints from this period that were used to illustrate popular plays and novels. Scrolling botanical imagery frames the four figural scenes, and thick brown lines provide a structured pictorial framework for the dense underglaze painting. The graceful treatment of the painted figures demonstrates the ability of Yuan ceramicists to translate two-dimensional scenes onto three-dimensional forms.

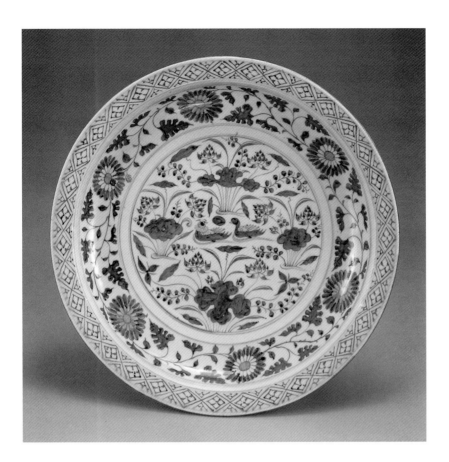

Blue and white porcelain is the best-known and most admired type of Chinese ceramics. Recent archaeological discoveries have proven that blue and white wares developed in China at a much earlier date than previously known, with several examples dating to the late Tang dynasty (618–907). It was during the Yuan dynasty, however, that blue and white porcelain reached a high level of sophistication, in terms of both shape and decoration. In the Yuan dynasty, blue and white porcelain was made in Jingdezhen, a city in southeastern China that remains an important site of blue and white porcelain manufacture.

Yuan dynasty blue and white porcelain, of which the Museum has three outstanding examples, is rare. This large dish, or charger, is decorated with a diamond-patterned geometric motif on the inner rim. A circular band bearing scrolling chrysanthemum flowers and leaves appears below the rim. The central medallion contains the primary decoration adorning this dish—a male and female duck amongst aquatic plants. Pairs of ducks are a traditional symbol of marital fidelity in Chinese art, as ducks were thought to mate for life. This large dish, therefore, may have been a wedding or anniversary present.

CHARGER
Chinese, Yuan dynasty,
1279–1368
Porcelain with underglaze
cobalt blue
h. 2¾ in. (7.0 cm);
diam. 18 in. (45.7 cm)
Gift of Lenora and Walter F.
Brown, 2008.21.30

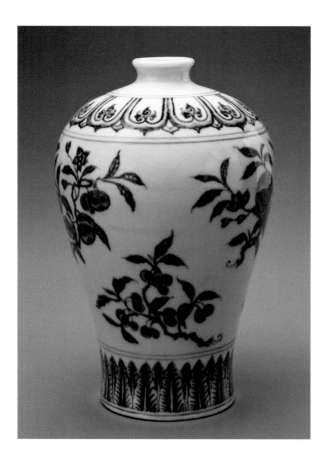

MEIPING
Chinese, Ming dynasty,
Xuande period, 1425–1435
Porcelain with underglaze
cobalt blue
h. 11½ in. (29.4 cm);
diam. 6¾ in. (17.1 cm)
Gift of Lenora and Walter F.
Brown, 2008.21.50

Vessels of this shape are known in Mandarin Chinese as *meiping*, which literally means "plum bottle." Perhaps based on the name of the vessel, scholars originally believed they were used to hold flowers. Further research, however, proved that meiping instead were used as vessels for holding wine and other libations. The underglaze painting on this meiping shows variations in hue ranging from light to dark blue, an effect known as "heap and pile," which lends a three-dimensional quality to the surface decoration. Pendant petals and stiff plantain leaves form stylized decorative bands encircling the shoulder and foot, respectively. Fruiting branches of lychee, peach, loquat, crabapple, pomegranate, and cherry are painted on the central section of the vessel, which is framed by double lines.

From the late fourteenth to nineteenth centuries, certain blue and white porcelain objects were made in Jingdezhen exclusively for the Imperial court. These Imperial porcelains were subject to stringent quality control, with only the finest works passing inspection for the court. Fine porcelain was considered luxurious during the early Ming dynasty, as porcelain was relatively expensive owing to the limited supply of finely made wares and the considerable cost of its manufacture.

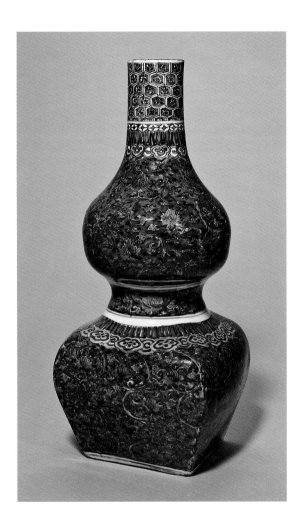

The date, size, shape, and surface decoration distinguish this vase as an exceptional example of Ming dynasty polychrome ceramics. The shape, with rounded upper section resting on a squared base, is a sixteenth-century elaboration of the double-gourd design. The double gourd is an auspicious shape in Chinese art since it connotes longevity and prosperity. In addition, according to traditional Chinese symbolism, the circle represents heaven and the square, earth. In this vase, therefore, the rounded gourd-like top represents heaven and rests upon the square lower section representing earth.

The vase is covered with a dense pattern of scrolling lotuses painted in underglaze cobalt blue. After its initial firing, the surface of the blue and white porcelain vessel was over-painted with bright enamels. Red enamel covers most of the originally white areas of the vase, creating a bold visual effect. Green enamel was also painted on the surface and is most visible on the neck. After the addition of the enamels, the vase was fired again to affix the colors.

DOUBLE GOURD VASE
Chinese, Ming dynasty, Jiajing period, 1522–1566
Porcelain with underglaze cobalt blue and overglaze enamels
h. 18½ in. (47.0 cm);
w. 8½ in. (21.7 cm); d. 8½ in. (21.7 cm)
Gift of Lenora and Walter F. Brown, 92.25.43

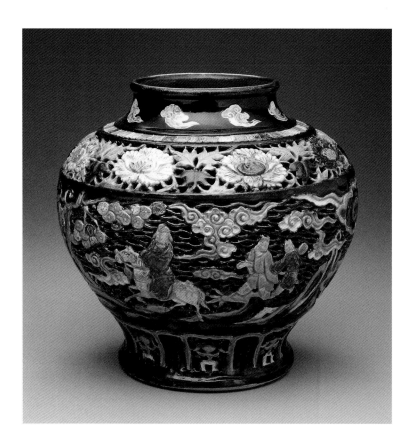

FAHUA JAR
Chinese, Ming dynasty,
16th century
Earthenware with white slip
and lead glaze
h. 13 in. (33.0 cm);
diam. 13¾ in. (35.0 cm)
Gift of Lenora and Walter F.
Brown, 92.25.34

Fahua literally means "bound designs" and refers to the method of containing glaze within bordered cells so that it does not run or drip. This technique is closely related to cloisonné metalwork, in which raised cells are filled with colored enamel. Fahua ware is typically decorated with a distinct color palette of dark blue, turquoise, russet, and yellow glazes. Fahua was first produced during the Ming dynasty (1368–1644) at kilns located in northern China. Its manufacture continued through the Qing dynasty (1644–1911), when production spread to southern China.

Adorning the surface of this globular vase is an image of a gentleman on horseback followed by two attendants. Some areas of the vessel, such as the flowers encircling the shoulder, are delicately carved in raised relief. The figural scene is set against a pierced ground reminiscent of basketry. This finely carved openwork pattern constitutes the decorative outer layer of the jar's "double skin" construction. A solid layer of clay lines the interior of the vessel and thus allows it to hold liquids. Jars of this shape were often used to hold wine, though the extraordinary carving and glazing of this vessel suggest that it was valued more for its aesthetic than for its functional qualities.

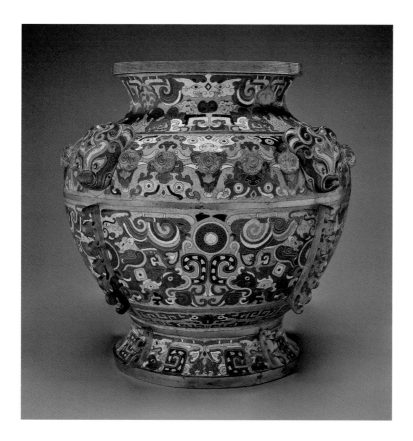

The manufacture of cloisonné began in northern China during the Yuan dynasty (1271–1368). Cloisonné is produced by attaching raised metal wire onto a metal substrate to form cells, or *cloisons*, which are filled with colored enamels and fired.

This vessel is a fine example of archaism, or the intentional revival of ancient forms as a means to celebrate and honor the past. Its shape, known as a *pou*, is based on bronze ritual vessels from the Shang (circa 1600–1046 BC) and Zhou (1045–256 BC) dynasties. The entire surface of the vessel is decorated with stylized interpretations of archaic bronze imagery, such as the prominent white monster mask, or *taotie*, just below the lip and the large bovine heads attached to the shoulder of the vessel. Separately cast knobs and ridged flanges also decorate the vessel. In China, archaism, or *fanggu*, began in the Song dynasty (960–1279) and is discussed in connoisseurship guides of that period. Archaism remained popular through the Ming (1368–1644) and Qing (1644–1911) dynasties, and played an important role in decorative schemes found in ceramics, metalwork, and cloisonné.

CLOISONNÉ POU
Chinese, Qing dynasty,
18th century
Metal alloys and enamel
h. 18½ in. (47.0 cm);
diam. 19 in. (48.3 cm)
Gift of Lenora and Walter F.
Brown, 2009.26.44

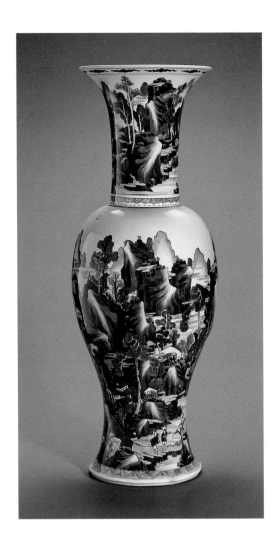

YEN YEN VASE
Chinese, Qing dynasty, Kangxi
period, 1662–1722
Porcelain with underglaze
cobalt blue
h. 30 in. (76.0 cm);
diam. 11 in. (27.9 cm)
Gift of Lenora and Walter F.
Brown, 2008.21.24

This vase was produced during the Kangxi period of the Qing dynasty, one of the greatest eras of blue and white porcelain production in China. Emperor Kangxi enjoyed the longest rule of any Chinese emperor and was an important patron of the arts, including the manufacture of porcelain. During the Kangxi period, underglaze cobalt-blue painting found on porcelain rivals that of ink painting in terms of subtle shading and tonality. Indeed, landscapes by famous painters such Dong Qichang (1555–1636) and Wen Zhenming (1470–1559) served as inspiration for the imagery found on the finest Kangxi vessels. The idealized landscape scene appearing on the main section of this vase includes an elaborate riverscape with a village nestled in the mountains. A similar landscape is repeated on the neck. Narrow bands of geometric designs frame the painted scenes. The deep sapphire-blue underglaze painted on a pure white ground is characteristic of the finest porcelain wares of the era. The shape of this vase, known in Mandarin Chinese as *yen yen*, was popular in the Kangxi period.

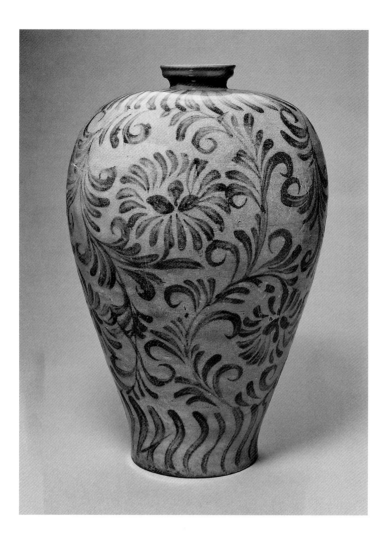

The short circular mouth of this vessel is set on a broad shoulder, which tapers to a narrow foot. This elegant and well-balanced shape is known in Korean as *maebyeong* and is found in numerous ware types. The shape is derived from Chinese *meiping* vessels, which were likely introduced to Korea during the Goryeo dynasty. Although meiping literally means "plum vase," such vessels were used primarily for storing wine. Originally this maebyeong would have had a matching ceramic lid.

During the Goryeo dynasty, light-green celadon ware was decorated with inlaid designs, incised, or, as with this example, painted with an underglaze. A clear celadon glaze covers the vigorously painted scrolling botanical imagery. The underglaze painting, which is composed of iron oxide, is fluid and complements the shape of the vessel. The scrolling vine and flower imagery is framed by lively curvilinear designs extending across the shoulder and near the foot. The glassy celadon overglaze results in a fine crackle.

MAEBYEONG
Korean, Goryeo dynasty, 918–1392
Stoneware with iron decoration and celadon glaze
h. 12½ in. (31.8 cm); diam. 8 in. (20.3 cm)
Gift of Lenora and Walter F. Brown, 2006.4.1

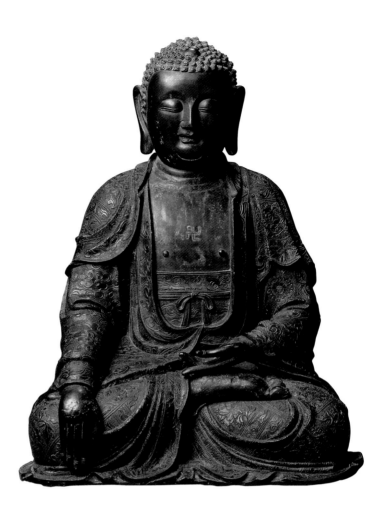

BUDDHA
Korean, Joseon dynasty,
17th–18th century
Bronze
h. 20¼ in. (51.4 cm); w. 16 in.
(40.6 cm); d. 11 in. (27.9 cm)
Gift of Floyd L. Whittington,
97.11.117

A Buddha is shown seated in meditation. Originally the figure would have been placed on a lotus-shaped base. The Buddha's lowered right hand is in the gesture of Earth-witnessing, known in Sanskrit as *bhumisparsha*, which is an allusion to the moment of enlightenment. His left hand rests above his right foot and is in an unusual gesture. The Buddha is shown with characteristic marks of enlightenment such as snail-curl hair, a protuberance at the crown of the head, and elongated earlobes. The precise identity of the Buddha has yet to be established, since both Shakyamuni, the historical Buddha, and Amitabha, the Buddha of Infinite Light, may be represented in a similar pose in this later period.

A prominent swastika, here a Buddhist symbol, is found on the center of the Buddha's chest. The swastika is a pre-Buddhist Vedic symbol originating in India and generally means "everything" or "in all directions." The bronze statue is very finely cast, with great care taken in the beautifully represented pattern of clouds and flowers adorning the patchwork robe. The naturalistic folds of the robe give the figure a corporeal presence.

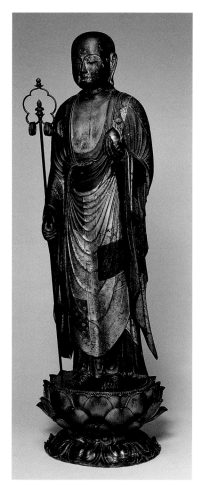

Front

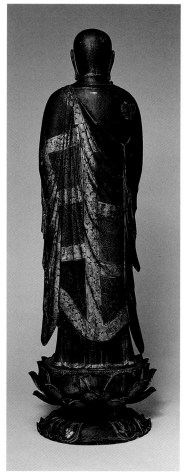

Back

Jizō Bodhisattva is revered in popular Japanese Buddhism as the protector of children, travelers, and the lost. Jizō is a common image in Japanese Buddhist art and is associated with funerary rituals, particularly those for deceased children. Jizō is also viewed as an example of the virtue of Buddhist pilgrimage.

In this carved wooden figure, Jizō holds his characteristic alarm staff in his right hand. The metal rings on the head of the staff jingle while it is carried through the forest and help scare away dangerous animals. The alarm staff became associated with travelers, of whom Jizō is a protector. The six rings on the staff represent the six Buddhist realms of existence beyond death. In his left hand Jizō holds a flaming pearl, a symbol of Buddhist teachings, resting on a lotus. The patchwork monk's robe, which attests to Jizō's oath of poverty, is beautifully painted with pigments and fine goldwork beneath clear lacquer. This large figure stands on a gold-painted disk outlined with raised beads set on an ornate lotus pedestal.

JIZŌ
Japanese, Edo period,
17th century
Lacquer, pigment, and gold
on wood
figure: h. 44½ in. (113 cm);
pedestal: h. 8¼ in. (21.0 cm);
diam. 12 in. (30.5 cm)
Gift of Lenora and Walter F.
Brown, 2004.22.5

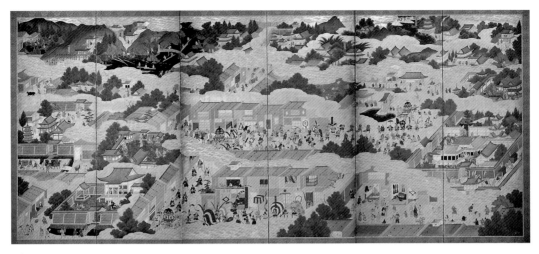

Left

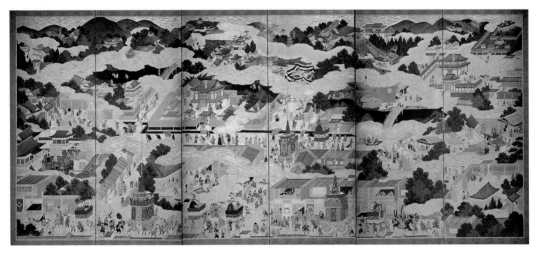

Right

SCENES IN AND AROUND KYOTO

Japanese, Edo period,
circa 1620–1625
Ink, color, and gold leaf
on paper
each screen: h. 66 in.
(165.4 cm); w. 144 in.
(366 cm)
Purchased with funds provided
by the Lillie and Roy Cullen
Endowment, 2001.51.a-b

This pair of six-fold screens depicts scenes of Kyoto in the early seventeenth century. Such paintings, known in Japanese as *rakuchu rakugai-zu*, form a genre of screen painting representing landmarks of Kyoto, including Imperial buildings, temples, and cultural districts. This genre was first mentioned in a diary by a courtier in 1506, which notes that Lord Asakura commissioned a pair of screens depicting Kyoto.

The screens provide a bird's-eye view of Kyoto, the old capital, and are filled with numerous detailed scenes of life in the bustling city. One vignette shows a Jesuit priest and Dutch or Portuguese traders walking outside a walled residence. The colorful Gion entertainment district is depicted during the annual Gion Festival, which was supported by local merchants. These screens capture the unique cultural geography of Kyoto in the early seventeenth century, when a period of peace and prosperity coincided with an exuberant lifestyle in the city.

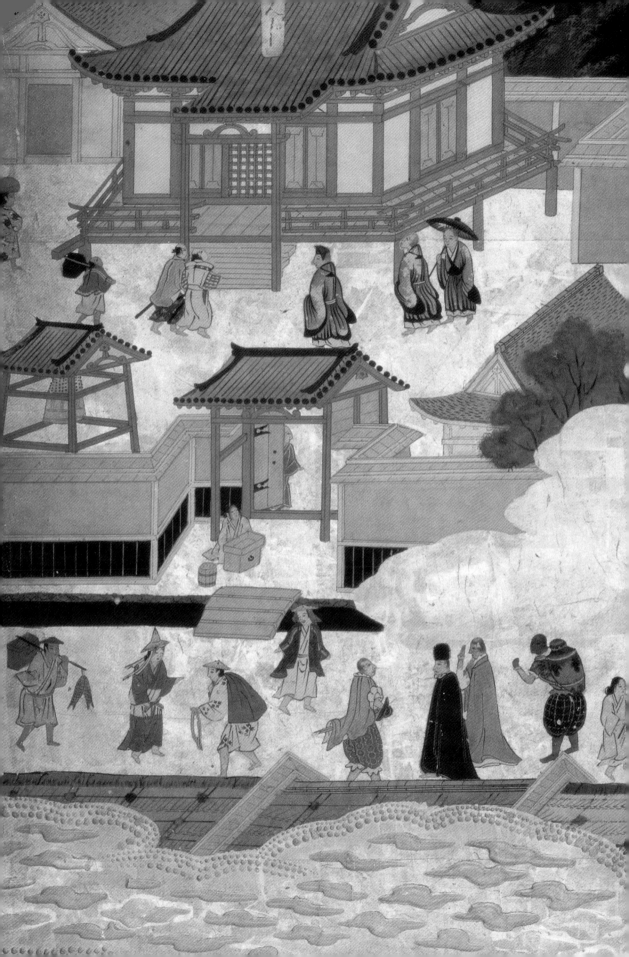

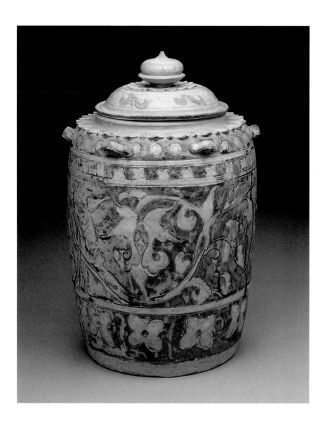

COVERED JAR
Vietnamese, Thanh-hoa
province, 11th–12th century
Brown and transparent glaze
on gray earthenware
h. 18 in. (45.7 cm);
diam. 10 in. (25.5 cm)
Gift of Lenora and Walter F.
Brown, 2004.20.3

This large, glazed earthenware jar belongs to a family of vessels with brownish-red decoration carved into a creamy white ground. Brown and white wares developed during the early years of the Ly dynasty, which was established in Hanoi in 1010. Archaeological evidence suggests that these vessels served as food, water, and wine storage jars, rather than as ritual objects. The vessel was first covered in an ash glaze, resulting in the creamy white color; then a thin layer of clay surrounding the foliate decoration was removed. This background was covered with an iron-oxide glaze, resulting in the brownish-red color.

The fitted lid of the jar is surmounted by a distinct jewel-shaped knob likely inspired by Buddhist imagery. A lotus collar is located on the top of the shoulder, just below the raised oval mouth. The teardrop-shaped lotus petals are individually delineated and were applied to the vessel before glazing and firing. Lotus collars are distinctively Vietnamese and appear not only in brown and white wares, but less frequently on later blue and white wares. On this jar, six lug handles are located just below the lotus collar. A band decorated with simplified images of four-petal flowers is above the largest area of decoration, which is formed by a scrolling vine motif. Large four-petal flowers form the lower band of decoration. Jars of this type may also feature decorative bands with human and animal figures, though botanical motifs, as on this example, are more common.

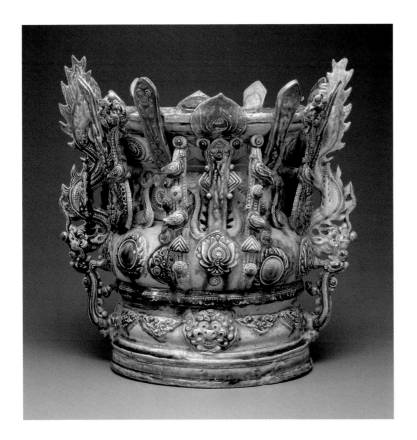

This vessel was used to hold incense on or in front of a Buddhist altar. The complex shape of the censer is achieved through a combination of techniques, including incised, impressed, molded, and applied ornamentation. Elaborate dragons chasing a flaming pearl form the handles of the vessel. The principal motifs found on the surface of the censer are flowers, fantastic creatures, and birds. Flaming pearls, which represent Buddhist teachings, also decorate the surface. The artist has playfully added other whimsical details, such as songbirds, in the complex surface decoration. Eight narrow, applied bands rise from the belly of the vessel and extend beyond the mouth. Near the center of the vessel is a prominent medallion of a cross section of a lotus, the quintessential Buddhist flower. On the lower section, a band of decoration comprising applied medallions, including those of animated fantastic beasts, encircles the vessel.

The three-color glaze used to cover the censer, while distinct in palette, is ultimately derived from Chinese *sancai* glaze. This three-color glaze was popular for ritual ware, including censers, in Vietnam beginning in the fifteenth century. Unlike the unruly early sancai glazes, the colors on the surface of this censer remain fixed in the areas where they were applied and do not run together.

CENSER
Vietnamese,
15th–16th century
Stoneware with cream,
green, and brown glazes
h. 14¼ in. (36.2 cm); w. 14 in.
(35.6 cm); d. 12 in. (30.5 cm)
Gift of Lenora and Walter F.
Brown, 2004.20.2

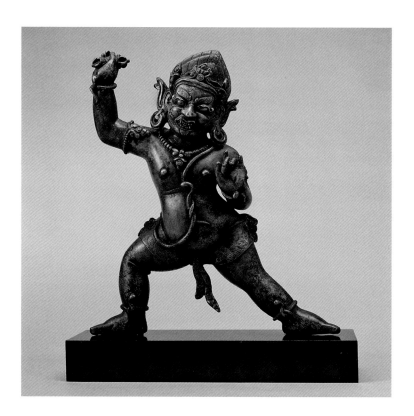

VAJRAPANI
Tibetan, 12th–13th century
Cast copper alloy
h. 12 in. (30.5 cm); w. 10¼ in.
(26 cm); d. 3⅜ in. (8.6 cm)
Purchased with funds pro-
vided by the Ewing Halsell
Foundation, 2004.6

In Vajrayana Buddhist teachings, Vajrapani represents the power of all the Buddhas and belongs to the important group of Eight Great Bodhi-sattvas. He is associated with the power to overcome obstacles. In this sculpture, Vajrapani is shown in wrathful form. He stands in the ener-getic Warrior Pose with right leg bent and left leg extended. His upraised right hand holds a five-pronged *vajra*, or thunderbolt scepter, while his left hand is in a threatening gesture. The vajra, in this context, represents power. Vajrapani wears a three-leaf crown, and his hair is textured in a manner suggesting flames. His mouth is open to reveal his fangs. Vajra-pani's compact, muscular body is adorned with snakes forming anklets, bracelets, and the largest of his necklaces. He also wears double earrings and a necklace bearing a pendant that matches the crown. A tiger skin covers his waist. This finely cast, soft copper figure is an early example of a metal image of Vajrapani originating in the Himalayan region. The facial features and adornments are rendered in great detail. This figure would have originally been set into a base, very likely of simplified lotus form, which is now lost.

MAITREYA
Nepalese, 16th century
Gilt bronze
h. 17 in. (43.2 cm); w. 5½ in.
(14.0 cm); d. 3½ in. (8.9 cm)
Gift of Rose Marie and John L.
Hendry, III, 2005.17

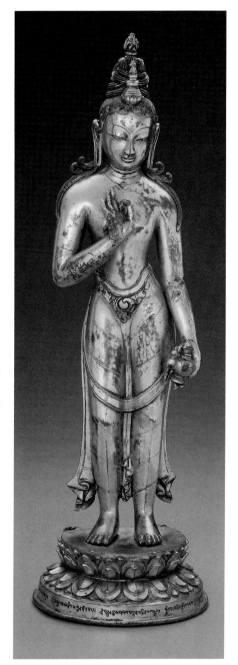

Maitreya, the Buddha of the Future, is beautifully represented in this gilt bronze sculpture. According to Buddhist tradition, Maitreya resides in Tushita Heaven and will appear in this world when Buddhist teachings are lost on Earth. This figure is an excellent example of Newar metalwork, one of the greatest achievements in Himalayan art. While the overwhelming majority of Newar metalwork was produced in Kathmandu Valley, Nepal, the Newar were, and are, quite itinerant with their craft and set up workshops throughout the Himalayas and beyond. An inscription in Tibetan appears on this sculpture between the base and the double lotus and states that it was commissioned by a Tibetan named Lodro Gyaltshen and made by the Newar artist Chandra.

The graceful figure is slightly elongated and elegantly proportioned with long limbs and narrow waist. The fire-gilding imparts a warm golden hue. The identity of Maitreya can be established by the specific attributes of a *stupa* (a tiered reliquary) on the crown of the head and the water vessel held in the lowered left hand. The upraised right hand is in the gesture of teaching. Maitreya's hair is gathered in a prominent topknot surmounted by a jewel. The lower garment gathered behind the figure and clinging to the front of the legs is expertly represented. Unlike earlier images of Bodhisattvas that include heavy jewelry and elaborate dress, this figure is restrained in ornamentation.

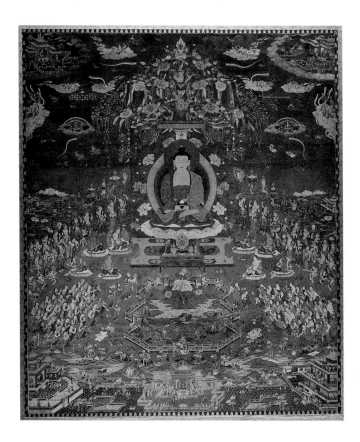

AMITABHA IN SUKHAVATI PARADISE
Tibetan, circa 1700
Ink, pigments, and gold on cotton
h. 67¾ in. (172 cm);
w. 58¾ in. (149.1 cm)
Purchased with funds provided by the Bessie Timon Endowment, 2010.8

This outstanding *thangka*, or scroll painting, features a complex composition executed in vivid pigments and gold painted on cotton. The thangka depicts a celebratory scene of the Buddha Amitabha seated in a meditative pose and resting on a lotus supported by a peacock throne. Around Amitabha are elaborate scenes featuring more than one hundred figures paying homage and making offerings to the Buddha. The painting is unusually large for a thangka, as most images of this size and detail are featured on wall paintings in temples rather than in scroll paintings. The quality and complexity of this painting suggest that it was produced at one of the major monasteries in central Tibet.

In the center of the composition is the golden figure of Amitabha, the Buddha of Infinite Light, presiding in his realm of Sukhavati, the Western Paradise. Amitabha became a focal point of Buddhist rituals, especially in East Asia, by the eighth century. The faithful would pursue practices such as chanting the name of Amitabha Buddha to help ensure their rebirth in his glorious Western Paradise. Amitabha holds a monk's bowl and is bedecked in garlands. Golden rays of wisdom issue from his heart. His hands are in the gesture of meditation. Elaborate flowers form a parasol-like cover over the Buddha. Female angels and monks fly through the air, which is raining flowers and jewels.

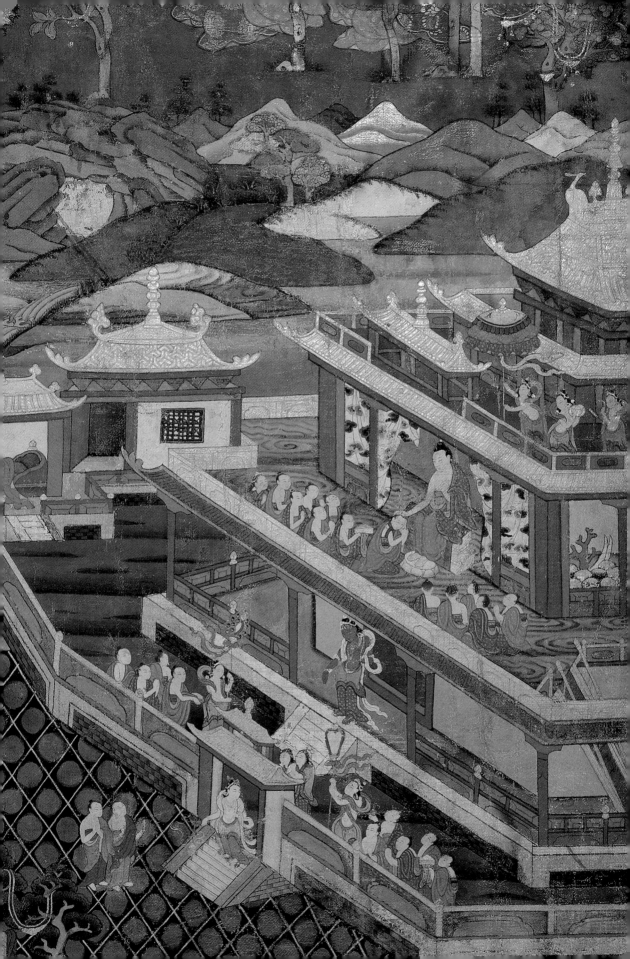

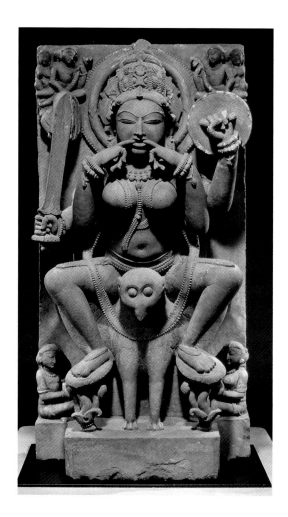

YOGINI
Northern Indian, Uttar
Pradesh or Madhya Pradesh,
10th–11th century
Buff sandstone
h. 34 in. (86.4 cm); w. 17¼ in.
(43.8 cm); d. 9¾ in. (24.8 cm)
Purchased with the John and
Karen McFarlin Fund and the
Asian Art Challenge Fund,
90.92

This beautifully carved sculpture is the most important work of Indian art in the Museum's collection. The female figure shown astride an owl is a yogini, a female spiritual adept. She has four arms. Her outer arms hold a sword and shield, which display her martial nature. Her inner hands are held in the unusual gesture of whistling. The large round breasts emphasize the sensuality of the yogini. Her feet are supported by two lotuses. She wears an elaborate crown and various kinds of jewelry, including necklaces and a large garland. The yogini is flanked by offering deities at the top and bottom of the panel. The figure is remarkable for the crisp and energetic carving that includes many fine details such as the wrinkled lips. Such yogini figures were usually placed on the exterior boundary of temple complexes and may have served a protective function. These distinctive yogini images originated in Uttar Pradesh or Madhya Pradesh in present-day central and eastern India. This figure may belong to a discrete group of sixty-four protective female deities venerated by the Sakta sect of Hinduism.

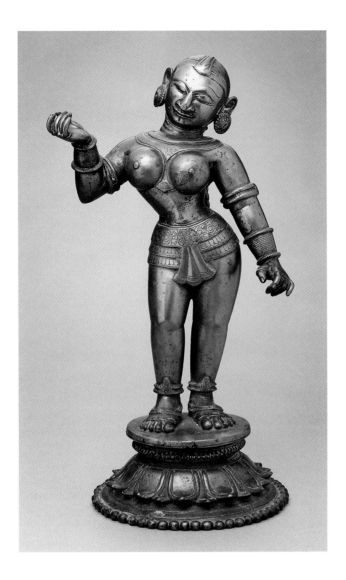

This robust figure of Radha, a Hindu deity, stands on a disk set atop a lotus base. She holds an offering in her raised right hand, while her left hand is extended to her side. Her large breasts, pinched waist, and broad hips are consistent with other images of Radha from this period. Radha's lower garment, a *dhoti*, clings to her body like wet drapery and is tied at the waist. Radha's jewelry includes bracelets, armlets, anklets, and wide circular earrings. Her body sways in the three-pointed pose known in Sanskrit as *tribanga*. The figure of Radha is very voluptuous, as befits the renowned lover of Krishna. Radha was a cow-herding girl, or *gopi*, and one of Krishna's favorite consorts. This powerfully modeled sculpture was manufactured in Orissa in present-day eastern India. Unlike similar figures from the Vijayanagar period with a dark patina, this statuette has a bright surface, which is the result of modern cleaning.

RADHA
Indian, Vijayanagar period,
15th–16th century
Copper alloy
h. 12 in. (30.5 cm); w. 7 in.
(17.8 cm); d. 6 in. (15.2 cm)
Gift of the Rubin-Ladd
Foundation under the bequest
of Ester R. Portnow, 2010.7.2

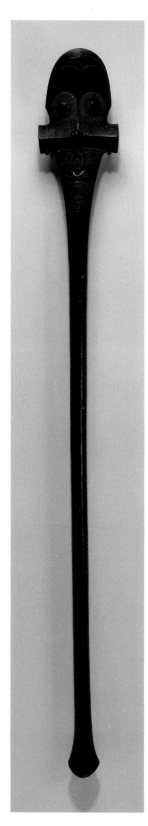

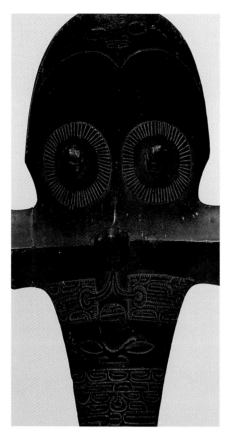

'U'U (CLUB)
Polynesia, Marquesas Islands,
probably 19th century
Wood
h. 56 in. (142.2 cm);
w. 6¾ in. (17.1 cm)
Gift of Bowie Duncan, 60.55

War clubs, called *'u'u*, are some of the most well-known and recognizable forms of traditional sculpture made in the Marquesas Islands in what is now French Polynesia. The clubs are the largest category of Marquesan objects found in museum and private collections. They served as effective weapons in combat, but were also objects of great prestige for the owners. The clubs have very distinctive and highly stylized designs that are said to be unique. The style of the clubs has shifted over time. The earlier style, as in this example, has rounded features and more equal proportions in the face or club head area. Over time, as the clubs were increasingly collected, the design elements became sharper and angular, thus creating a visual chronology and providing clues to the time of their manufacture.

At the top end of the long, rounded club is a design based on the human face. Usually, the clubs have faces on both sides of the head. The facial features are incised or carved into the club. Typically each eye is defined by a large circle of radiating lines. At the center of each eye is a small head carved in raised relief. The nose is also represented as a head and, like the eyes, is carved in the classic Marquesan *tiki* (human-form) style with round flat eyes, a wide short nose, flat circular ears, and wide parallel lips.

Carved and painted two-dimensional figures are among the traditional forms of wooden sculpture made by artists in the Papuan Gulf area of the island of New Guinea. This figure is of a type called *bioma*, which are related in function and design to the traditional spirit boards made by artists in villages throughout the Papuan Gulf region. Bioma, like spirit boards, were carved from the wood of discarded canoes and are anthropomorphic references to ancestral beings. Bioma and spirit boards were displayed within cubicles or shrines devoted to specific clans, families, or individuals. The bioma stood alone or were placed on top of painted decorated crocodile and pig skulls, which provided the ancestral spirits with a type of supernatural sustenance. The bioma and other carvings kept in the shrine were thought to attract the spirits of ancestors by their inventive, decorative designs. They also served as a reminder to the living of their societal obligations to the extended family, community, ancestors, and the land.

This two-dimensional figure has well-defined, curvilinear limbs. A fluid, symmetrical design unifies the entire front of the figure. Bioma, like all art from the region, have diverse and stylistically distinct patterns. This figure is of a style that was made in the central and western Papuan Gulf villages.

BIOMA (FIGURE)
Papua New Guinea, Gulf of Papua, Era River area, early 20th century
Wood and pigment
h. 23 in. (58.4 cm); w. 11 in. (27.9 cm); d. ¾ in. (1.9 cm)
Gift of Gilbert M. Denman, Jr., 77.1035

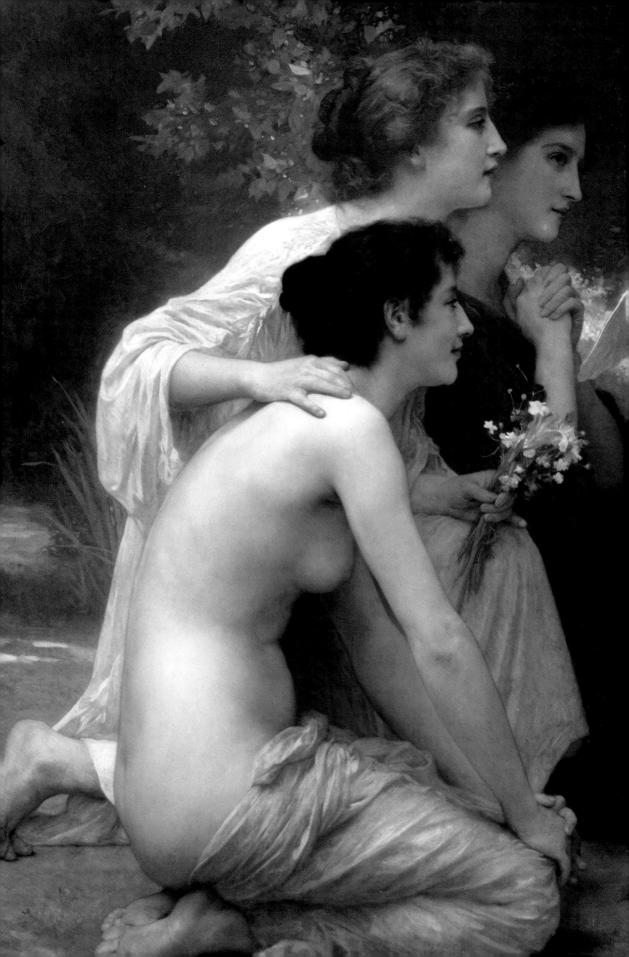

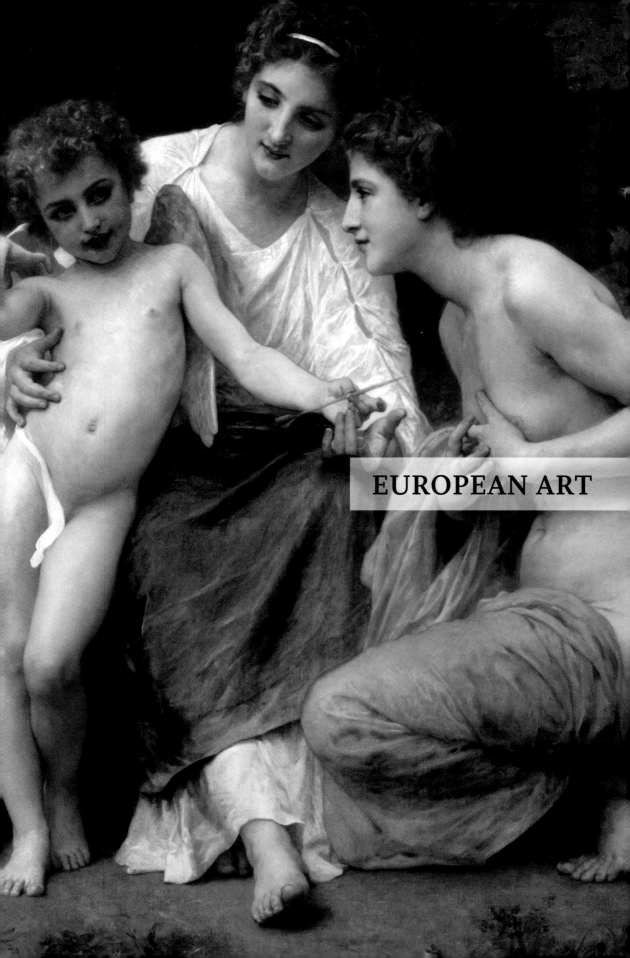

EUROPEAN ART

THE ENTOMBMENT
English, 15th century
Alabaster
h. 21¼ in. (54.0 cm);
w. 16¼ in. (41.3 cm);
d. 3½ in. (8.9 cm)
Purchased with funds provided
by the Sarah Campbell Blaffer
Foundation, 97.21

Nottingham, in the eastern midlands of England, became a major center for the production of alabaster religious reliefs in the fifteenth century, and sculpture produced there was traded throughout late medieval Europe. Alabaster is a soft, semitranslucent gypsum, much easier to carve than marble, and its newly carved surfaces harden on contact with the air. The Nottingham artists worked with alabaster quarried nearby in south Derbyshire, the color of which varied from a pale ivory to a rich honey-beige. Most of the religious reliefs carved in Nottingham were hand-colored before sale. The trade was so large that orders came from places as distant from England as Iceland, Poland, Spain, and Croatia, although the largest market was France.

Today, these "Nottingham Alabaster Reliefs" are scattered even more widely, and examples can be found in museums throughout the world. The Museum's relief is among the finest in America. It represents the Entombment of Christ and is unusually well preserved, showing extensive—and probably original—coloring. Most reliefs of this type were combined in rows to form alabaster altarpieces devoted to the life of Christ or of the Virgin and also of important saints, including the life of Thomas Becket. Although most of these altarpieces have been disassembled and sold as individual reliefs like the present example, well-preserved original ensembles can be found in Westminster Cathedral and the Victoria and Albert Museum in London.

Since few Italian Renaissance paintings were signed, and contract documents are rare, scholars use the comparative methods of the traditional connoisseur to identify their artists. This circular painting—called a *tondo* in Italian—was attributed to Piero di Cosimo when it was acquired by Samuel Kress, who formed an important private collection early in the twentieth century. This attribution was changed several times before scholars reached a consensus that it is the work of Giuliano Bugiardini, a contemporary of Michelangelo, with whom the younger artist is said to have worked on the Sistine Ceiling in 1508. The tondo represents the Virgin and Child with Saint Joseph, the husband of the Virgin, in a benign and spacious landscape. Its highly finished, precisely linear style is associated with Bugiardini and his masters.

Italian Renaissance paintings are exceedingly rare in the permanent collections of Texas art museums. The presence in San Antonio of this well-preserved High Renaissance painting attributed to Giuliano Bugiardini can be explained by the fact that it was a gift to the museum in 1937 from the foundation that distributed the Kress Collection.

GIULIANO BUGIARDINI
Italian, 1475–1554
The Holy Family, circa 1530
Oil on panel (*tondo*)
diam. 38¼ in. (97.2 cm)
Gift of the Samuel H. Kress
Foundation, 37.6785

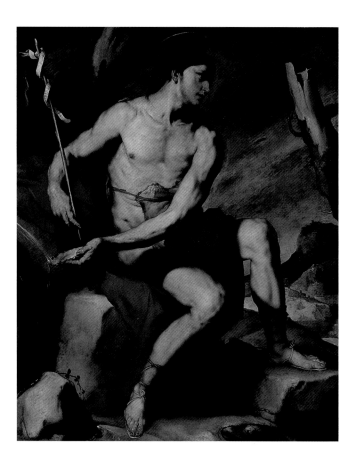

LUCA GIORDANO
Italian, 1634–1705
*Saint John the Baptist in the
Wilderness*, circa 1660
Oil on canvas
h. 57½ in. (146.1 cm);
w. 46¼ in. (117.5 cm)
Gift of the Ewing Halsell
Foundation in memory of
Mary Halsell Vilan, 84.46

Luca Giordano was among the greatest painters of the Italian Baroque. Because he was born and died in Naples, he was deeply affected by the Naples-based Spanish painter, Giuseppe Ribera, whose style was in turn rooted in the extraordinary realism and emotional intensity of the Italian painter Caravaggio. All three artists created images with strong contrasts of light and dark and with an almost pitiless interest in imperfections of the flesh. This style was appropriate to the representation of Saint John the Baptist in the wilderness, where Christ's boyhood friend lived much of his adult life as an ascetic.

There are almost countless representations of Saint John the Baptist in Renaissance and Baroque religious art. Many of these concentrate on Saint John's interactions with Christ, both as an infant, as derived from the Gospel of Saint Luke, and as an adult who baptized Christ. Among the finest are those which, like Giordano's, represent the future saint alone in the wilderness, where he lived a life that challenged the luxurious habits of the often oppressive Roman rulers of the Holy Land. In this canvas, Giordano emphasized the saint's extraordinary strength and perseverance and suggests, by the cross, that he too will be martyred while young. Saint John was in his twenties when he was beheaded.

Although signatures on paintings remained rare in the seventeenth century, this large still-life painting was initialed AVB by one of the greatest Dutch masters of that century, Abraham van Beyeren, sometime in the 1660s. It represents the remains of a sumptuous banquet and is filled to overflowing with luxurious fabrics and expensive porcelain and silver vessels stacked one atop the other, beautiful cutlery, and "fancy" foods like hot-house fruits and shellfish. The sheer instability of the arrangement and the fact that certain of the fruits have already been cut for serving and eating gives the picture a sense of arrested action, and the viewer is placed in the position of a would-be consumer of this fulsome meal. Yet, we know that, should we pick a grape or select a peach, the entire edible edifice will tumble from the table. Here today, gone tomorrow.

Van Beyeren was, with his contemporaries Willem Kalf and Jan de Heem, the master of this type of luxury still life, and his paintings were eagerly sought by precisely the same wealthy clientele they cautioned with their pictorial moralism. Interestingly, the greatest museum of Dutch seventeenth-century painting, the Rijksmuseum in Amsterdam, owns a virtually identically composed still life, which, before the discovery of the San Antonio version in a private collection in the early 1980s, was considered to be his masterpiece.

ABRAHAM VAN BEYEREN
Dutch, 1620–1690
A Banquet Still Life with Roses,
circa 1665
Oil on canvas
h. 51 in. (129.5 cm); w. 43 in.
(109.2 cm)
Purchased with funds provided
by the Lillie and Roy Cullen
Endowment, 85.38

JOSEPH WALKER
Irish, active from 1690
Comb Box, 1717–1718
Silver
h. 3½ in. (8.9 cm); w. 10¾ in.
(27.1 cm); d. 8½ in. (21.6 cm)
Bequest of John V. Rowan, Jr.,
2004.13.160

The fashion for grand silver or silver-gilt toilet or dressing table services—extensive collections of containers like the one to which this splendid box originally belonged—originated in seventeenth-century France before arriving in Great Britain with the restoration of King Charles II in 1660. Luxury objects and dazzling expressions of social status, the services were customarily given to an aristocratic bride by her parents or betrothed, or on occasion as a gift in honor of a christening. Comprising as many as thirty pieces and intended for display in a woman's bedroom, the elaborate services functioned as props in the ritual surrounding the daily *levée* or ceremonial dressing, a semiprivate, often choreographed, event attended by family and friends.

The components of the toilet service were standardized by the late seventeenth century, and their variety reflects the complexity of the beauty regimen in the period. The most common elements of the services included a pair of rectangular boxes such as this one for combs and other notions, powder boxes, patch boxes, jars for ointments and pomades, brushes, pincushions, scent bottles, candlesticks, porringers and covers, and large silver-framed mirrors. The ridged decoration, or gadrooning, and engraved armorials on the Museum's box are characteristic features on toilet services produced in the early decades of the eighteenth century. The arms are those of the Earl of Meath quartering others.

Eighteenth-century Venice saw a second florescence of painting—a late Baroque "renaissance"—that almost equaled that of the age of Titian two centuries earlier. The city once again produced a group of major painters, several of whom dominated world art and traveled to make major works for far-flung churches and palaces in Spain, England, Germany, and Russia. Perhaps the least studied of these is the draftsman and painter Francesco Fontebasso, who was overshadowed in his lifetime by his contemporary Giambattista Tiepolo. The number of major commissions received by Fontebasso was extraordinary, however, and his career was capped by a summons from Catherine the Great to paint in the Winter Palace and the Hermitage in St. Petersburg in 1761—an honor never granted to his rival Tiepolo.

Paintings by Fontebasso are rare in American museums, and *Christ on the Road to Calvary* is surely among the finest. Executed in a vigorous, painterly style, it represents a scene toward the end of Christ's life in a manner that, due to its highly serious subject, replaced the pastel-hued elegance that typifies Venetian eighteenth-century painting with the dark hues and emotional intensity of earlier Baroque painting.

FRANCESCO FONTEBASSO
Italian, 1707–1769
Christ on the Road to Calvary,
circa 1750
Oil on canvas
h. 58 in. (147.3 cm);
w. 75½ in. (191.8 cm)
Purchased with the Grace
Fortner Rider Fund, 85.46

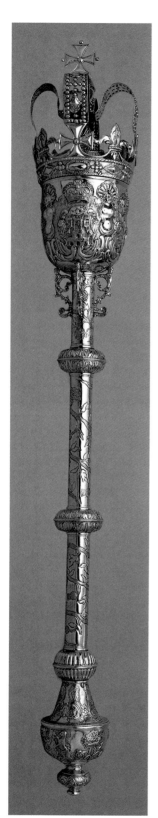

MACE OF THE BOROUGH
OF ATHY
Irish, 1746–1747
Silver
h. 46¼ in. (117.5 cm);
diam. 7 in. (18.0 cm)
Bequest of John V. Rowan, Jr.,
2004.13.274

Maces—ceremonial staffs of office such as this spectacular example—
evolved from an early form of heavy-headed military weapon. As early
as the thirteenth century, they were established as symbols of rank and
authority whose primary function was to be paraded before heads of state
or other high officials during civic ceremonies. One of a small number
of eighteenth-century examples of this scale and elaborate design known
today, the Museum's mace was originally commissioned by James, Earl
of Kildare (1722–1773). He presented the mace to the Borough of Athy,
a town southwest of Dublin, on September 29, 1746, as an inscription
engraved on the mace documents.

The Borough of Athy was abolished in 1840 and replaced by a demo-
cratically elected town council, at which time the mace was gifted to John
Butler, the last sovereign or leading official of Athy's Borough Council,
as another inscription on the mace records. The head of the mace, which
is surmounted by a coronet, is decorated with the arms of George II (the
inclusion of the royal arms was stipulated in the fifteenth century); the
crowned emblems of Ireland, in the form of a harp; of England, in
the form of a rose and thistle; of France, in the form of a fleur-de-lys; and
the seal of Athy. The emblems of the three countries along with the arms
of Kildare also appear on the terminating knop.

Jean-Baptiste Greuze was the greatest genre painter in France during the second half of the eighteenth century. Born in the small central French town of Tournus, he was apprenticed to a minor portrait painter in Lyon and arrived in Paris in 1750. There he drew and painted from the model at the French Academy and began to exhibit genre paintings representing middle- and lower-middle-class French life. His particular combination of closely observed realism, skillful compositional classicism, and moralizing narrative content was unique, and his work was highly praised by the first great French art critic, Denis Diderot, in his reviews of the annual Salon exhibitions at the Louvre.

This drawing is a red chalk or, in French, *sanguine*, study of a head. It represents the intense emotional reaction of a young woman to the death of her father and is a study for a prominent figure in Greuze's 1778 masterpiece, *The Punishment of the Son*, in the Louvre. The painting, one of two in a series, is a modernization of the New Testament story of the prodigal son, but, in Greuze's version, the son arrives only as his father dies surrounded by his large and faithful family. The contrast between the searing grief of the daughter in this drawing and the huddled guilt of the son is a triumph of observation, and the San Antonio drawing is among the most important studies for this masterpiece.

JEAN-BAPTISTE GREUZE
French, 1725–1805
Study for *Le fils puni*,
1776–1778
Red chalk on paper
h. 15 in. (38.1 cm); w. 12 in.
(30.5 cm)
Bequest of Gilbert M.
Denman, Jr., 2005.1.173

BENJAMIN WEST
British, 1738–1820
*Noah Sacrificing after the
Deluge*, circa 1800
Oil on canvas
h. 72 in. (182.9 cm); w. 138 in.
(350.5 cm)
Purchased with funds provided
by the Sarah Campbell Blaffer
Foundation, 80.131

Benjamin West was the first internationally successful American-born artist. At twenty-two, he was sent to Italy by a wealthy Philadelphia merchant to learn to paint by copying Old Master paintings and drawing Greek and Roman sculpture. Three years later, he traveled to London, where he quickly became one of the most prominent British painters. A confirmed royalist, he never returned to what became the United States of America and was the preeminent painter to the court of George III. Cofounder of the Royal Academy in 1768 with Sir Joshua Reynolds, West was also, with one year's exception, its president from 1792 until his death, as well as Surveyor of the King's Pictures from 1791 until his death.

This canvas is, in fact, a full-scale oil "cartoon" for a stained-glass window designed by West for Saint George's Chapel in Windsor Castle. Representing a scene from the Old Testament, it was part of an enormous scheme for all the windows in what was to be a completely new neo-Gothic chapel to replace the late medieval one. Conceived as part of a royal program to instill religious fervor into wealthy Anglican England, the chapel designs occupied West from 1782, when he was first approached by the king, until his death nearly thirty years later. Although none of the chapel was actually completed, the paintings and drawings made for it are scattered in public and private collections in the United States and Great Britain.

This extraordinary but rather enigmatic pair of cruets is among the finest nineteenth-century silver pieces in the Museum's superb collection of Irish silver. Difficult to categorize stylistically, the cruets recall both the animate curving forms and fantastic shapes of the seventeenth-century auricular style, as practiced by such Dutch silversmiths as Adam van Vianen, and the asymmetry and naturalistic decoration of the eighteenth-century Rococo style. The elaborate chased and repoussé decoration, which covers much of the vessels' surface, is typical of silver produced in Ireland beginning in the 1820s. This exuberant style stands in marked contrast to the classically inspired, sparingly decorated silver made a decade or so earlier.

The original function of the cruets is a matter of speculation. Cruets— glass bottles that were meant to hold oil and vinegar and that came with and without stands to hold them—have been known since the seventeenth century; however, because of the acidity of the vinegar, these shapes were never produced in silver. Pairs of cruets intended to contain the water and wine used in the Mass—essential components of the Roman Catholic rite—had been known since the Middle Ages. The Museum's cruets were perhaps made for use in a private chapel since they are engraved with an unidentified heraldic crest in the form of a tree trunk and the motto *tandem* (Latin for "in the end").

ROBERT W. SMITH
Irish, active from 1784
Pair of Cruets, 1831–1832
Silver
each: h. 7¼ in. (18.4 cm);
w. 4½ in. (11.2 cm); d. 3 in.
(7.4 cm)
Bequest of John V. Rowan, Jr.,
2004.13.184.1-2

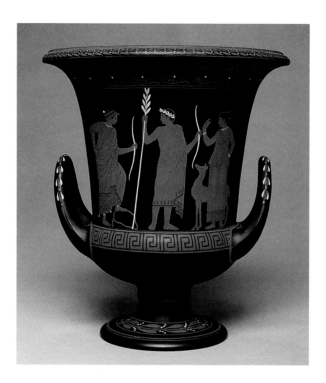

WEDGWOOD FACTORY
English, est. 1759
Vase in the Form of a Calyx-krater, late 18th–early
19th century
Stoneware (basalt ware) with
encaustic decoration
h. 10½ in. (26.7 cm);
diam. 9¼ in. (23.5 cm)
Gift of Kittie Nelson Ferguson
and Henry Rugeley Ferguson,
2001.52.75

Josiah Wedgwood (1730–1795), founder of a ceramics factory in England that still bears his name, was an early admirer and imitator of the art of classical antiquity. Wedgwood named the estate on which he built his factory Etruria after the land of the Etruscans, who in the mid-eighteenth century were (erroneously) thought to be responsible for the red-figure ceramics then being discovered in Italy. Among the many important contributions Wedgwood made to the field of ceramics was the refinement of a ceramic body known as basalt ware, a hard, fine-grained, unglazed black stoneware, such as that employed in the manufacture of the Museum's vase. For the decoration of his basalt wares, Wedgwood patented a type of decoration he labeled "encaustic" that imitated the style, though not the technique, of the red-figure painting practiced by classical potters.

The inspiration for the shape and decoration of many of Wedgwood's "encaustic" pieces, including this example, came from the *Collection of Etruscan, Greek and Roman Antiquities from the Cabinet of the Honble. Wm. Hamilton*. Published between 1766 and 1776, this catalogue documented the collection of some seven hundred classical vases that was amassed by William Hamilton, the British ambassador to the Kingdom of Naples from 1764 to 1801. The shape of this vase may have been based on an ancient calyx-krater form illustrated in plate 33 of volume 1 of Hamilton's catalogue, and the three figures—provisionally identified as Artemis, Apollo, and a woman—were taken from plate 109 of the same volume.

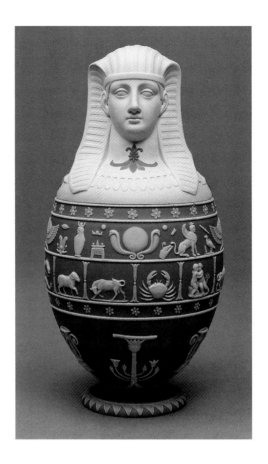

Canopic jars, which take their name from the city of Canopus in the Nile delta, were used in ancient Egyptian burial practices to store and preserve the internal organs as part of the mummification process. Made in a variety of materials including wood, stone, and pottery, the jars customarily had lids decorated with sculpted images of the four sons of the god Horus, including the human-headed Amset. Canopic jars or vases were among the earliest and most popular Egyptian forms produced at the ceramic factory of Josiah Wedgwood (1730–1795) and his partner Thomas Bentley (1731–1780).

This vase, with its white relief decoration applied to a colored ground of a type perfected by Wedgwood in the mid-1770s and known as jasperware, is among the Wedgwood factory's later and less archaeologically accurate canopic vases. The vase is decorated with signs of the zodiac and pseudo-hieroglyphs consisting of images of owls, crocodiles, cobras, and lotus blossoms. The latter were not based on Egyptian precedents but rather were invented by designers working at the Wedgwood factory at the end of the eighteenth century. The introduction of canopic vases of this model at Wedgwood in the 1860s coincides with the Egyptomania that swept Europe around the opening of the Suez Canal in 1869.

WEDGWOOD FACTORY
English, est. 1759
Canopic Vase, circa 1865–1870
Stoneware with applied relief decoration (jasperware)
h. 10 in. (25.4 cm); diam. 5 in. (12.7 cm)
Gift of Kittie Nelson Ferguson and Henry Rugeley Ferguson, 2001.52.78.a-b

NARCISSE DIAZ DE LA PEÑA
French, 1807–1876
The Gypsy Princesses,
circa 1865–1870
Oil on panel
h. 31 in. (78.7 cm); w. 23 in.
(58.4 cm)
Bequest of Gilbert M.
Denman, Jr., 2005.1.168

Anyone reading the name "Narcisse Diaz de la Peña" knows instantly that it is not French. Yet the painter who bore this name was born in Bordeaux to Spanish parents, who lived in exile in the western French city at the same time as the greatest Spanish early nineteenth-century painter, Francisco Goya. Diaz remained in France and was apprenticed as a painter of figures and charming scenes on porcelain before meeting the great realist landscape painter Theodore Rousseau. Although Diaz is known today principally as a landscape painter, he "borrowed" exotic figural subjects of pretty women and children who were either Gypsies, Middle-Eastern women, or North Africans, placing them in lush landscape settings and evoking their costumes with brilliant hues.

This painting represents figures that have been called "Gypsy princesses" on a small wooden panel and is, hence, a wonderfully fresh and delightful "cabinet picture," created for a French private collector who lived in a small apartment and who liked refined and elegant beauty of a slightly exotic character. One can see easily why Renoir admired Diaz's aesthetic—indeed, both artists shared origins in porcelain painting.

Gustave Courbet was the central painter of a loosely organized movement called "Realism" that dominated the artistic discourse of mid-nineteenth-century Paris. Courbet himself eschewed membership in any organization, but proclaimed an aesthetic (in painting and his rare texts) rooted in the real world. Realism permitted no idealization, no historical, mythological, or religious subjects, and a powerful sense of the physical quality of the world. With thick paint and a palette knife, which he preferred to a brush, Courbet reenacted his experience in paint, once saying, "Show me an angel, and I will paint it."

This landscape represents a lake in the far east of France, near the Swiss border and in the area of Courbet's birthplace of Ornans. Among the largest lakes in France, Saint Point was a considerable hike from Ornans. The painter went there to stay with the Joliclerc family in November of 1872, when he painted this painting and a larger canvas now in Stockholm. Bleak and desolate, the painting was once called *Before the Storm*, and, indeed, Courbet communicates a sense of impending disaster. This, in fact, he experienced on returning to Paris in December, when he was fined a huge sum for his role in toppling the Vendôme Column during the Commune the year before. Indeed, the mountains in the background are in Switzerland, where Courbet fled into exile in 1873 to avoid paying the punishing fine and where he died.

GUSTAVE COURBET
French, 1819–1877
The Lake, Near Saint-Point, 1872
Oil on canvas
h. 19¼ in. (48.9 cm); w. 23 in. (58.4 cm)
Bequest of Gilbert M. Denman, Jr., 2005.1.166

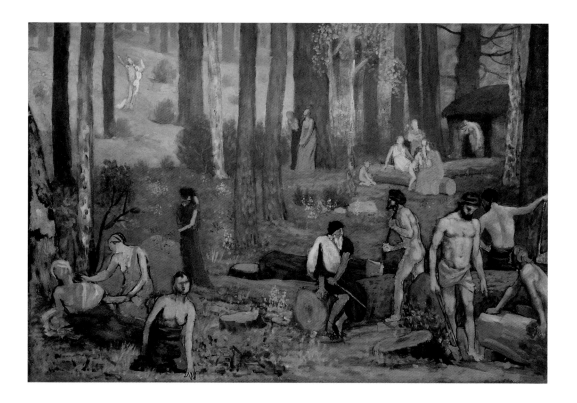

PIERRE PUVIS DE
CHAVANNES
French, 1824–1898
The Woodcutters, 1871–1873
Oil on paper on canvas
h. 30 in. (76.2 cm); w. 44 in.
(111.8 cm)
Bequest of Gilbert M.
Denman, Jr., 2005.1.178

Pierre Puvis de Chavannes was the greatest painter of large-scale murals in France during the second half of the nineteenth century. His immense paintings, usually done on canvas and glued to the wall, can be found throughout France. The most famous of them are the murals recording the life of the Parisian patron saint, Saint Genevieve, in the Pantheon in Paris and the staircase murals in the fine arts museums of Rouen and Lyon. His almost abstract style was marked by planar compositions, eloquent contours, and rigorously simple forms and was admired deeply by artists of the next generation, including Seurat, Gauguin, Matisse, and Picasso.

The Woodcutters was made as a preparatory oil study for a large mural that was never completed. Dating from the early 1870s, just as the young Impressionists started to exhibit in Paris, the painting has been plausibly but inconclusively related to two decorative schemes on which Puvis worked in 1871 and 1873—in one it is the putative pendant to a picture of "work" and in the other, to one entitled *Summer*. In spite of its unfinished state, this canvas is among the best-known European paintings in the Museum's collection and has been published and exhibited widely.

GUSTAVE DORÉ
French, 1832–1883
Castle on the Rhône, circa 1878
Oil on canvas
h. 39½ in. (100.3 cm);
w. 29 in. (73.7 cm)
Bequest of Gilbert M.
Denman, Jr., 2005.1.169

Gustave Doré was among the most prolific and famous French artists of the mid-nineteenth century. Born in Strasbourg when it was still part of France, the artist had moved to Paris by the time of the Franco-Prussian War (1870–1871). However, when France lost his beloved Alsace and its great city to the Germans after the war, he became all but obsessed with his native landscape. Today Doré is known principally for his steel-engraved illustrations for canonical texts—most importantly, for Cervantes's *Don Quixote* and the Bible. He painted throughout his life, however, and even turned to sculpture in the decade before his premature death in 1883.

Paintings by Doré are scattered throughout museums in France, Britain, and the United States. The San Antonio landscape represents a romantic, abandoned thirteenth-century castle at Spesbourg in the hills southwest of Strasbourg. Ironically, Doré refused to visit this landscape after it became "German" and painted this work from sketches and memory, evoking a landscape that had been lost to France. This powerfully painted work was surely seen by the younger Monet, who painted similar compositions in mountainous central France a decade later.

Berthe Morisot and her expatriate American friend, Mary Cassatt, were considered the two greatest women artists associated with the Impressionist movement. Born into a wealthy family, Morisot studied painting with Camille Corot and Edouard Manet before marrying the latter's brother. In spite of her independent means, she considered herself a professional artist and exhibited in seven of the eight Impressionist exhibitions before her death in 1895. The executor of her estate was Auguste Renoir, and her only child, Julie Manet, married into a great collecting family and wrote important journals about the artists and writers of her time.

Like Degas, Renoir, and Pissarro, Morisot excelled at the pastel medium and sent major pastels to four of the Impressionist exhibitions. It is highly probable that this large pastel showing a series of women ice skaters was one of these, most likely done in 1881 or 1882. Roller-skating and ice-skating were fashionable in Third Republic Paris, and Morisot, Renoir, and her brother-in-law and friend Manet all represented the subject. The crumbling pastel medium and the line of skaters lend a sense of imbalance and movement to this beautiful drawing.

BERTHE MORISOT
French, 1841–1895
The Skaters, circa 1881–1882
Pastel on paper
h. 17 in. (43.2 cm); w. 23¼ in. (59.1 cm)
Bequest of Gilbert M. Denman, Jr., 2005.1.176

HENRI FANTIN-LATOUR
French, 1836–1904
Rienzi: Act V, The Prayer of Rienzi, 1886
Lithograph
h. 12¾ in. (32.4 cm);
w. 9⅝ in. (24.5 cm)
Bequest of Gilbert M. Denman, Jr., 2005.1.367

Although he was a very good friend of the radical painter Edouard Manet, Henri Fantin-Latour was much less a rebel and spent his life painting floral still lifes and portraits of his friends in a deeply felt, if conventional, style. He was too timid and too interested in "high culture" to exhibit with the Impressionists and spent many of his evenings in Paris going to the theater, the ballet, and, most fervently, the opera. Indeed, like Edgar Degas, Fantin was closely associated with the opera. The lithographs he made evoking scenes from Berlioz, Wagner, Verdi, Donizetti, Mozart, and other composers are perhaps the most distinguished works of "operatic" art ever made.

Through the collection of the San Antonio attorney and opera-lover Gilbert M. Denman, Jr., the Museum possesses one of the most complete collections of lithographs by Fantin in the world. The example pictured here was inspired by Richard Wagner's third opera, *Rienzi, the Last of the Tribunes*, which, although completed in 1840 and premiered in 1842, did not receive its American premiere until 1977, when Mr. Denman sponsored its performance in San Antonio. There are 148 other lithographs in this superb collection of Fantin's work.

William Adolphe Bouguereau was born into a family of oil and olive merchants in the French west-coast port city of La Rochelle. His uncle, a Catholic priest, recognized the young man's talent and convinced his father to send him to Paris for training. There, he quickly matured as an artist and won the French Rome Prize in 1850. From then until his death, Bouguereau was the triumphant academic master of Raphaelesque women and children. His smooth and beautifully finished paintings sold to newly minted millionaires throughout the world, finding particular favor in America. Indeed, the artist's second wife, Elizabeth Jane Gardner, was a wealthy American artist, who strengthened Bouguereau's connections to the nouveaux riches of that country and caused the elderly painter to champion women artists.

Admiration is among Bouguereau's finest late works. Completed in 1897, it was exhibited in both the official Paris Salon of 1899 and, to even greater acclaim, in the Universal Exposition held in Paris in 1900. It represents two almost nude and three clothed young Italian women dressed in historically ambiguous clothing in a pleasant forest with views of the buildings of ancient Rome in the upper left. They all seem enraptured by a young boy whose downy wings indicate that he is a cupid. It goes without saying that Bouguereau was despised by his contemporaries, the Realists and Impressionists.

WILLIAM ADOLPHE
BOUGUEREAU
French, 1825–1905
Admiration, 1897
Oil on canvas
h. 58 in. (147.3 cm); w. 78 in. (198.1 cm)
Bequest of Mort D. Goldberg, 59.46

LATIN AMERICAN ART

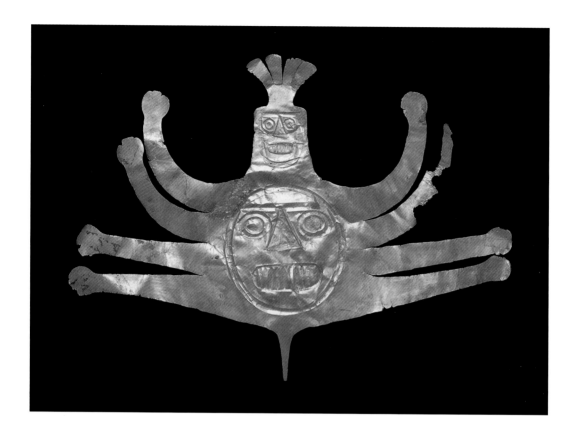

BIFACIAL PLAQUE WITH
TRESSES
Nazca culture, Peru, 200–400
Gold
h. 6 in. (15.2 cm); w. 9 in.
(22.9 cm)
Gift of Mr. and Mrs. Lindsay A.
Duff, 2004.25.4

Nazca culture flourished on the south coast of Peru between 100 BC and AD 600, and its economy throughout that period was based on agriculture, harvesting marine life, and herding camelids, including llamas. Among its greatest artistic achievements were polychrome slip-painted ceramics, complexly designed and woven textiles, and gold objects used as personal adornment for the living and dead elite.

Gold jewelry and ceremonial objects played important roles in the social and religious ritual life of the Nazca, as in most Andean societies. The Museum owns a small but interesting collection of Andean gold objects, both hammered and mold-made. This hammered gold plaque may have been a votive offering to the sun god or an attachment for a tunic or headdress. It depicts an anthropomorphic solar disk with eight tentacles, perhaps representing the sun's rays. Above the solar disk is a headdress with another anthropomorphic face.

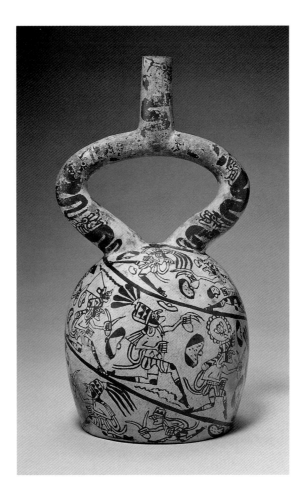

Moche culture was based primarily on agriculture and flourished on the north coast of Peru between 100 BC and AD 700. It is known for its highly developed mold-made ceramic tradition depicting human portraits, sexually explicit scenes, warfare, and complex scenes of religious ritual. Their pottery contains abundant information about Moche society. During the classic period of Moche ceramics, potters began painting complex scenes on the bodies and stirrup spouts of vessels using fine brushstrokes.

Painted in red on a cream background, this fineline vessel depicts a series of elaborately dressed warriors running within an upwardly spiraling band. Eared serpents, possibly associated with fertility, lightning, and rain, encircle the stirrup spout. Ritual running is one of the most frequent subjects found on Moche fineline vessels of this period. Here, the runners hold small bags, probably containing lima beans encoded with messages. These beans are also scattered throughout the scene. The Moche used beans of various colors and shapes in accounting, divination, and other important rituals.

STIRRUP VESSEL WITH
RITUAL RUNNERS
Moche culture, Peru, 400–600
Earthenware with slip and
pigment
h. 11½ in. (29.2 cm);
diam. 5½ in. (14.0 cm)
Gift of Mark L. Duff and
Beth C. Senne-Duff, 2003.41.1

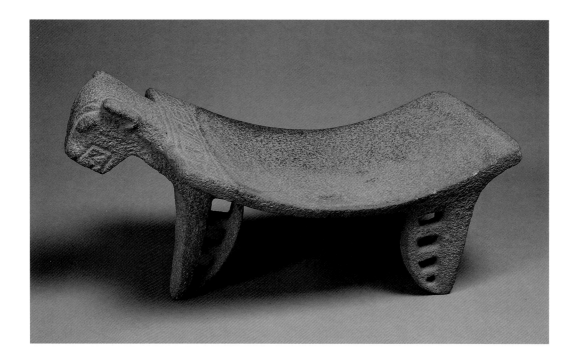

CEREMONIAL METATE WITH
JAGUAR MOTIF
Costa Rica, Atlantic Watershed
region, circa 800
Basalt
h. 15 in. (38.1 cm); w. 28 in.
(71.1 cm); d. 13 in. (33.0 cm)
Gift of Mrs. A. A. Seeligson, Sr.,
77.1157

Three of the most important artistic contributions of the chiefdoms of
Central America were gold jewelry, polychromed ceramics, and large
basalt sculpture. Because pre-Columbian peoples had not developed
metal tools, stone was carved with other, harder stone or fire-hardened
wood. Such was the case in the manufacture of this ceremonial *metate*
or grinding platform. Made to be interred with the deceased for use in
the afterlife, sculptures such as this metate were among the finest stone
objects made in the pre-Columbian Americas. Usually crafted from a
single piece of basalt, these extraordinary stone sculptures range in com-
plexity from elegantly simple pieces to those with intricately entwined
animal and human figures. In addition to ceremonial metates, these carv-
ings also take the form of ceremonial thrones, carved stools, standing
warriors, and trophy heads.

This metate is carved in the shape of a jaguar, the most feared and
respected animal in pre-Columbian Latin America. It was associated
with the night and with cosmic and political power. The metate's open-
work legs, which lighten the weight of the object, are decorated with
abstract designs that embellish its otherwise plain appearance. A *mano*,
or grinding stone, probably accompanied this piece.

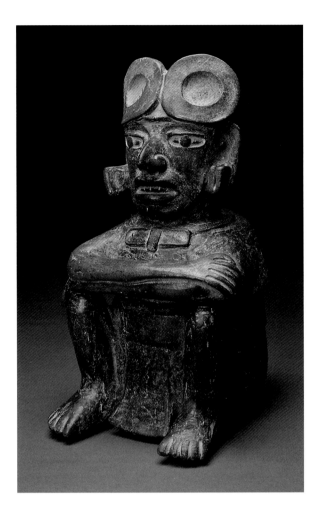

The Classic Maya (250–900) had a long and rich tradition of representing human figures in sculpture, on two-dimensional painted ceramic surfaces, and on screen-fold pictographic manuscripts, known as codices. These images represent rulers, priests, warriors, and other distinguished individuals, both male and female.

This elegant two-piece vessel depicts a seated warrior wearing a loincloth, earlobe bars, a bowtie-like necklace, and a headdress with two large circles on it. It was made during a politically complicated period when Guatemalan Maya societies were aligned with or controlled by rulers from Teotihuacán, a non-Maya city located more than five hundred miles to the north. The prominent goggle-like headdress worn by this individual is typical of Teotihuacán warrior attire associated with the cult of Tlaloc, the rain god. The vessel, which may have been an incense container, is divided into two sections, with the top half fitting snugly over the figure's waist and resting on its knees. The rich color of the vessel, ranging from amber to black, was achieved by burnishing.

VESSEL IN THE FORM OF
A WARRIOR WITH ARMS
CROSSED
Maya culture, Guatemala, Tikal
region, 300–500
Earthenware with slip
h. 11½ in. (29.2 cm); w. 7 in.
(17.8 cm); d. 8 in. (20.3 cm)
Bequest of Elizabeth Huth
Coates, 97.1.28.a-b

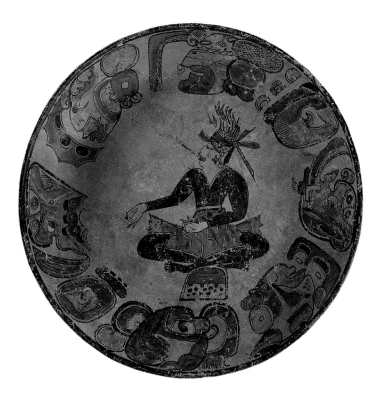

PLATTER WITH A SEATED NOBLEMAN
Maya culture, Guatemala, Northern Petén, circa 600
Earthenware with pigments
h. 2½ in. (6.4 cm);
diam. 15¾ in. (40.0 cm)
Bequest of Mrs. A. A. Seeligson, Sr., 98.12.10

Maya hieroglyphs were painted on manuscripts, carved stelae, palace and tomb walls, ceramic vessels, and other surfaces. This important codex-style polychrome platter is a fine example of the sophistication of Maya ceramics from the Classic Period (250–900). The focal point of the platter is a nobleman seated on a jaguar-skin cushion or throne. The jaguar played an important part in Maya life, both religious and secular. Here, it represents nobility and leadership. The nobleman appears barefoot and his legs are crossed. His arms, torso, and legs are painted black, associating him with underworld deities. The cigar he smokes and the black spot on his cheek further establish his relationship with the underworld. The figure's hand gestures suggest that he is about to receive a gift or offering.

Eight glyphs form a ring around the edge of the platter. All are in some way related to the underworld and probably belong to a longer Maya myth. This platter may have been made in atelier fashion, with different specialists crafting the platter, painting the glyphs, and illustrating the seated figure and his attributes. Because of its fine quality, it was clearly commissioned by someone of great wealth, who presented it during the burial ritual to aid the soul of the deceased on its journey to the afterlife.

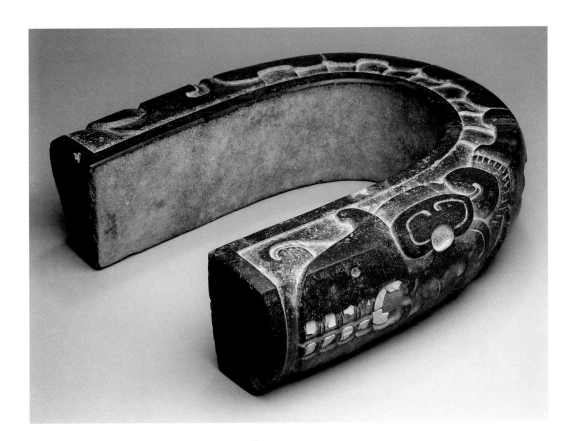

One of the defining cultural characteristics of Mesoamerican civilization was the ritual ball game. This game, known during Aztec times as *tlaxtli*, involved the movement of a round rubber ball along a court by competing individuals with the goal of passing the ball through a stone ring, usually set into the side of the court. Ballplayers wore protective gear, including broad belts, or yokes, made of wood or leather, as well as helmets and other accoutrements. Symbolic heavy stone yokes commemorating the ball game have been found buried on or near ball courts. Most of these yokes have been elaborately carved on the outside surface, but others are unadorned. These band-like carvings frequently represent animals and reptiles, but some display human faces, perhaps those of the ballplayers themselves.

This yoke is one of the finest surviving examples. The beautifully rendered, deeply carved designs on the outer surface probably depict a reptile. The head of this creature contains mother-of-pearl inlays representing teeth and vestiges of red pigment, possibly cinnabar. A horn or crest is atop the head. Its segmented body encircles the yoke and terminates in what appear to be rattles, suggesting that the creature is a rattlesnake. Alternatively, this figure may be interpreted as a centipede.

YOKE WITH REPTILIAN
MOTIF
Huastec culture, Mexico,
Veracruz, 600–900
Stone with mother-of-pearl
inlay
h. 14¾ in. (12.0 cm);
w. 16½ in. (41.9 cm);
d. 14 in. (35.6 cm)
Bequest of Elizabeth Huth
Coates, 97.1.12

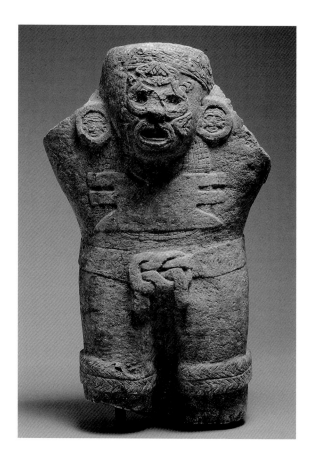

ATLANTEAN FIGURE
Maya or Toltec culture,
Mexico, Yucatán, 900–1150
Limestone with traces of
pigment
h. 26½ in. (67.3 cm); w. 16 in.
(40.6 cm); d. 9 in. (22.9 cm)
Museum Purchase, 78.327

During the Maya post-Classic Period (1000–1500), major sites in the Yucatán Peninsula were heavily influenced by the Toltec culture centered in Tula, just north of present-day Mexico City. This influence was especially evident in art and architecture, in such forms as large serpentine columns and other sculpted figures. The present sculpture is filled with Toltec symbols and proportions. Used as an altar support, this priest-like figure has his arms raised above his head in a weight-bearing position like Atlas, hence the popular name of "Atlantean." Used in connection with petitions for rain, this sculpture is adorned with symbols of water and rebirth. The eyes, mouth, and waist are encircled by rattlesnakes— symbols of fertility—and lightning bolts associated with rain. It wears a butterfly pectoral, which again is associated with spring and rebirth. The figure's headdress is composed of bands of stylized water, and the earspools depict anthropomorphic suns.

At one time colorfully painted, this powerful sculpture still retains vestiges of blue and red pigment. The nineteenth-century British traveler and artist Adele Breton (1849–1923) sketched several rooms at the Maya site Chichén Itzá crowded with dozens of figures such as this one, many still colorfully decorated.

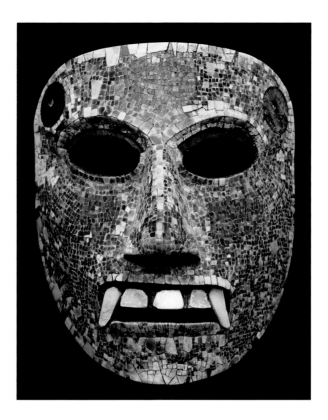

The use of masks dates to the earliest periods of pre-Columbian art. From Olmec times forward, masks were worn by shamans in rites of transformation. Military brotherhoods required their members to use masks associated with eagles, jaguars, and other iconic animals. This elaborately crafted burial mask is thought to have come from the area around Tilantongo, Oaxaca. This area was the highland birthplace of Eight Deer Tiger Claw, the great leader of the Mixtec people during the eleventh and twelfth centuries. Because of the prominent fangs, the mask is associated with the cult of the jaguar, the most highly revered animal in Mesoamerica.

This mask is made of Mexican bald cypress wood, encrusted with small tiles of turquoise and mother-of-pearl. Two tortoiseshell disks adorn the mask's temples. Fine mosaic work was an important artistic development of post-Classic Mesoamerica, especially among the Mixtec and Aztec cultures of the period immediately preceding the arrival of Europeans in the early sixteenth century. Surviving examples of this delicate work are rare. Previously it was thought that turquoise was not indigenous to Mesoamerica, but recent explorations have located turquoise sources within the central highlands of Mexico. In addition to decorating masks, turquoise mosaics were used to adorn human skulls and ritual weapons, such as knives and shields.

MASK
Mixtec culture, Mexico, Oaxacan Highlands, circa 1500
Wood with turquoise, mother-of-pearl, and tortoiseshell
h. 6 in. (15.2 cm); w. 5 in. (12.7 cm); d. 3½ in. (8.9 cm)
Bequest of Elizabeth Huth Coates, 97.1.18

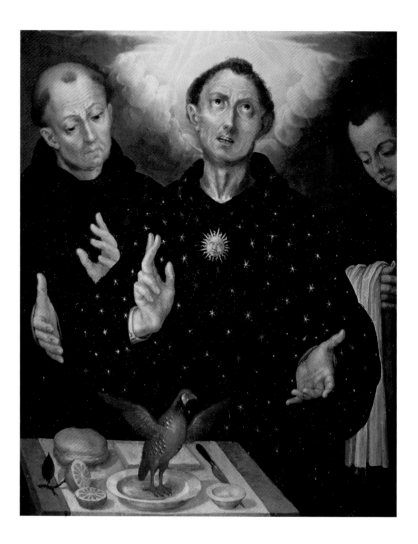

ATTRIBUTED TO FRAY
ALONSO LÓPEZ DE HERRERA
Spanish, circa 1580–1660
*The Miracle of Saint Nicholas of
Tolentino*, early 17th century
Oil on panel
h. 14½ in. (36.8 cm);
w. 11½ in. (29.2 cm)
Purchased with funds provided
by the Robert J. Kleberg, Jr.,
and Helen C. Kleberg
Foundation, 91.6

Fray Alonso López de Herrera was born in Valladolid, Spain, around 1580 and was brought to Mexico in 1608 under the patronage of the Dominican order and Archbishop of Mexico Fray García Guerra (1560–1612). López de Herrera was among the earliest Spanish artists to teach painting in New Spain. He worked in a Mannerist style popular throughout Europe in the late sixteenth century, and Saint Nicholas's exaggerated hands and elongated body reflect this tradition.

In this painting, Saint Nicholas of Tolentino, dressed in the black habit of an Augustinian friar, stands behind a small table set for a meal. He is flanked by two subordinate male figures. The scene depicts a miraculous incident in the saint's life, in which he fell ill and was being cared for by the abbot of a small monastery. Unaware that Saint Nicholas was a vegetarian, the abbot served him a dish of cooked quail. Upon seeing the dish, the saint made the sign of the cross, whereupon the quail returned to life and flew away.

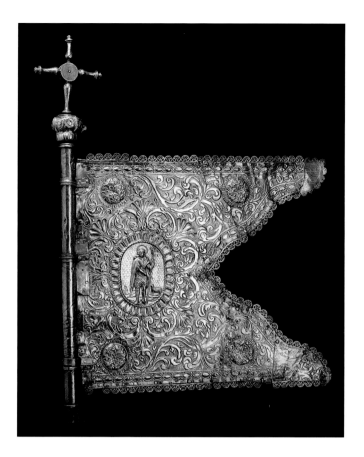

When the Spanish arrived in the Americas in the sixteenth century, they discovered that the new land was rich in precious metals and that there was a long indigenous tradition of working these highly valued materials. Silver mines were opened throughout Mexico, Guatemala, Argentina, Peru, and elsewhere. Guilds were established to help control production and quality and to assure that the Crown received its share. Most silver was sent to Spain as bullion. Much, however, remained in the Americas, where it was worked into beautiful objects of art, many as special orders for the local Roman Catholic church.

This silver processional banner is an excellent example of Guatemalan Baroque art, with the entire surface covered with exuberant decoration. Made of two sheets of silver fastened together back-to-back and attached to a pole topped with a cross, this banner originally belonged to a *cofradía*, or religious brotherhood. On each side of the banner, repoussé decoration consisting of four rosettes amid scrolling vines surrounds a gilded central medallion. Saint John the Baptist, with staff in hand and a lamb at his feet, occupies the medallion on the front, while the reverse medallion depicts a monstrance, a vessel in which the Host is displayed for adoration, bearing the letters IHS, a monogram for Christ.

PROCESSIONAL BANNER
Guatemala, late 17th century
Silver with gilding
h. 30¼ in. (76.8 cm);
w. 23½ in. (59.7 cm)
Purchased with funds provided by Elizabeth and George Coates, 75.188.47

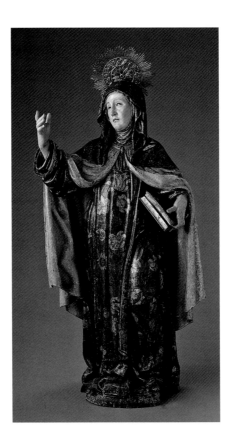

SANTA TERESA DE ÁVILA
Guatemala, late 17th century
Painted wood, glass, silver
h. 50½ in. (128.3 cm);
w. 22½ in. (57.2 cm);
d. 17½ in. (44.5 cm)
Museum Purchase, 74.60.17

From the earliest years of the Viceregal Period (1520s–1820s), sculptors working in Guatemala carved some of the finest wooden religious images in the Americas. This nearly life-size statue of the fifteenth-century Spanish saint Teresa of Ávila is a fine example of Guatemalan sculpture in the Baroque style. Carved from cedar, the statue was first covered with a layer of gesso, and then prepared in the *estofado* technique, in which the surface was gilded before it was painted. The floral patterns decorating the saint's garments were then incised through the layers of pigment to reveal the gilding beneath. This costly process was highly prized since it created the illusion of an embroidered textile surface. The realistic, flesh-like quality of Saint Teresa's face and hands was achieved through multiple applications of special paint, each layer meticulously polished, a process known as *encarnación*.

Saint Teresa of Ávila (1515–1582) was a Carmelite nun who founded the strict order known as the Discalced or Barefoot Carmelites. Here Saint Teresa's bare toes are visible under the bottom of her habit. She was an important theologian of the Spanish Counter-Reformation and wrote widely on mysticism and meditation practices. One of her most important works, *The Interior Castle*, describes the contemplative life and her special relationship with Christ.

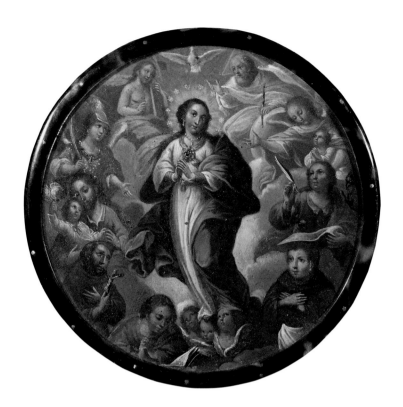

In eighteenth-century Mexico, Roman Catholic nuns belonging primarily to the orders of Saint Jerome and of the Virgin of the Immaculate Conception wore round copper disks signifying their religious order and the objects of their individual devotions. The disks, usually framed in turquoise or elaborately painted wood, were sewn onto the front of a nun's habit. Scholars have suggested that these disks, known as *escudos de monjas*, or nuns' emblems, were used to deflect attention from a nun's physical attributes to her spiritual qualities. Usually nuns were interred wearing these symbol-laden disks. Some nuns' emblems were painted by such well-known academic painters as Miguel Cabrera (1695–1768) and José de Páez (1727–1790), but most were done by anonymous, albeit gifted, artists.

The subject of this emblem is the Virgin of the Immaculate Conception, cloaked in heavenly blue and wearing a starry nimbus and bejeweled necklace. She is supported by three *putti*, or childlike angels. Immediately above her is the Holy Trinity, comprising God the Father, represented as a bearded elderly man; the Son, a resurrected Christ; and the Holy Spirit, in the form of a dove. The figures surrounding the Virgin include, moving clockwise from the Trinity, a guardian angel guiding a child; Saint John the Evangelist with writing quill and scroll in his lap and eagle by his side; Saint Pasqual, patron of the kitchen; Saint Luke the Evangelist; Saint Francis of Assisi; Saint Joseph with the Christ Child; and the Archangel Michael.

NUN'S EMBLEM
Mexico, 18th century
Oil on copper with tortoise-shell frame
diam. 6¼ in. (15.9 cm)
Purchased with funds provided by the Robert J. Kleberg, Jr., and Helen C. Kleberg Foundation, 93.45

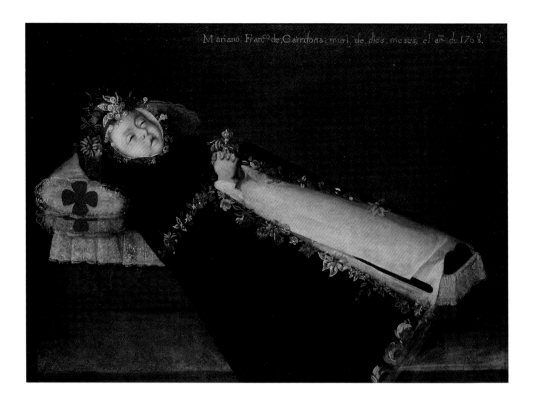

PORTRAIT OF MASTER
MARIANO FRANCISCO DE
CARDONA
Mexico, circa 1768
Oil on canvas
h. 31 in. (78.7 cm); w. 39¼ in.
(99.7 cm)
Purchased with funds provided
by the Robert J. Kleberg, Jr.,
and Helen C. Kleberg
Foundation, 91.104

During the eighteenth and the nineteenth centuries, European, North American, and Latin American painters were hired to quickly capture likenesses of the deceased before their interment. This was a costly endeavor and therefore was limited to the wealthy. Near life-size portraits were painted as well as jewel-like miniatures on ivory, often accompanied by a clip of hair attached to the back. These portraits allowed family and friends to hold onto visual memories of their departed loved ones.

Death portraits, particularly those of children, became increasingly popular among the upper classes of Mexico during the eighteenth century. These tender portraits provide a window into popular beliefs about death and the afterlife. In the Catholic tradition, deceased baptized children are assumed to go directly to heaven and are frequently referred to as *angelitos*, or "little angels." The deceased children were often portrayed wearing the attire of members of the clergy, the Virgin, or archangels. The present portrait is of Mariano Francisco de Cardona, who was only ten months old when he died. He is dressed in traditional Dominican vestments consisting of a white scapular and a black hooded cloak, which perhaps reflect a special devotion to that order on the part of the young boy's family. His floral crown and trim are reminiscent of crowned-nun portraits and symbolize the conquest of death through spiritual rebirth. The tradition of death portraiture became accessible to a broader population and continued into the early twentieth century with the advent of photography.

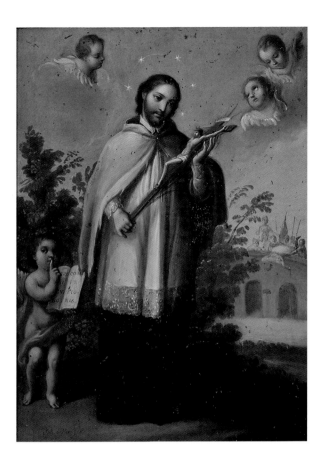

José de Páez was born and trained in Mexico City. He became one of New Spain's most important and admired painters of the eighteenth century. He painted large canvases as well as small intimate works, usually on copper. De Páez is known as a magnificent colorist and for his ability to infuse the drama of Mexican High Baroque painting with a new tenderness.

This work depicts Saint John of Nepomuk, who, during the late fourteenth century, served as confessor to the wife of Bohemian King Wenceslaus IV. The saint, holding a crucifix, stands in a tranquil outdoor setting, while his violent martyrdom is depicted in the background. According to legend, the king suspected his wife of infidelity and demanded that Saint John reveal the nature of her confession. He refused and was tortured and killed, and his body was thrown from a bridge in Prague. The cherub at bottom left, who raises a finger to his lips and holds a book inscribed *pro sigillo confetionis* ("in accordance with the seal of confession"), symbolizes the saint's steadfastness in maintaining the secrecy of confessions. This martyred saint is the patron of lawyers, confessors, and bridges, and he is also invoked for secret keeping. Saint John of Nepomuk was especially revered among members of the Society of Jesus, or Jesuits, who spread devotion to him throughout the Americas.

JOSÉ DE PÁEZ
Mexican, 1727–1790
San Juan Nepomuceno
(*Saint John of Nepomuk*),
18th century
Oil on copper
h. 11¾ in. (29.8 cm);
w. 8½ in. (21.6 cm)
Gift of Del Baker, Jr., 81.191.35

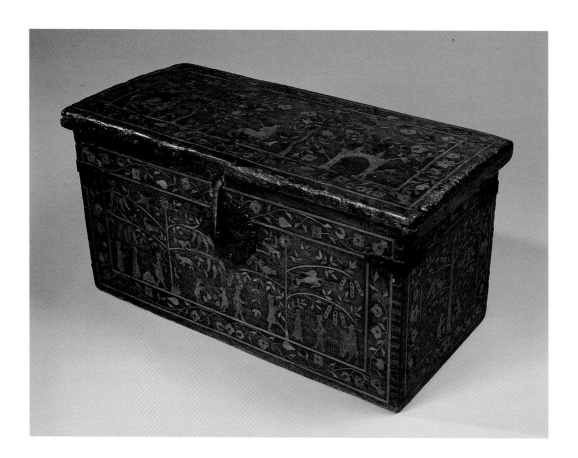

TRUNK
Peru, 18th century
Wood with iron
h. 18¼ in. (46.4 cm);
w. 37 in. (94.0 cm); d. 18½ in.
(47.0 cm)
Purchased with the Latin
American Art Acquisition Fund,
2002.3

Starting as early as the seventeenth century, carpenters throughout many parts of Latin America began making wooden furniture richly inlaid with contrasting colored woods, a technique broadly known as marquetry. Although wood inlay techniques were used by pre-Columbian artists, the style and technique of most colonial pieces were heavily influenced by European and Asian artisans. Special centers were established in Oaxaca (Villa Alta), Guadalajara, Ecuador, Alto Peru (Bolivia and Peru), and other parts of Latin America. Many of these workshops were initiatives of the Catholic Church, which patronized both fine and decorative arts in Latin America.

This lavishly decorated trunk, or *baúl*, is an excellent example of Andean folk marquetry. The sides and lid of the trunk are richly decorated. The front is adorned with men and women dancing and playing musical instruments and leafy fruit trees populated by animals and birds, all framed by garlands of flowers. The top is inlaid with images of classical Greek and Roman subjects: Hercules wrestling a lion, a centaur, and an arch festooned with banners. Both ends of the trunk are intricately decorated as well, with depictions of trees heavily laden with fruit. The iron fittings were added after the inlay was completed.

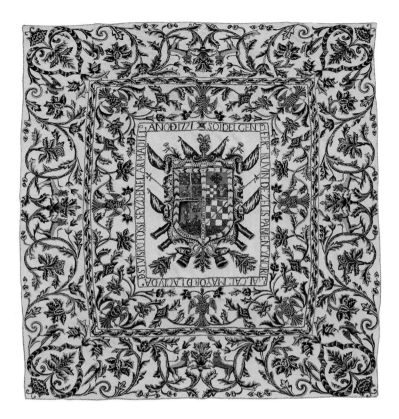

Embroidery, or textile decoration created with a threaded needle, was unknown in Mexico before the arrival of Europeans. In 1534 master embroiderer Sancho García de Larraval, the nephew of Archbishop Juan de Zumárraga, arrived in Mexico to teach this art to the Indians. By 1546 a special guild was founded to set rules and control the quality of embroidery. The San Antonio armorial hanging is unique: few Spanish colonial textiles from Mexico survive in such perfect condition.

This richly embroidered armorial hanging was made in the small town of Armadillo, Mexico, about 28 miles from the wealthy mining town of San Luis Potosí. It was commissioned by General Don Fernando Rubin de Celis, Spanish colonial *alcalde* (mayor) of San Luis Potosí during the second half of the eighteenth century. Rubin de Celis held a noble title in Asturias, Spain, and many of the great families of that region still display their coats of arms on special occasions. His coat of arms adorns the center of the textile, framed by an embroidered inscription: *Soi del General Don Fernando Ruvin de Zelis Pariente y Noriega Alcalde Mayor de la Ciudad de San Luis Potossi se yeso en el Armadillo Ano de 1771* ("I belong to General Don Fernando Rubin de Celis Pariente y Noriega, Mayor of the Town of San Luis Potosí. Made in Armadillo, in the Year 1771"). The border consists of two ornate flowering vine scrolls, the inner one inhabited by two-headed eagles, and the outer one by pairs of opposed lions and birds.

ARMORIAL HANGING
Mexico, Armadillo, circa 1771
Cotton and wool embroidery
on linen ground, natural dyes
h. 93⅛ in. (235.5 cm);
w. 90½ in. (229.9 cm)
Purchased with funds provided
by the Lillie and Roy Cullen
Endowment, 2011.14

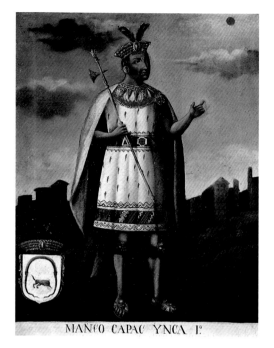

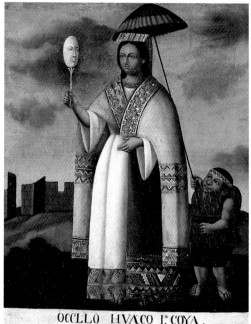

MANCO CAPAC YNCA Iº

OCCLLO HVACO Iª COYA.

MANCO CAPAC
and MAMA OCLLO
Peru, circa 1840
Oil on canvas
each: h. 22¾ in. (57.8 cm);
w. 19 in. (48.3 cm)
Purchased with funds provided
by Betty and Bob Kelso,
2003.10.1-2

Sets of portraits of Inca rulers first appeared in Peru during the early seventeenth century, decades after the end of the Inca dynasty. Later in the Viceregal Period (1520s–1820s), Spanish authorities ordered many such sets destroyed because they were seen as threats to Spanish rule, especially during periods of indigenous revolt. Occasionally, however, authorities used these portraits to their advantage by adding Spanish viceroys to the sets of Inca rulers as an attempt to legitimize their own rule. Inca portraits enjoyed a revival following Peru's independence from Spain in 1824, when sets were vigorously collected by Peruvians as well as European travelers.

These two full-length portraits represent the first Inca (Manco Capac) and his spouse (Mama Ocllo). He is shown as a personification of the sun and she of the moon. They are part of a set of sixteen portraits in the Museum's collection that represent two hundred years of Inca rule. The set is arranged in chronological order, and only the first Inca is given a full-length portrait and is accompanied by his spouse. Inca portraits, of course, are not physical likenesses, but rather represent generic political types, loosely based on pre-Columbian and colonial ideals. Inca descent was based strictly on bloodlines, and, in the majority of the half-figure portraits of later Inca rulers, the arms are bare, revealing prominent veins. Each portrait displays accoutrements of Andean power. Textiles, diadems, scepters, and other markers identify the subjects as special and distinct from the ordinary citizenry.

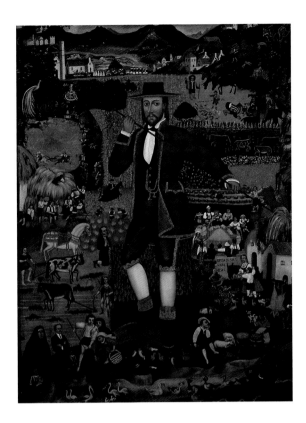

Saint Isidore the Farmer is the patron saint of Madrid and of farmers throughout the Spanish-speaking world. Born in Madrid at the end of the eleventh century, Saint Isidore was an exemplary Christian who gave freely of his time to the Church. Because of his devotion and the attribution of miracles to him, he was widely respected throughout the Roman Catholic world. With the spread of Christianity to the Americas, he became important to thousands of agrarian communities, and many adopted him as their patron.

This mid-nineteenth-century depiction of Saint Isidore is by Joaquin Castañon, a provincial painter from the rich agricultural region of Cochabamba, Bolivia, and it is among Castañon's largest and most complex works. The saint, who dominates the center of the painting, miraculously finds water during a drought by thrusting his staff into a hillside. Two of the surrounding vignettes depict other miracles attributed to Saint Isidore: at left, archangels sent by God assist him with his plowing, and at right, the saint feeds birds during a blight. These miracles are shown against typical elements of the Bolivian landscape, from soaring Andean mountains to tropical lowlands, from highland llama and alpaca to jungle monkeys and toucans. The densely painted images represent local ethnic groups, indigenous and *mestizo* costumes, and traditional amusements and religious rituals.

JOAQUIN CASTAÑON
Bolivian, active mid-19th century
San Isidro Labrador (*Saint Isidore the Farmer*), 1866
Oil on canvas
h. 72 in. (182.9 cm);
w. 56¼ in. (142.9 cm)
Purchased with funds provided by the Lillie and Roy Cullen Endowment, 94.49

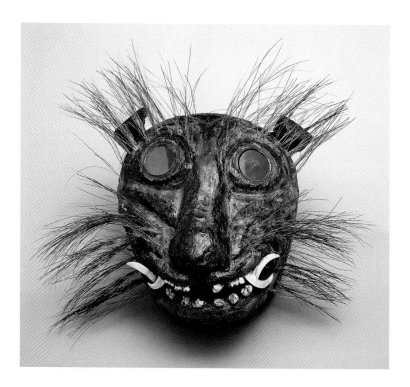

JAGUAR MASK
Mexico, Guerrero, late 19th century
Glass, painted wood, animal teeth, boar bristle
h. 13 in. (33.0 cm); w. 12 in. (30.5 cm); d. 7½ in. (19.1 cm)
The Nelson A. Rockefeller Mexican Folk Art Collection, 85.98.642

Dance masks representing human, animal, or spiritual entities have been worn in Mexico for over three thousand years. Today their use continues throughout rural Mexico, where they are worn in dances celebrating saints' feasts, reenactments of important historical events, and centuries-old rituals asking for rain.

The jaguar, often referred to as *tigre*, or tiger, was the most feared animal in the pre-Columbian world. It was associated with the night, the underworld, and fertility. Among the Aztecs, the jaguar was believed to control lightning and rain. Sixteenth-century dances still used jaguar masks in special rituals, especially those to petition for rain, but the dances were quickly outlawed by Spanish authorities, who associated them with acts against the Catholic faith. Eventually jaguar masks crept back into ritual use, often in association with Christian celebrations. As in the past, the jaguar continues to be among the most popular animal masks in Mexico.

This rare nineteenth-century jaguar mask from Guerrero, Mexico, was worn by dancers petitioning for rain. The folk artist has successfully created a ferocious-looking creature, complete with fangs and bristling whiskers. The mirrored eyes reflect the light as well as the faces of the audience and are believed to protect the dancer from witchcraft.

SEATED MONKEY
Mexico, Guanajuato,
circa 1900
Earthenware
h. 40 in. (101.6 cm); w. 18 in.
(45.7 cm); d. 15 in. (38.1 cm)
The Robert K. Winn Collection,
85.1.673

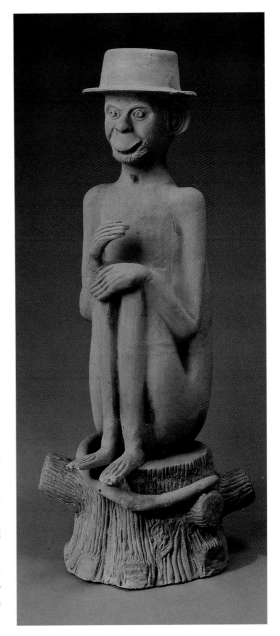

Humans have always been fascinated by the monkey, an animal whose antics frequently seem to parody our own. In ancient Mexico, the monkey served as an intermediary between the human and supernatural realms. In a Maya creation myth from the sacred book, the *Popol Vuh*, one of the main protagonists is a monkey. Monkeys were also perceived as the originators of the visual and performing arts. Recent archaeological excavations at the Great Temple in Mexico City have revealed votive objects dedicated to the wind god Ehecatl in the form of stylized howler monkeys.

In present-day Mexico, monkeys are frequently seen as tricksters. Intoxicating *mescal* is often sold in earthenware monkey bottles, perhaps to warn consumers of possible embarrassing misbehavior. Politicians are satirized as monkeys, whose charming ways are attractive and repulsive at the same time. This rare present-day earthenware sculpture depicts a seated monkey flashing a wry smile and wearing a jaunty top hat. He confidently sits atop a fake wood (*faux bois*) stool, typical of those popular in public parks in Mexico City and other major cities worldwide during the nineteenth and twentieth centuries.

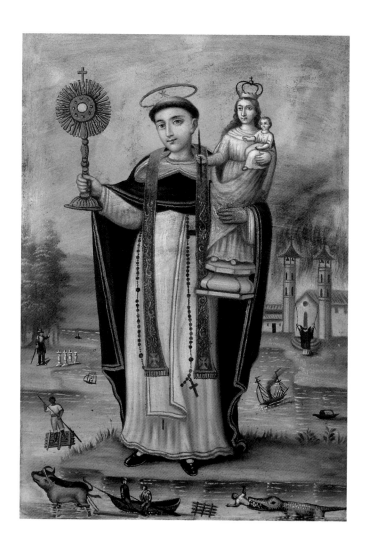

SAN JACINTO YAGUACHI
Ecuador, 19th century
Oil on tin
h. 21 in. (53.3 cm); w. 15 in.
(38.1 cm)
Gift of Peter P. Cecere, 99.21.1

Saint Hyacinth of Poland was a twelfth-century Dominican monk, whose popularity is still widespread throughout Poland and the surrounding countries. This painting depicts one of the miracles associated with his life: the saint's rescue of the Holy Sacrament and an image of the Virgin Mary from a church fire during the Tatar invasion of Kiev, Russia, where he was serving as priest.

During the colonial era in Ecuador, an image of Saint Hyacinth (in Spanish, San Jacinto) is said to have miraculously appeared in a tree. Henceforth, his cult became widely popular throughout the region, especially in and around the community of Yaguachi, not far from the port city of Guayaquil. His feast day there is August 16, a celebration that attracts as many as half-a-million pilgrims to his shrine. This painting places the saint in a coastal Ecuadorean environment—a verdant tropical setting with crocodiles devouring local bathers, Afro-Ecuadorans poling along in traditional rafts, and other scenes of life in the region.

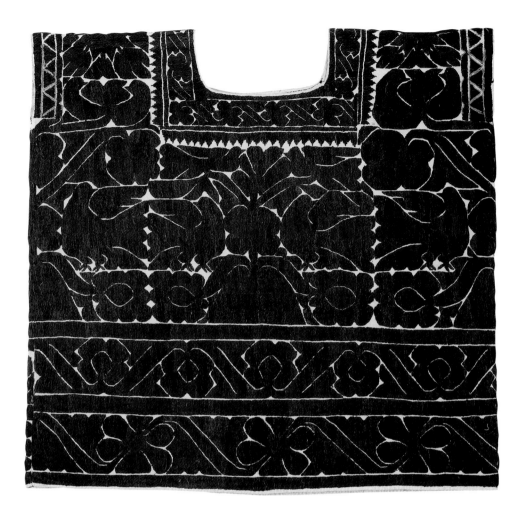

The *huipil* is a loose, sleeveless tunic worn since pre-Columbian times by indigenous women of Mexico. Among the ancient Maya, Aztec, Zapotec, and other groups, these garments were gender markers as well as signifiers of community affiliation. The Aztec lords of Tenochtitlán demanded that huipiles be paid as tribute on a regular basis. In some households, they were passed down from mother to daughter, while in others they were set aside to be worn by the weaver for her burial. Because of their ephemeral nature, few antique huipiles have survived into the present.

This rare early twentieth-century Mazatec huipil was woven from hand-spun cotton thread on an indigenous backstrap loom. The entire surface of both sides is embroidered with indigo-dyed cotton thread using alternating bird and flower motifs. The rectangular collar is likewise embroidered. The fine quality of the embroidery and the superbly balanced design indicate that this huipil was fashioned by a woman who was a master of her craft.

HUIPIL
Mazatec Culture, Mexico, Oaxaca, San Felipe Jalapa de Díaz, circa 1910
Cotton and natural dye
h. 28¾ in. (73.0 cm);
w. 30¼ in. (76.9 cm)
Gift of Mrs. J. Orr Campbell, 29.4009

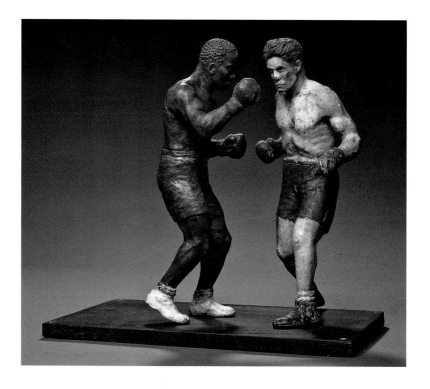

BOXERS
Ecuador, mid-20th century
Painted wood
h. 13¾ in. (34.9 cm);
w. 4½ in. (11.4 cm); d. 5 in.
(12.7 cm)
Gift of Peter P. Cecere,
2006.1.289.a-b

There is a long tradition of sculpted wooden figures in Ecuador. Beautifully rendered sculptures representing the Virgin Mary, Nativity scenes, images of saints, and other figures became an important part of convent, church, and household collections from the seventeenth century onward. As late as the middle of the twentieth century, folk artists from regions around Quito, Cuenca, and other Ecuadorean cities continued to carve well-made images using traditional techniques and proportions.

This handsome pair of boxers shows the continuity of Ecuador's rich sculptural tradition. The carver, whose identity is unknown, was well versed in the popular sport of boxing. The artist has successfully captured the highly developed musculature required by the sport, as well as the tenseness of the boxers as they prepare to deliver and receive blows. Ecuador is a racially mixed society, and this scene may record a locally famous match between black and white contestants. It also may represent a match of international fame, such as Joe Louis versus Max Schmeling, Floyd Patterson versus Ingemar Johansson, or other celebrated fights.

This ensemble of kinetic figures represents *concheros*, so-named because of the stringed instruments, or *conchas*, they play. Concheros come together as a confraternity to honor the Virgin of Guadalupe or other important religious figures. Their music and dance are acts of devotion to give thanks for blessings bestowed on a community by the Virgin or in anticipation of future gifts. Seldom do these groups perform for money, and most consider their performances sacred. The bodies of many conchas are still fashioned from armadillo shells and are believed to protect the musicians from malevolent spirits and curses. Concheros can still be seen today during saint's-day festivals in central and northern Mexico. Conchero groups from Los Angeles, San Antonio, and other cities in the United States continue to make annual pilgrimages to Mexico City on December 12 to celebrate the Feast of the Virgin of Guadalupe. This colorful group of figures was cleverly fashioned from hand-painted ceramic heads, small pieces of recycled paper, bottle caps, chicken feathers, and other readily available materials.

CONCHERO DANCERS
Mexico, Aguascalientes, circa 1960
Painted earthenware, feathers, cardboard, paper, and bottle caps
average h. 18 in. (45.7 cm); w. 4 in. (10.2 cm); d. 3 in. (7.6 cm)
The Nelson A. Rockefeller Mexican Folk Art Collection, 85.98.1348

DIEGO RIVERA
Mexican, 1886–1957
El Séptimo de Noviembre, Moscú
(*The Seventh of November,
Moscow*), 1928
Oil on canvas
h. 26¾ in. (67.9 cm);
w. 31¼ in. (79.4 cm)
Gift of Laurance S. Rockefeller,
99.9.4

Mexican painter Diego Rivera was one of the most important artists of the twentieth century. Born in Guanajuato and schooled at Mexico City's prestigious Academia de San Carlos, he quickly caught the attention of his instructors, who encouraged him to visit Europe. Between 1908 and 1921 he resided in Spain and Paris, where he immersed himself in the French avant-garde, paying close attention to the Cubism of Picasso and Braque and other advances of the French modernists, especially Cézanne. In 1921, he returned to Mexico to create murals and paintings extolling the merits of the Mexican Revolution and the art of the new order. Rivera became a leader in Mexico's Social Realism movement.

In 1927, Rivera was invited to the Soviet Union to meet with Soviet artists, to lecture, and to participate in political gatherings. He stayed in Moscow for more than nine months. During that time, he signed a contract to paint murals for the Soviet Army Club, a project that was never completed. Rivera's famous *May Day, Moscow Sketchbooks* (1928) were associated with the mural project and are now in the collection of the Museum of Modern Art in New York. *The Seventh of November, Moscow* is from the same period. It records a celebration marking the tenth anniversary of the Bolshevik Revolution in St. Petersburg. Here, Rivera captures the mood of that occasion by showing a sea of red banners and faceless soldiers against a somber background of gray buildings and wintry weather.

Joaquín Torres-García was one of the most influential artists of twentieth-century Latin America. Born in Montevideo, Uruguay, and raised in the Spanish province of Catalonia, he studied art in Barcelona. Some of his earliest work includes classical murals in Barcelona and stained glass windows for the Majorca Cathedral. He became an advocate and practitioner of Constructive Universalism, in which images are transformed into symbols and are contained by vertical and horizontal structures. In 1933, he issued a famous manifesto on Constructivism in Spain. Shortly afterward, he returned to Montevideo, where he taught, lectured, painted, sculpted, and founded his influential studio, Taller Torres-García.

Dos Figuras is characteristic of Torres-García's style. The composition is defined by horizontal and vertical grids filled with symbolic shapes. The two figures are defined by a few simple lines. Torres-García's geometric blocks of color are typical of a style in which perspective is flattened to emphasize essence over representation.

JOAQUÍN TORRES-GARCÍA
Uruguayan, 1874–1949
Dos Figuras (*Two Figures*), 1929
Oil on heavy paper on board
h. 49 in. (124.5 cm);
w. 41½ in. (105.4 cm)
Purchased with funds provided by the Lillie and Roy Cullen Endowment, 95.46

DAVID ALFARO SIQUEIROS
Mexican, 1896–1974
El Grito (*The Scream*), 1931
Encaustic on burlap
h. 42¼ in. (107.3 cm);
w. 34 in. (86.4 cm)
Purchased with funds provided
by the Robert J. Kleberg, Jr.,
and Helen C. Kleberg
Foundation, 96.51

David Alfaro Siqueiros was born in Chihuahua, Mexico, and fought in the Mexican Revolution of 1910–1920. In 1919, he was sent to Europe by the new Mexican government, where he discovered the modern art movement and the avant-garde artists associated with it. He returned to Mexico in 1922 and became heavily involved in the Mexican mural movement. Siqueiros was a founder of the Social Realism movement, which drew inspiration from pre-Columbian and Mexican folk motifs. Because of his strong leftist political views, Siqueiros spent many years in prison, where he painted the walls of his cells. His artistic influence was international. In the United States, some of those inspired by Siqueiros include Charles White (1918–1979) and Jackson Pollock (1912–1956). In addition to his important mural work, Siqueiros also painted portraits and landscapes and produced a broad range of works on paper.

The cry of *El Grito*, an expression of outrage and frustration over persistent world poverty and injustice, is almost audible in this painting. Similar expressions of rage are evident in the *Echo of a Scream* (1937) at the Museum of Modern Art, painted while Siqueiros was in Spain during the Civil War. Throughout his long career, Siqueiros constantly experimented with new techniques. For *El Grito*, he used encaustic, a method in which the pigments are combined with wax.

José Clemente Orozco was one of the greatest artists to emerge from Mexico's early twentieth-century social and political turmoil. As a member of the Social Realism movement, he was a supporter of the main principles of the Mexican Revolution and was well known for his public murals promoting messages of the new order. Orozco left a large body of work, including portraits, landscapes, socially poignant sketches, and powerfully rendered murals in Mexico and the United States.

Orozco's works offer social commentary on injustice, exploitation, corruption, betrayal, suffering, war, and other human afflictions, and this extraordinary painting is no exception. Painted at the height of World War II, during a period when wartime atrocities were most severe, *Martirio de San Esteban I* depicts the savage stoning of Saint Stephen, Christendom's first martyr, by a wild gang of animal-like men driven senseless by hate. Standing stoically on the left, in stark contrast to the others, is the erect, completely composed figure of Saul, who witnessed the stoning and, as a man of influence, had the power to stop the attack but did not. Witnessing this event played an important role in Saul's conversion to Christianity days later and his adoption of the new name Paul. With this painting, Orozco is perhaps commenting on the silence of the many citizens who stood by and quietly acquiesced in the deaths of millions during World War II.

JOSÉ CLEMENTE OROZCO
Mexican, 1883–1949
Martirio de San Esteban I
(Martyrdom of Saint Stephen I),
1943
Oil on canvas
h. 37½ in. (95.3 cm); w. 52 in.
(132.1 cm)
Purchased with the Mary
Katherine Lynch Kurtz Fund
for the Acquisition of Modern
Latin American Art, 2003.19

MIGUEL COVARRUBIAS
Mexican, 1904–1957
La Tehuana (*Woman from Tehuantepec*), 1944
Oil on canvas
h. 37 in. (94.0 cm); w. 31 in. (78.7 cm)
Purchased with funds provided by the Robert J. Kleberg, Jr., and Helen C. Kleberg Foundation, 96.37

Miguel Covarrubias made significant contributions to the fields of archaeology, dance, painting, caricature, literature, and ethnology, and his works continue to be valuable resources for cultural studies of Mexico and other regions. During the early 1930s, Covarrubias and his wife Rosa worked under the auspices of the Guggenheim Foundation in Bali, which resulted in the publication of *The Island of Bali* (1937). A second Guggenheim Fellowship allowed Covarrubias to travel to southern Oaxaca, Mexico, in the 1940s. Out of this exhaustive study came *Mexico South: The Isthmus of Tehuantepec* (1946), which is a sweeping description of the archaeology, history, and ethnography of that region, heavily illustrated with paintings, drawings, and photographs.

La Tehuana comes from Covarrubias's fieldwork in Mexico. It depicts a typical Zapotec woman from Juchitán de Zaragoza, Oaxaca, as she confidently strolls across the local plaza. Known for their unquestioned control of the local market and statuesque bearing, Zapotec women of the Tehuantepec area manage many important aspects of local society. At the bottom left of the painting is the lesser figure of a Huave-speaking woman carrying an iguana to market. The relative size of these two women indicates that the Huave were economically, politically, and socially subservient to the Zapotec.

Sergio Hernández was born in Oaxaca and studied art at the Escuela Nacional de Artes Plásticas and the Academia de San Carlos in Mexico City. He lived for two years in Paris and later traveled to other parts of Europe and the Middle East. Hernández was heavily influenced by the work of fellow Oaxacans Rufino Tamayo (1899–1991) and Francisco Toledo (born in 1940). Instead of concerning himself with religion and politics, Hernández strives to understand his own creativity better. Consequently, he is an important practitioner of Oaxacan Magical Realism.

The brilliant red of *Brujo de Malasia* is inspired by cochineal, a color derived from an insect that lives on the nopal cactus and for centuries was an important aspect of the Oaxacan economy. Overlaying this large red field, evocative of his native Mexico, Hernández has combined real and imagined images from life, both local and foreign, which are common devices of Oaxacan Magical Realism.

SERGIO HERNÁNDEZ
Mexican, born 1957
Brujo de Malasia (*The Sorcerer of the East Indies*), 2004
Oil and sand on linen
h. 71¼ in. (181.0 cm);
w. 118½ in. (301.0 cm)
Gift of the artist, 2004.18

AMERICAN ART

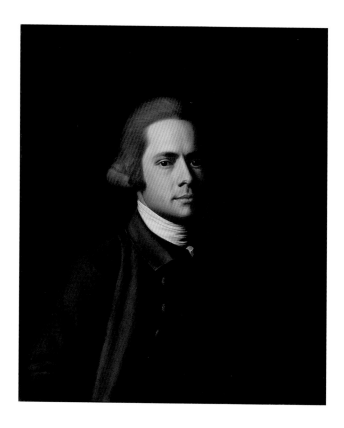

JOHN SINGLETON COPLEY
American, 1738–1815
Portrait of a Man in a Blue Coat,
1770
Oil on canvas
h. 30 in. (76.2 cm); w. 25⅛ in.
(63.8 cm)
Purchased with funds pro-
vided by the Ewing Halsell
Foundation in memory of
Clarence Halsell Holmes,
77.918

Born in Boston, John Singleton Copley was the most significant painter in colonial America. At age fifteen, Copley began to imitate the works of prominent artists, following the formats and imagery of portraiture popular with the elite families of New England. Copley's understanding of color and brushstrokes was transformed in 1755 by the arrival of the English painter Joseph Blackburn, who brought to Boston the elegant Rococo style fashionable in Europe. What distinguished Copley's subsequent work was his ability to meld the brighter palette and fluid texture of the European manner with the American preference for representation. Patrons favored Copley's likenesses, which conveyed both refinement and directness and often appeared to capture the inner essence of the sitter.

Around 1770, Copley's style became distinctly more restrained and at times showed the figure against a simplified, darkened background with few furnishings and other props. These works are some of Copley's most vivid portraits, due to the dramatic contrast of light and shade and the intense concentration on the sitter. In *Portrait of a Man in a Blue Coat*, Copley used a focused light source that sharply illuminates one side of the figure and nearly immerses the other side in gradations of shadow. By restricting his palette to white, gray, and a dark yet sumptuous blue, Copley accentuated the confident, piercing gaze of this colonial gentleman.

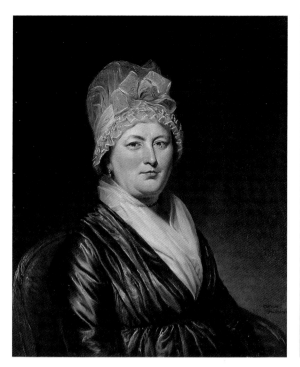 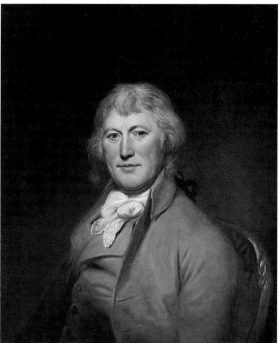

Charles Willson Peale was one of the most enterprising artists of the early Republican period. After his early training, Peale worked for three months in the Boston studio of John Singleton Copley, whose unparalleled status transformed Peale's artistic ambitions. Peale also studied with Benjamin West in London for two years, where he developed a more sophisticated portrait style. Peale's talents brought immediate success when he returned to Philadelphia, with commissions for portraits of statesmen, Revolutionary War heroes, and private patrons—portraits that possessed a distinctive straightforward realism and understated gentility.

In 1798 Peale painted companion portraits of Anna (1746–1832) and James de Peyster (born 1745), who had resided in the West Indies during the Revolution but had returned to New York. The artist sketched the de Peysters while staying in their home and ultimately produced both oil paintings and miniatures of their likenesses. Seen together, these portraits demonstrate Peale's stylistic versatility. For James's image, Peale employed the familiar composition of a spotlighted figure against a neutral background, but his fluid rendering of the sitter's head and cravat reveals his adoption of the expressive European manner increasingly favored by elite clients. By contrast, while no less technically accomplished, Anna's portrait presents a more "old-fashioned" aesthetic, with a subdued palette and simplicity of rendering that downplays the sitter's wealth and social status.

CHARLES WILLSON PEALE
American, 1741–1827
Portrait of Anna de Peyster and
Portrait of James W. de Peyster,
1798
Oil on canvas
each: h. 29¾ in. (75.6 cm);
w. 25 in. (63.5 cm)
Portrait of Anna de Peyster:
Gift of Dr. and Mrs. Frederic G.
Oppenheimer, 51.32.2
Portrait of James W. de Peyster:
Purchased with funds provided
by Dorothea Oppenheimer
and Family, 2008.20

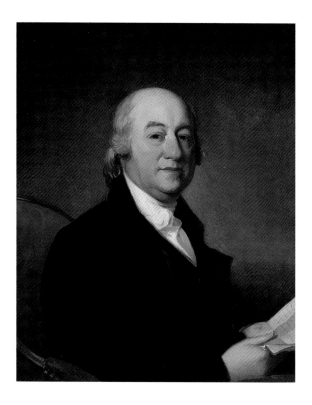

GILBERT STUART
American, 1755–1828
Portrait of Philip Wager,
circa 1802
Oil on panel
h. 29 in. (73.7 cm); w. 23½ in. (59.7 cm)
Gift of Dr. and Mrs. Frederic G. Oppenheimer, 51.32.1

One of many aspiring American painters to study with master artist Benjamin West in London, Gilbert Stuart used his training in the "Grand Manner" to become the foremost portraitist in the new United States. When Stuart returned to New York, he introduced clients to fashionable European styles and became known for his brilliant brushwork. No American painter could match his ability to combine naturalistic likeness with images of elegant gentility, which led to commissions from the nation's most prominent citizens, including President George Washington.

Having moved to Philadelphia, in 1802 Stuart completed portraits of Philip Wager (1749–1813), a prosperous wine merchant, and his wife Hannah. With a restrained yet gracious style, Stuart used a simple composition and palette of colors—dark browns, black, and white for Wager's costume, rich red for the chair back, and neutral gray-green for the background—to direct attention to the sitter's head and face, the elements of portraiture that were his specialty. Stuart's gift for shaping human features is evident, as the soft strokes of pinks and grays and the strong light source from the left together create an impression of the maturity and humanity of Mr. Wager. Just as accomplished is Stuart's ability to convey the varying textures of different kinds of cloth, including velvet, satin, and silk. The high level of skill displayed in most of the portrait suggests that Wager's right hand, which is painted in a more rudimentary style, may have been the work of a studio assistant.

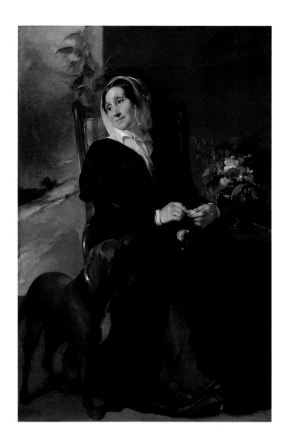

Thomas Sully was the son of English actors who emigrated to Charleston, South Carolina, in the 1790s. Initially trained as a miniature painter by his brother Lawrence, in 1807 Sully moved to Boston. With the support of Gilbert Stuart, Sully joined the London studio of Benjamin West, where he studied history painting in the classical tradition, though he was equally impressed with the emerging romantic portrait style of Sir Thomas Lawrence. Returning to America in 1810, Sully established a thriving portrait business in Philadelphia, and by the late 1820s, he was the most admired portraitist in the country.

Sarah Annis Sully was Lawrence Sully's widow. In 1806, Thomas married his sister-in-law and adopted her three children. In the course of their sixty-year marriage, the couple had nine more children. This sizable portrait combines Sarah's imposing seated form with a sense of tenderness and informality, as if we encounter her at ease in a private moment of reverie. Sully included emblems that represent aspects of his wife's identity and personality, emblems that would have been readily understood by American audiences. For instance, the lush flower arrangement refers to Sarah's status as a mother of twelve, just as the dog and the sprig of ivy both stand for fidelity. The sensitive treatment of his wife's features, along with his ability to convey the overall mood of tranquility and harmony that marks the portrait, demonstrates Sully's painterly skills.

THOMAS SULLY
American, 1783–1872
Portrait of Sarah Sully and Her Dog, Ponto, 1848
Oil on canvas
h. 61¾ in. (156.8 cm);
w. 41 in. (104.1 cm)
Gift of Dr. and Mrs. Frederic G. Oppenheimer, by exchange, 86.57.1

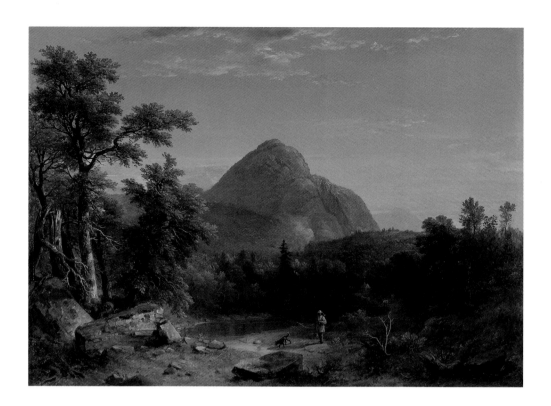

ASHER B. DURAND
American, 1796–1886
Landscape, Haystack Mountain, Vermont, 1852
Oil on canvas
h. 30¼ in. (76.8 cm);
w. 42¼ in. (107.3 cm)
Given in memory of
Mrs. Henry Drought, by
exchange, 86.57.2

After a prosperous career as an engraver, in the mid-1830s Asher B. Durand started painting landscapes and sketching the woods near his New Jersey studio. He was inspired by Thomas Cole, whose acclaimed works demonstrated that landscape paintings could embody grand themes as well as depict nature, and who encouraged Durand to travel in Europe to study the noble traditions of Flemish, Italian, and English art. While abroad, Durand realized his love for the distinctly American landscape and turned increasingly to painting directly from nature. By the mid-1840s his paintings relied less on European landscape conventions and more on the details of natural light and texture that he could directly observe. This shift in Durand's style may derive from the writings of English art critic John Ruskin, who advocated "truth to nature" in all art.

With the death of Thomas Cole in 1848, Durand became the premier artist of the Hudson River School. His paintings of wilderness and settled landscapes in upstate New York and New England were hailed for their atmospheric and spatial effects, which encouraged viewers to establish a transcendental "communion" with nature. Much of Durand's philosophy about painting the American landscape is evident in this painting. Praised for his "sense of sunlight" and ability to capture varied natural textures, Durand here provided a remarkable panoramic expanse from the highly detailed foreground to the strong conical shape of this particular Vermont mountain, majestically positioned in the center of the composition.

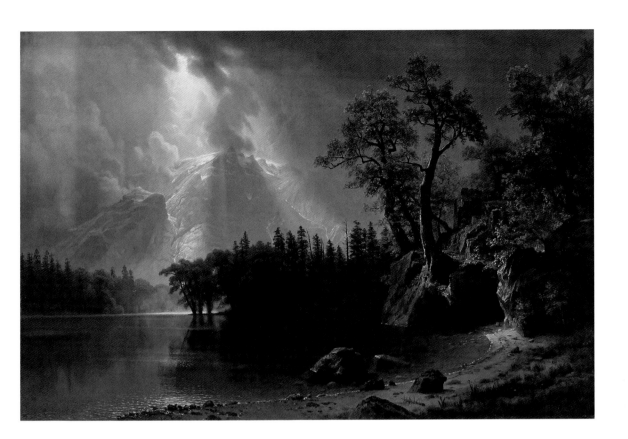

Born in Germany, Albert Bierstadt was raised in New Bedford, Massachusetts, and initially learned to paint landscapes by emulating engravings of works of the Hudson River School. He studied at the Düsseldorf Academy, where he became skilled at drawing from nature and absorbed the dramatic landscape style of his German teachers. Inspired by the possibility of bringing this heroic approach to distinctive American scenery, Bierstadt joined several expeditions to the West, where he accumulated sketches and photographs of the mountains, valleys, flora, and fauna that characterized territory largely unknown to East Coast audiences. Working in his New York studio, Bierstadt created large-scale views that were grounded in the specifics observed in his Western travels, but were essentially imaginative compositions that embody epic themes of romantic literature and nationalistic pride.

Bierstadt's monumental paintings became immensely popular during the Civil War when images of a seemingly pristine wilderness, untouched by war and industry, offered the promise of rebirth and prosperity. The Sierra Nevada mountains of California were a subject that Bierstadt returned to frequently; he was drawn to the powerful geometry of the jagged cliffs and glassy alpine lakes. In this painting, the looming thunderstorm creates an electric intensity, with rifts in the clouds highlighting both the distant snowy slopes and the calm shoreline where the viewer stands to witness the sublime power of nature.

ALBERT BIERSTADT
American, 1830–1902
Passing Storm over the Sierra Nevadas, 1870
Oil on canvas
h. 36½ in. (92.7 cm); w. 55 in. (139.7 cm)
Purchased with funds provided by the Robert J. Kleberg, Jr., and Helen C. Kleberg Foundation, 85.94

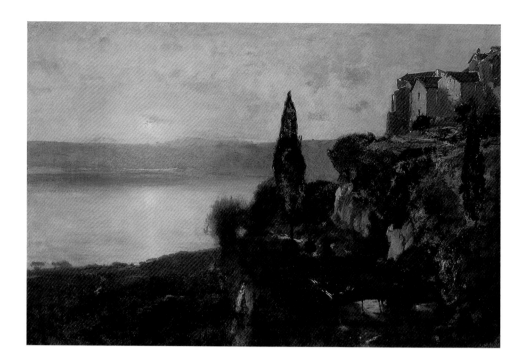

GEORGE INNESS
American, 1825–1894
View on Lake Nemi, 1871
Oil on canvas
h. 20 in. (50.8 cm); w. 30 in.
(76.2 cm)
Given in memory of William A.
Remy by his family, 96.3

George Inness was one of the most original and influential American painters of the nineteenth century. Raised in Newark, New Jersey, he had early artistic training in Brooklyn with French landscapist Regis François Gignoux. Although aware of the maturing American landscape movement, Inness was more interested in European landscape traditions and worked abroad during three significant periods of his career. First, in 1851 and 1852, Inness embraced Italian Renaissance and Baroque approaches in highly detailed and idealized scenes. In 1853 he traveled mostly in France and was directly influenced by the expressive Barbizon School techniques of treating landscapes as atmospheric and poetic environments through looser brushstrokes and more informal compositions.

In 1864 Inness discovered the naturalistic spiritualism of Swedish philosopher Emanuel Swedenborg, whose beliefs about the resonant relationship of religion and nature further shaped the sophisticated character of Inness's approach to painting. Finding an active market for his style of evocative landscapes, Inness spent five more years abroad, sending his works to dealers in Boston and New York. *View on Lake Nemi* was completed on this trip and, though it refers to a specific destination south of Rome, as seen at a particular time of day, this work is more broadly an expression of mood rather than a strictly descriptive landscape. Using elements of nature to express stillness and harmony in a sunset scene, Inness also demonstrated masterful skill in balancing the composition and capturing the poetic effects of radiant golden light on water, foliage, and masonry.

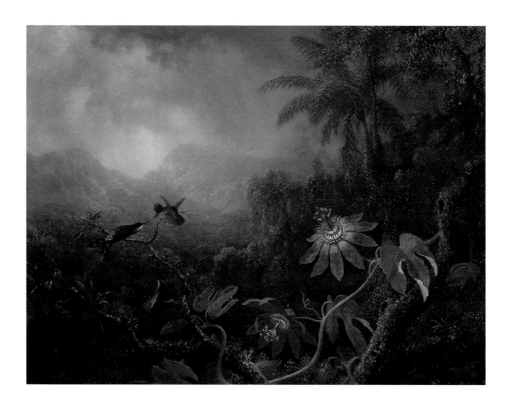

Martin Johnson Heade was a prolific painter known for his landscapes in the Luminist style, which emphasized the treatment of light. Born in rural Pennsylvania, he studied with the Quaker painter Edward Hicks and began to exhibit works in the 1840s. After two trips to Europe, he settled in New York City. In 1863, Heade took an extended trip to Brazil, where he prepared naturalist studies for a book on South American hummingbirds. He then transformed these scientific sketches into highly detailed paintings of birds and flowers that were exotic to American audiences. These works introduced Heade's signature style of combining still-life compositions in brilliant, jewel-like colors with luminous, almost mysterious landscape backgrounds. His paintings were admired both for their precise technique and for the extravagant display of pristine nature, which evoked an Eden-like wilderness free from the ravages of the industrial age. In most of these paintings, Heade used orchids to accompany the hummingbirds, but only ten of his works feature passion flowers. This painting is unique for the presence of three (rather than two) hummingbirds and for the dynamic interaction of two male birds of different species, seemingly in a contest for the female on a lower branch. In contrast to the almost breathless stillness shown in other works, *Passion Flowers* has a dramatic feel in all its elements, including its depiction of the life cycle of the flower and of the intense lushness of the jungle and mountain scenery in the distance.

MARTIN JOHNSON HEADE
American, 1819–1904
Passion Flowers with Three Hummingbirds, circa 1875
Oil on canvas
h. 17¼ in. (43.8 cm);
w. 22⅛ in. (56.2 cm)
Purchased with funds provided by the Robert J. Kleberg, Jr., and Helen C. Kleberg Foundation, 82.77

CHARLES ETHAN PORTER
American, 1847–1923
Still Life, circa 1880
Oil on canvas
h. 13 in. (33.0 cm); w. 20 in.
(50.8 cm)
Gift of Harmon and Harriet
Kelley in honor of Milbrew and
Shirley Davis, 96.48

Charles Ethan Porter grew up near Hartford, Connecticut, and took private art lessons while a teenager. In 1869, after two years of art classes in Massachusetts, Porter enrolled at the National Academy of Design in New York, where he studied portraiture and watercolors and became known as a talented colorist. He was also introduced to the history of Dutch still-life painting, and he observed the active market for still-life painting by American artists. Porter was one of the few African American artists to exhibit at the National Academy. He then decided to move back to Hartford. Already the chosen home of Mark Twain and Harriet Beecher Stowe, Hartford also aspired to become an art center. Consequently, Porter's professional training and the praise for his flower and fruit still-life paintings were highlighted in the local press.

Still Life dates from this first Hartford period, before Porter went to Paris in 1881 carrying a letter of introduction from Twain. In this work, Porter was inspired both by the Dutch still-life tradition and by the sparse arrangements of fruit and ceramic objects produced by Philadelphia artist James Peale. The deceptively simple composition of diverse shapes and surfaces—the sharp edges of the nutshells, the translucent spheres of the grapes, the rich tonalities of the apples, and the commanding ceramic vessel emerging from the deep shadow—vividly displays Porter's technical skills and also evokes a quiet intensity.

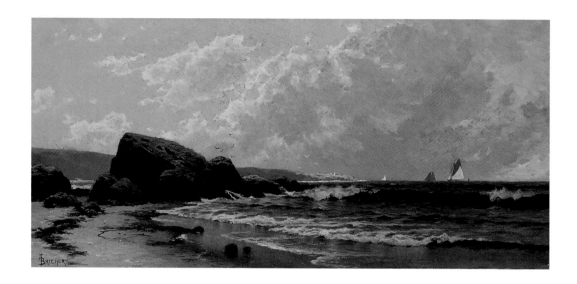

Known for seascapes of the New England and Canadian coastlines, Alfred T. Bricher had little formal training before opening art studios in Boston and Newburyport, Massachusetts, in 1859. His style was influenced by artists of the Hudson River School, such as John F. Kensett, and he probably knew about the distinctive Luminist landscapes of Martin Johnson Heade, who also lived in Newburyport. Bricher traveled extensively along the East Coast, sketching marine settings from New Jersey to Maine and Nova Scotia, and in the 1880s he built a summer home on Long Island. Bricher's primary interests in maritime scenery were the detailed effects of light and clouds in the open skies and the changing textures of the ocean in different weather conditions. One of Bricher's favorite subjects was the distinctive rocky shores of Grand Manan, an island off New Brunswick, Canada. Hetherington's Cove is a secluded inlet, which Bricher showed at low tide to highlight the contrast between the broad low horizon on the right and the rock outcropping on the left. The entire composition is tied together by a long curved line that picks up a distant lighthouse in a bright pocket of sunlight and continues to the waves rolling onto the calm stretch of beach in the left foreground. Bricher's attention to subtle details of nature is evident in the touches of brilliant blue and green where the water meets the rocks.

ALFRED T. BRICHER
American, 1837–1908
Low Tide, Hetherington's Cove, Grand Manan, circa 1881
Oil on canvas
h. 15 in. (38.1 cm); w. 32 in. (81.3 cm)
Purchased with funds provided by Elizabeth and George Coates, 74.115

JOHN SINGER SARGENT
American, 1856–1925
Portrait of Mrs. Elliott Fitch
Shepard (Margaret Louisa
Vanderbilt), 1888
Oil on canvas
h. 84½ in. (214.6 cm);
w. 48½ in. (123.2 cm)
Purchased with funds provided
by the Lillie and Roy Cullen
Endowment, 84.57

Although John Singer Sargent was educated in Europe and spent most of his career abroad, he nevertheless regarded himself as an American artist. Academically trained in Italy and France, he also traveled to absorb the traditions of Baroque painting in Spain and the Netherlands. Ultimately, Sargent established an international reputation as a versatile and prolific painter in oils and watercolors. Influenced by his teacher, Carolus-Duran, Sargent became most renowned as a portraitist of the social elite, working in Paris and London before executing over sixty paintings during two visits to the United States in the 1880s. Sitters from the most prominent families were attracted to the elegance and sophisticated techniques of Sargent's style, which showed his brilliance in capturing detail and textures, but which also created the impression of psychological intimacy with his subjects.

The monumental portrait of Margaret Louisa Vanderbilt Shepard required over forty sittings at her New York home. The daughter of William H. Vanderbilt, Mrs. Shepard was a mother of six who was active in charitable works, notably shelters for transient women and the YWCA. Using a format associated with the seventeenth-century Spanish painter Diego Velázquez, Sargent has the figure emerge from a dark background, which further accentuates the richness of color surfaces and the delicacy of Margaret's skin tones. Although he chose to depict her in a sumptuous crimson gown, with other trappings of her status in the furnishings, he also captured the essence of Margaret's unassuming personality in the sensitive rendering of her face and hands.

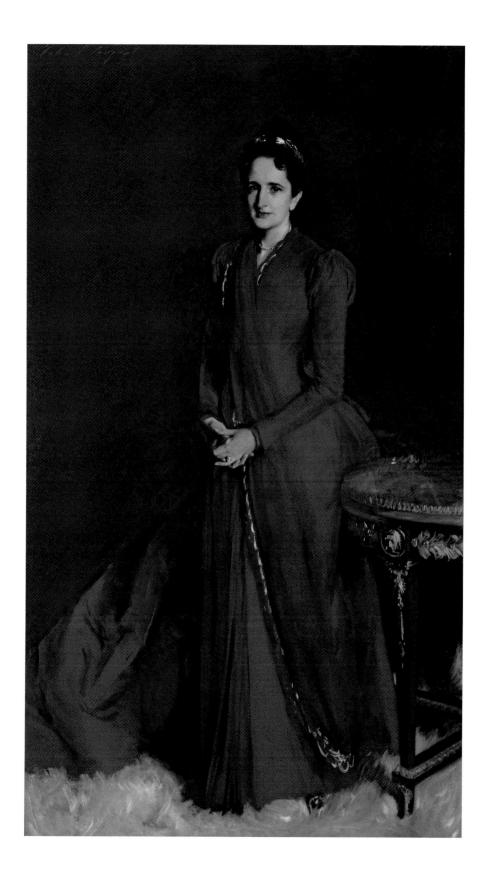

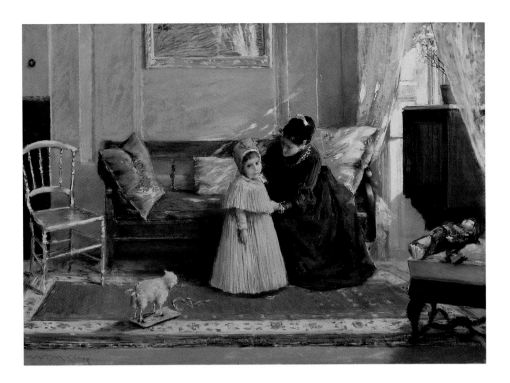

WILLIAM MERRITT CHASE
American, 1849–1916
Mrs. Chase and Child (I'm Going to See Grandma), circa 1889
Pastel on paper
h. 29 in. (73.7 cm); w. 41 in. (104.1 cm)
Gift of Mrs. Frederic G. Oppenheimer, 50.6

Raised in Indianapolis, William Merritt Chase received his initial artistic training in still-life painting. In 1869 he attended the National Academy of Design in New York, but after only a year moved to St. Louis to support his family. Aided by local art patrons, Chase traveled to Europe in 1872 and enrolled in the Munich Royal Academy. His teachers emphasized the rich colors and painting techniques of seventeenth-century masters Diego Velázquez and Frans Hals, but Chase also learned the detailed German Realist style. While in Europe, he also saw works by eighteenth-century French and Italian artists who specialized in the pastel medium.

Considered the most influential American instructor of his generation, Chase trained a wide range of notable artists. In 1878 he began teaching at the Art Students League in New York, before founding the Chase School of Art. At a time when modernist approaches were on the ascent in American art, Chase continued to emphasize technique, preaching the importance of brushwork and color relationships. In his own prolific career, Chase excelled in virtually all styles, ranging from subdued Realism to brilliant Impressionism.

Mrs. Chase and Child is characteristic of the artist's fondness for scenes of domestic life. Set in his own Manhattan residence, this pastel captures the intimacy of maternal affection between his wife and daughter. Using a fluid style that combines clarity of interior detail with luminous sunlight dappling the walls and fabrics, Chase created a vivid backdrop for the engaging little girl who is the centerpiece of the composition.

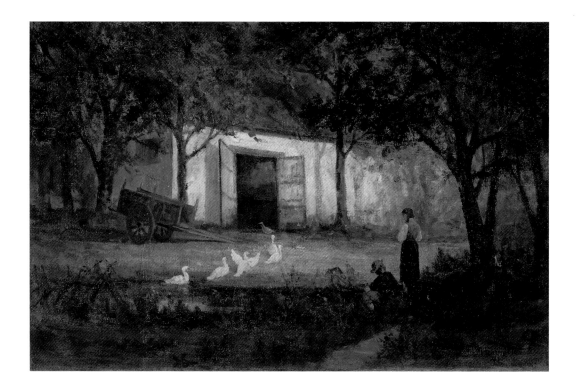

Edward Mitchell Bannister is notable as one of few African American artists to specialize in landscape painting. Born in New Brunswick, Canada, he initially worked as a sailor, but also developed an interest in art by visiting museums in major port cities. In 1848 Bannister moved to Boston, where he joined integrated social circles and began to paint portraits, historical scenes, and landscapes. By 1856 he was taking classes in photography and photoengraving at the Lowell Institute. In that same year, the expressive Barbizon School of landscape painting was introduced in Boston by artists following the style of French painter Jean-François Millet. After moving to Providence, Rhode Island, in 1871, Bannister began to paint the distinctive New England shorelines and serene rural landscapes. A member of the Providence Art Club, he gained national attention in 1876 by winning a medal at the Centennial Exposition in Philadelphia.

Emulating Millet's deeply spiritual approach to nature, Bannister chose in *After the Bath* to depict the simple barnyard with atmospheric tonalities and rich texture, which he created by roughening the surface of the painting. His sketchy style creates the impression of a spontaneous encounter at a particular time of day in which the figures and trees are reduced to silhouettes, and the overall warmth of color provides a sense of intimacy and quiet. Carefully balancing the earthy forms with pockets of sunlight and accents of red and white, Bannister offered his patrons a nostalgic glimpse of peaceful, rustic existence.

EDWARD MITCHELL
BANNISTER
American, 1828–1901
After the Bath, 1891
Oil on canvas
h. 36 in. (91.4 cm); w. 49 in.
(124.5 cm)
Gift of Harmon and Harriet
Kelley, 94.61

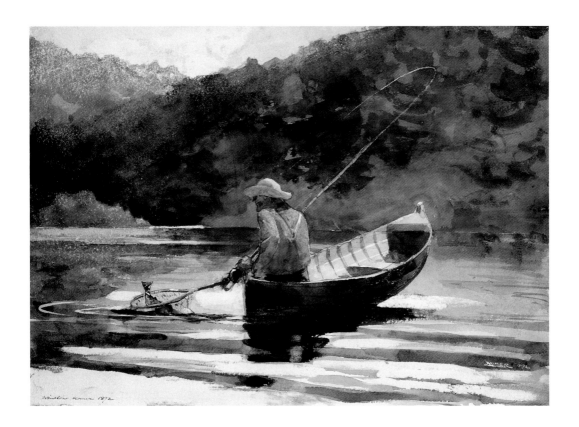

WINSLOW HOMER
American, 1836–1910
Boy Fishing, 1892
Watercolor on paper
h. 14⅝ in. (37.1 cm); w. 21 in.
(53.3 cm)
Purchased with funds provided
by the Robert J. Kleberg, Jr.,
and Helen C. Kleberg
Foundation and Friends of
the San Antonio Museum
Association, 86.130

Winslow Homer, one of the most original American artists of the nineteenth century, used his time abroad to improve his ability to express essential themes of the American experience. Visiting France in 1866, Homer was influenced by outdoor landscape painting, with the result that his scenes of American society gatherings and farmsteads featured a brighter palette of rich colors. Watercolor painting, which brought together his close observation of nature with his skill in drawing, emerged as one of Homer's hallmarks in the 1870s. While his oil paintings became more introspective, dramatic, and textured in the following decade, Homer continued to produce some of his most breathtaking works in watercolor.

An avid outdoorsman, Homer traveled frequently from his home on the coast of Maine to the Adirondack Mountains. *Boy Fishing* is from a series of watercolors done between 1889 and 1900 that demonstrate his unsurpassed skill with this medium and his compositional brilliance in encapsulating a quintessential moment of communion with nature. Characteristically, the lone figure is anonymous and isolated, but completely at ease in his surroundings, and demonstrates elegant expertise with his net. Homer captured the subtle drama of the moment in the rising diagonal of the canoe and the curve of the fishing line, which he actually scratched into the paper.

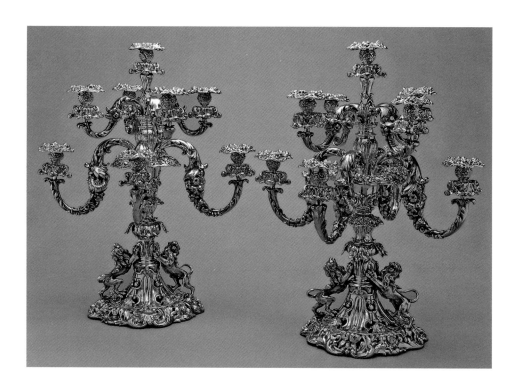

The "American Renaissance" extended from the 1876 Centennial Exposition to World War I. This period was characterized by an intensified American nationalism, as well as an explosion of creative developments in architecture, the visual arts, and craft movements. Fueled by the post-Civil War wealth of elite families and their cosmopolitan tastes, American art became both more distinctly American and more extravagant in adopting European stylistic revivals. The expensive furnishings of late nineteenth-century great houses reflect this taste.

The most successful purveyor of such finery was Charles Tiffany, the son of a Connecticut cotton manufacturer, who in 1837 established a company to sell porcelain, glassware, cutlery, clocks, and jewelry. By the 1850s, Tiffany & Co. had opened offices in London and Paris, as well as in its famed location on Fifth Avenue in New York City. In 1902, at the time of Charles's death, his son Louis Comfort Tiffany had assumed artistic leadership in the firm. Already known for his expertise in stained glass, Louis contributed his knowledge of the latest developments in design associated with the Art Nouveau and Arts & Crafts movements. But Tiffany's was also known for maintaining traditional patterns of taste for its clientele, and so this pair of candelabra with nine lights and heraldic lions hearkens back to the grand historical periods of silver design. The florid decorative surfaces—with every inch covered in plant forms and filigree—reveal the popularity of an aristocratic neo-Rococo style during the emergence of the modern era.

TIFFANY & CO.
American, est. 1837
Pair of Candelabra, circa 1902
Silver
each: h. 25½ in. (64.8 cm);
w. 21½ in. (54.6 cm);
d. 21½ in. (54.6 cm)
Gift of Helen Hogan Perkins and Henry Perkins in memory of Gretchen and Preston Northrup, 2002.27.a-b

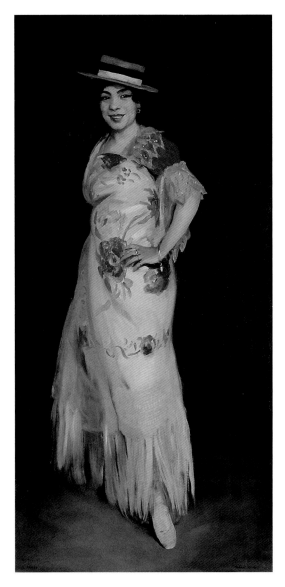

ROBERT HENRI
American, 1865–1929
El Tango, 1908
Oil on canvas
h. 77 in. (195.6 cm); w. 37 in.
(94.0 cm)
Purchased with funds provided
by Elizabeth and George
Coates, 74.16

Robert Henri first studied at the Pennsylvania Academy of Fine Arts in Philadelphia, and then at the Académie Julian in Paris, where he became interested in Impressionism. After he returned to Philadelphia in 1891, his studio became a gathering place for promising young artists, including several who would later exhibit together as The Eight, including John French Sloan, William Glackens, George Luks, and Everett Shinn. Henri turned away from the Impressionist style in the 1890s and became influenced by the works of seventeenth-century masters Diego Velázquez and Frans Hals, whose dramatic use of light had already shaped the distinctive portrait style of John Singer Sargent. Henri also admired the work of Edouard Manet, which combined Impressionist technique with what Henri called "truth and originality" in art.

Continually drawn to Spanish art, in 1906 Henri established a summer studio in Madrid, where he created a series of full-length figure paintings of gypsies, matadors, and musicians. *El Tango* shows the famous dancer Manoleta Mareques in a dynamic, twisting posture that captures the appeal of her personality. With the figure set against a dark brown background, Henri used the texture of the paint to further accentuate the vibrancy of his subject's brightly colored costume.

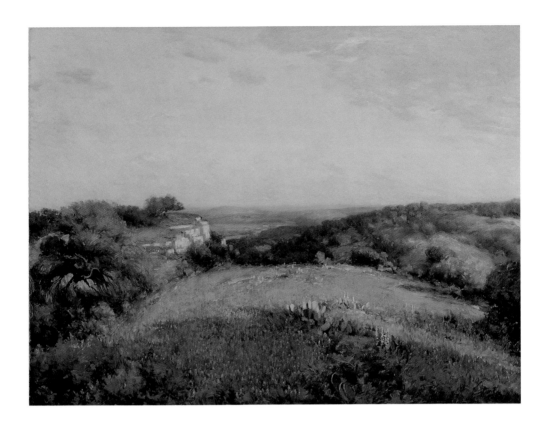

Robert Julian Onderdonk was born in San Antonio and followed in the footsteps of his father, Robert Jenkins Onderdonk (1852–1917), who was one of the state's first professional painters to gain a national reputation. Like his father, Julian trained in New York City, where he first studied academic and realist styles. In 1901, he was introduced to American Impressionism at the famous Shinnecock Art School of William Merritt Chase. The experience of working directly from nature to capture the light of a particular place altered Julian's approach to landscape painting, which he brought back to Texas in 1909.

Though aware of modernist artistic trends in New York and Europe, Onderdonk quickly established himself as a painter of the distinctive natural settings around San Antonio and the Hill Country. One of his most popular subjects was the explosion of wildflowers, especially the bluebonnet, which colored the hillsides and valleys in the springtime. In *Near San Antonio*, Onderdonk chose a panoramic view of hills rolling into the distance, with an atmospheric golden sky and pockets of light and shadow on the landforms. Onderdonk immersed the viewer in a field of purple blossoms, using small brushstrokes that are loose but still descriptive. What Onderdonk called the "riotous" profusion of seasonal color provides a brilliant contrast with the sage greens of the scrub brush and the chalky tones of the limestone cliffs at the horizon.

ROBERT JULIAN
ONDERDONK
American, 1882–1922
Near San Antonio, circa 1918
Oil on canvas
h. 30¾ in. (78.1 cm); w. 41 in.
(104.1 cm)
Gift of Mr. and Mrs. I. L.
Ellwood, 84.103

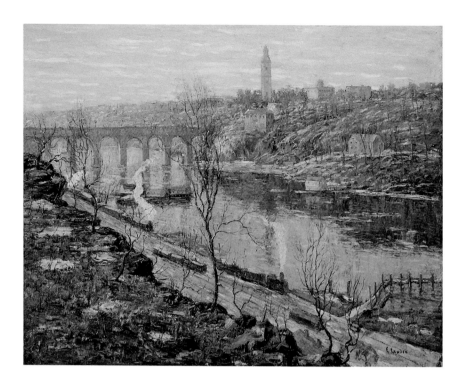

ERNEST LAWSON
American, 1873–1939
High Bridge, Harlem River, 1912
Oil on canvas
h. 40 in. (101.6 cm); w. 50 in.
(127.0 cm)
Purchased with funds provided
by Elizabeth and George
Coates, 73.129

Born in San Francisco, Ernest Lawson trained at the Art Students League
in New York, where he was pointed toward a richly colored and atmo-
spheric landscape style. In 1893 Lawson studied at the Académie Julian
in Paris, and he was also mentored by celebrated French Impressionist
Alfred Sisley. Ten years after returning to New York in 1898, Lawson
was exhibiting with a new wave of painters dubbed the Ashcan School.
Although he shared their realist goal of portraying urban scenes, Law-
son retained an essentially optimistic view of the city. His later style was
characterized by increasingly rough texture, with the painted surface
becoming nearly sculptural in places.

Like many Impressionist painters, Lawson painted a limited range of
subjects from various perspectives, in different seasons and at changing
times of day. He favored winter scenes, which offered opportunities for
intense observation of subtle tonalities and color ranges. But Lawson also
favored scenes highlighting the coexistence of nature and industry, which
conveyed a dialogue between the built and unbuilt environments. Lawson
frequently returned to High Bridge, at the north end of Manhattan, in his
work. In this version, he chose an elevated vantage point that allows for a
panoramic view to the urban horizon, which is interrupted by the echo-
ing shapes of a tower and a tree. Throughout the painting, Lawson uses
such complementary forms, giving the whole scene an underlying sense
of structure. Just as visually compelling is the energetic painted surface,
which one critic described as "a palette of crushed jewels."

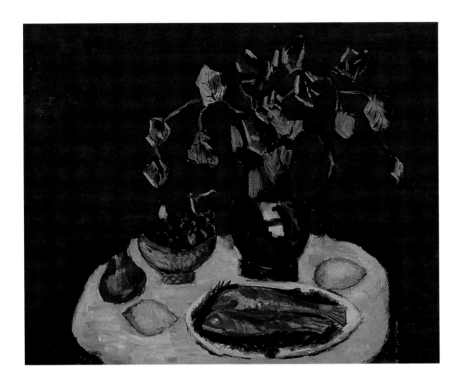

Edmund (Marsden) Hartley was a pivotal figure in American Modernist art. He joined avant-garde artistic circles in France and Germany in the early twentieth century but struggled to come to terms with American culture. *New England Still Life* represents a later phase in his career and reveals Hartley's return to the still-life genre.

Born in Lewiston, Maine, Hartley survived a tumultuous childhood and in 1892 won a scholarship to the Cleveland Institute of Art. In 1899, he began study at the National Academy of Design in New York. The bold shapes and colors in Hartley's early landscapes caught the attention of photographer and art patron Alfred Stieglitz, who arranged an exhibition at the Modernist art gallery 291 and prompted Hartley to go abroad. Powerfully influenced by Wassily Kandinsky and the Blaue Reiter circle in Munich, Hartley turned away from landscape toward still life as the most important vehicle for the "new art."

New England Still Life demonstrates Hartley's analytical and deeply emotional approach to the subject. Rejecting conventions of perspective, Hartley used the arrangement of fruit, fish, and plants on a tabletop to reveal a balance between abstraction and representation. Bold outlines define the edges of the forms, and the sculptural texture of the paint also draws the viewer's attention. The rich palette includes the reddish-brown background color, which also appears on individual objects, such as the fish and pear. These dark tones are enlivened by bright flashes of coral, yellow, and green to produce a complex visual experience.

MARSDEN HARTLEY
American, 1877–1943
New England Still Life,
1928–1929
Oil on canvas
h. 25 in. (63.5 cm); w. 31½ in. (80.0 cm)
Purchased with funds provided by the Painting and Sculpture Council, Mrs. Ferdinand P. Herff, and Endowment Funds, 76.14

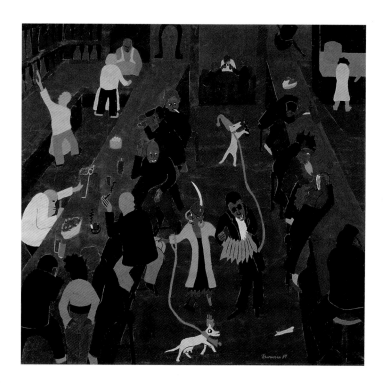

JACOB LAWRENCE
American, 1917–2000
Bar 'n Grill, 1937
Casein on paper
h. 22¾ in. (57.8 cm);
w. 23¾ in. (60.3 cm)
Purchased with funds pro-
vided by Mr. and Mrs. Hugh
Halff, by exchange; Dr. and
Mrs. Harmon Kelley; and
Dr. Leo Edwards, 95.58

Jacob Lawrence was one of the most important African American artists of the twentieth century. As a painter, teacher, and (along with his wife, artist Gwendolyn Knight) a philanthropic supporter of younger artists, Lawrence's distinguished career spanned from the Harlem Renaissance in the 1930s to notable public art commissions in the 1990s.

Lawrence was born in Atlantic City, New Jersey, before moving with his mother to New York in 1924. He began training at the Harlem Art Workshop at age fifteen and then received a scholarship to the American Artists School. Like many of his contemporaries, Lawrence worked for the Works Progress Administration (WPA) Federal Art Program, which led to a solo exhibition at the Harlem YMCA in 1938. In 1941, he was the first African American artist to be included in the permanent collection of the Museum of Modern Art. Inspired by diverse sources, including abstract modernism and African art, Lawrence's unique Expressionist style fused the imagery of black urban culture with bold patterns and simplified forms.

Bar 'n Grill is among Lawrence's earliest portrayals of everyday life in Harlem and demonstrates his use of flat shapes in strong colors combined with sinuous outlines that animate the figures. In this sharply tilted bird's-eye view of a busy tavern, Lawrence captures a cast of distinctive characters and expresses both the energy of the social scene and an underlying tone of sadness during the Depression era.

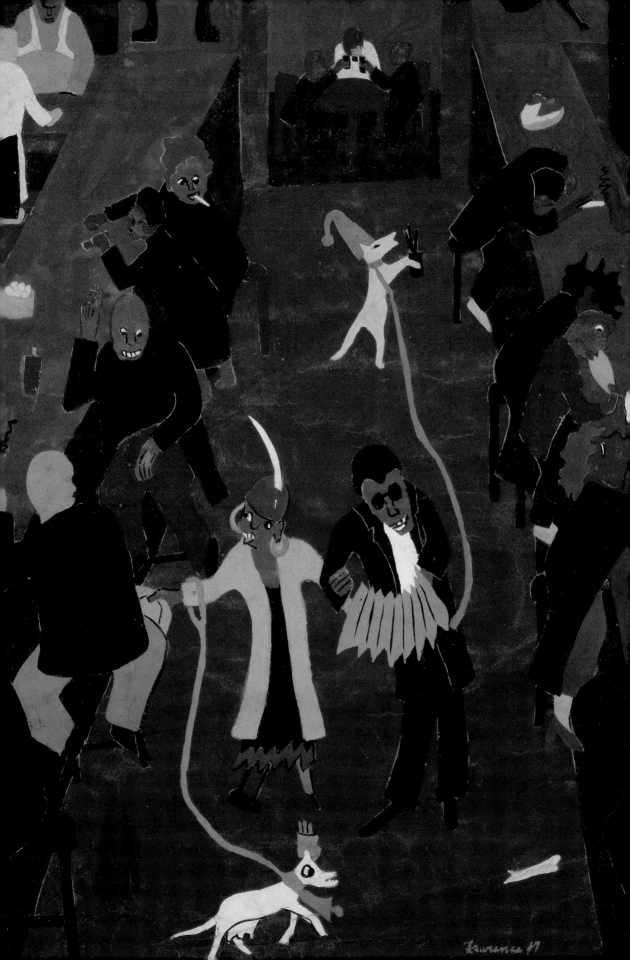

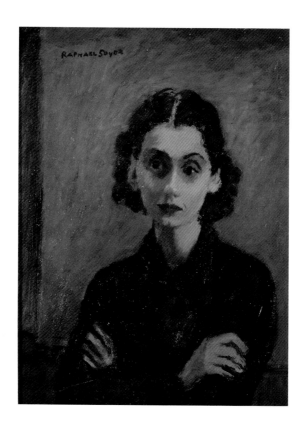

RAPHAEL SOYER
American, 1899–1987
Aline, circa 1950
Oil on canvas
h. 22⅝ in. (57.5 cm);
w. 18¾ in. (47.6 cm)
Bequest of Helen Miller Jones,
89.93.6

Raphael Soyer was a leading figure in the American Realist movement of the early twentieth century. Born in Borisoglebsk, Russia, Soyer emigrated with his family to New York City in 1912. He studied at the Cooper Union and then entered the National Academy of Design, where he was inspired by the figurative work of French Impressionist Edgar Degas. After World War II, Soyer concentrated on painting individual figures, which increasingly appeared as if they were psychological studies. By the early 1950s, his painting style became more loose and sketch-like, and this is probably when *Aline*, which is undated, was painted. Soyer's *Self-Portrait* of 1950 shows textured brushstrokes and sharp contrasts of light and dark within an otherwise painterly rendering of the face and body, elements of style and overall feeling also evident in *Aline*. In *Aline*, Soyer used broad strokes of yellows and browns to fashion the illuminated and sculptural face of the sitter, whose posture in relation to the viewer suggests a bond of friendship or intimacy with the artist. The simplicity of the studio setting, with the figure's dark costume and hair silhouetted against a lighter green backdrop, increases the impact and psychological depth of the portrait. Characteristic of much of Soyer's later work, what may at first seem like a somber statement emerges as a sensitive observation of human presence, painted when the American art world was increasingly captivated by various forms of abstract painting.

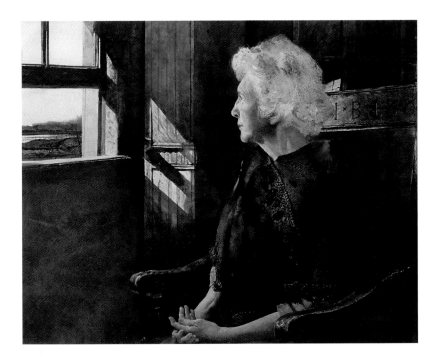

Andrew Wyeth was one of the best-known American artists of the twentieth century, achieving celebrity status along with mixed critical regard. Over the course of an exceptionally long career, Wyeth was renowned for meticulous and haunting paintings of the surroundings familiar to his family in eastern Pennsylvania and Maine.

The youngest child of eminent illustrator N. C. Wyeth, Andrew was frail as a youngster and was educated at home. Along with lessons in drawing, his father passed on his deep admiration for the nature writing of Henry David Thoreau and Robert Frost. Self-taught in art history, Andrew was especially drawn to early Renaissance masters and some prominent American artists, such as Winslow Homer, who conveyed an emotional connection with landscape. Adept at figure study and architectural rendering, Wyeth was particularly skilled at watercolor painting. He became known for the drybrush technique, in which wet pigment is squeezed from the brush.

Portrait of Henriette encapsulates many of the elements for which Wyeth became known, including the abiding connection to his clan: the sitter is his older sister, who was an accomplished artist in her own right. She is shown seated in an antique chair. Stylistically, this work demonstrates Wyeth's capacity for observing architectural detail and limiting the range of color to emphasize the impact of light penetrating the quiet of a darkened room. Equally mesmerizing is the stillness of Henriette's upright posture and aged hands as she gazes through the window at the placid winter landscape.

ANDREW WYETH
American, 1917–2009
Portrait of Henriette, 1967
Drybrush and tempera
on paper
h. 22½ in. (57.2 cm);
w. 28½ in. (72.4 cm)
Purchased with funds provided
by the Robert J. Kleberg, Jr.,
and Helen C. Kleberg
Foundation, 85.95

CONTEMPORARY ART

HANS HOFMANN
German, 1880–1966
Liberation, 1947
Oil on canvas
h. 60 in. (152.4 cm); w. 50 in. (127.0 cm)
Purchased with funds provided by Lenora and Walter F. Brown, 80.172

A renowned teacher and theorist as well as a celebrated artist, Hans Hofmann moved from Germany to America in 1930. Hofmann viewed the internal rhythms within the space of a painting the same way physicists understand the dynamics of movement in physical space. Using phrases like "push and pull" and "expansion and contraction," he advocated that for every movement of a line in one direction, the painter should make a mark of equal force in the opposite direction. Similarly, if a color seems to advance forward into the viewer's space, it should be countered with a color that appears to recede within the composition. Hofmann also believed that colors express emotions. He was, in fact, the first artist to be labeled an Abstract Expressionist. The term is today commonly used to refer to the generation of New York City-based artists who pioneered a new abstract style that dominated the art world from the late 1940s through the 1950s.

This painting is from a brief period of Hofmann's career when he used biomorphic abstraction, a style that was popularized by the Surrealists, a group of artists interested in the images found in dreams and the unconscious. Such images suggest primordial creatures that appear to be hybrids of animal, vegetable, or mineral forms but are not specifically identifiable. As was his custom, Hofmann titled the work after completing it. The term "liberation" was likely a response to the exuberant colors and sweeping curvilinear shapes, as well as a reference to the recent conclusion of World War II.

From the 1940s until her death in 1971, Irene Rice Pereira restricted her pictorial vocabulary to a geometric system of floating rectangles, squares, trapezoids, and parallelograms. Fascinated by the twentieth-century idea that there is a fourth dimension that goes beyond three-dimensional mass and volume to include space and time, Pereira developed a visual language to represent the space-time continuum. Her thinking included the idea, then novel, that theories about science and spirituality need not be at odds with one another. While her geometric grids bring a structure to her conception of space and time, the radiant light and color of her compositions, combined with appealing paint textures, lend a spiritual and emotional tone to her vision. Pereira became enthralled by the magical quality of rainbows as a child, but considered her interest in the mysteries of space to have been accelerated by an awe-inspiring visit to the Sahara Desert in 1931.

Pereira came of age as an artist at a time when women artists were generally given little acknowledgment, and thus she was rarely mentioned in histories of art written during her lifetime. As a result of the feminist movement of the 1970s, which led to greater recognition for women artists, Pereira's work has become more widely known.

IRENE RICE PEREIRA
American, 1902–1971
Pillar of Fire, 1955
Oil on canvas
h. 57⅜ in. (145.7 cm);
w. 37⅜ in. (94.9 cm)
Purchased with funds provided by Charles M. Knipe, by exchange, 95.3

FRANK STELLA
American, born 1936
Double Scramble, 1968
Fluorescent alkyd on canvas
h. 69 in. (175.3 cm);
w. 138 in. (350.5 cm)
Purchased with funds provided
by the National Endowment
for the Arts and The Brown
Foundation, 76.27

During the 1960s, Frank Stella was highly regarded for his advances toward making paintings that were purely about painting. As early as 1958, he was exploring symmetry and the repetition of identical shapes with the goal of eliminating illusionistic picture space. In 1966, Stella commented on the difficulties of avoiding the suggestion of illusion when painting hard edges. In *Double Scramble*, he addressed this concern by leaving lines of raw canvas between the concentric bands of color to soften their edges, thereby minimizing the potential for each color to yield optical interactions with neighboring colors. In spite of such precautions, it is impossible to deny that the painting is alive and pops with dazzling visual energy, attributable in part to the use of bold fluorescent colors.

From 1960 to 1965, Stella actively experimented with new and innovative paints, beginning with aluminum paint in 1960; then he worked his way through copper, alkyd, colored metallic, zinc chromate, metallic powder in polymer emulsion, and fluorescent alkyd. Although Stella may have wanted viewers to perceive *Double Scramble* as depicting a perfectly flat space, the intensity of the palette tends to encourage multiple readings of the concentric squares as alternatively concave or convex. This effect is also facilitated by the sequencing of colors, which move in diametrical opposition, with the outer band of one sequence corresponding to the inner square of the other.

When Mel Casas moved from El Paso to San Antonio in 1961, he found that the only accepted style of painting in the area was the Bluebonnet School. Paintings from this school are characterized by landscapes showing fields populated with the state flower and executed in the style of nineteenth-century Impressionism. Believing that the pretty lyricism of Impressionism was in direct contradiction to the rugged qualities of the Texas landscape, Casas critiqued the Bluebonnet School in this painting.

This painting is one of many from a large series that Casas called *Humanscapes*, a term he coined while thinking about the human motivation behind what he decided to paint. The series was inspired by the incongruity of the imagery on a large drive-in movie screen against the landscape, which Casas saw from his car window while driving. Here, the sharp division between twentieth- and nineteenth-century approaches to painting is represented by the stark contrast between the dominant part of the composition, a panoramic screen with a diagrammatic depiction of a bluebonnet flower, and the pastoral Bluebonnet landscape over which it boldly hovers.

MEL CASAS
American, born 1929
Humanscape #57, 1969
Acrylic on canvas
h. 73 in. (185.4 cm);
w. 76¾ in. (194.9 cm)
Purchased with the John and Karen McFarlin Fund, 90.76.2

RICHARD DIEBENKORN
American, 1922–1993
Ocean Park No. 53, 1972
Oil on canvas
h. 100 in. (254 cm); w. 76 in.
(193.2 cm)
Purchased with funds provided
by the National Endowment
for the Arts and The Brown
Foundation, 73.173

Early in his career, Richard Diebenkorn fluctuated between abstract and figurative painting. In the 1950s, he became recognized as one of the leading artists of the San Francisco Bay Area Figurative School, a group that included several painters who favored the thick and expressive brushwork that characterized the nationally prominent Abstract Expressionism of the day, but preferred the traditional, recognizable subjects of the figure, the landscape, and still life.

After a move to Southern California in the mid-1960s, Diebenkorn returned to an abstract pictorial language. From 1967 through the end of his life, he employed a predetermined structure made up of horizontal and vertical geometric sections. Within this structure, he explored endless possibilities for compositions that joyfully exploit the expressive potential of the interaction of lines, colors, and textures. In metaphoric or poetic terms, this aesthetic interplay evokes an ephemeral equivalent of the varying qualities of light and air that Diebenkorn enjoyed while working in his studio in the Ocean Park neighborhood of Santa Monica, California. Each painting in the artist's *Ocean Park* series was developed through a process of layering and constant revising. Lines would be drawn and painted over, and the process repeated until a satisfactory balance of all the pictorial elements was achieved.

In the tradition of the early twentieth-century Surrealists, James Surls often develops his imagery from his dreams. Characteristically, he transforms ordinary tree trunks into fanciful anthropomorphic creatures that take on lives of their own. In this sculpture, he has embedded glass eyes within a small pyramid, crowning a four-legged being with spindly winglike appendages extending from its upper body. While the eyes evoke the idea that the sculpture looks back at the viewer, their placement within the pyramid suggests that they might be manifestations of the mystical all-seeing eye, found on the back of an American one-dollar bill.

Surls created this sculpture from trees around Taos, New Mexico, where he spent his summers in the early 1970s. As the son of a carpenter, he learned to use axes, chain saws, and other tree-cutting tools during his childhood, while clearing the land on the family farm. Surls is also proficient in many other sculptural mediums, including bronze and steel, as well as in drawing and printmaking.

JAMES SURLS
American, born 1943
The Eyes Have It, 1974
Pine, maple, glass, twine
h. 54 in. (137.2 cm); w. 38 in.
(96.5 cm); d. 38 in. (96.5 cm)
Gift of Nancy B. Negley,
80.37.9

HELEN FRANKENTHALER
American, 1928–2011
Eden Revisited, 1967–1976
Acrylic on canvas
h. 130 in. (330.2 cm);
w. 39½ in. (100.3 cm)
Purchased with funds provided
by the National Endowment
for the Arts, The Brown
Foundation, and the Sarah
Campbell Blaffer Foundation,
77.33.9

Helen Frankenthaler is widely recognized for her unique method of applying color by saturating unprimed or raw canvas with paint. Her process, which she developed in the early 1950s, was to staple unstretched, unsized canvas to the floor and then soak or stain paint into it from all directions, using sponges and rags. Working intuitively, Frankenthaler added the paint rhythmically until a composition unfolded as a brightly colored space. The resulting transparent sheaths of color seem to resemble watercolor washes, but on a monumental scale. Frankenthaler determined the final composition after viewing the canvas from all four sides to select the most successful configuration. In this example, Frankenthaler added an additional finishing touch several years after she first completed the work. Believing that the space should resonate more, she tinted some areas that had previously been left unpainted. Although Frankenthaler's titles are somewhat arbitrary, the reference to the Garden of Eden seems appropriate, given this painting's lush and vibrant colors.

Because of the prevalence of patterning in her paintings of the 1970s, Cynthia Carlson was included in several exhibitions at the time devoted to a movement known as Pattern and Decoration. Traditionally, decorative patterning had been associated with pop culture or consumer items such as wallpaper, gift wrapping, or furniture. In the hands of Carlson and her peers, patterning became a viable subject for paintings, sculptures, and room-sized installations.

In this and other paintings from the period, Carlson experimented with a variety of formats and procedures for making lively patterns from thick chunks of paint. Here, the paint has been squeezed through a pastry tube to form modular patterns that resemble the sewn-together pieces of a quilt. The playful squiggles within each module were conceived as humorous caricatures of the bold brushstrokes of the Abstract Expressionist painters of the 1950s, who viewed their oversized painted gestures as heroic and decidedly masculine. Both Carlson's process and this painting's imagery evoke domestic life. *Short Job* was painted during the pivotal years of the women's movement, and its emphasis on the meaningfulness of activities traditionally performed by women makes it an important example of feminist art.

CYNTHIA CARLSON
American, born 1942
Short Job, 1976
Acrylic and oil on canvas
h. 60 in. (152.4 cm); w. 48 in. (121.9 cm)
Gift of the artist, 2007.4

PHILIP GUSTON
American, 1913–1980
Ocean, 1976
Oil on canvas
h. 78 in. (198.1 cm);
w. 116½ in. (295.9 cm)
Purchased with funds provided
by the National Endowment
for the Arts and The Brown
Foundation, 78.1280

Throughout his career, Philip Guston worked in a variety of styles. As a child, he drew cartoons. In the 1930s, he made Social Realist paintings and worked on murals for the Works Progress Administration. By the 1950s, he had become a painter of pure abstraction and earned national recognition as a member of the New York School, a group that is also known as the Abstract Expressionists. In the late 1960s and early 1970s, at a time when the nation faced political conflicts over Civil Rights, the war in Vietnam, and the Watergate scandal, Guston became dissatisfied that his abstract art seemed to lack relevance and returned to making representational images. His initial venture was a group of satirical paintings about the Ku Klux Klan, rendered in a semiabstract style that blended the sumptuous paint handling of his earlier lyrical abstractions with a cartoon-like manner of drawing. Considered shocking at the time because abstraction was still the dominant style, Guston's late works have since been widely acclaimed and have been enormously influential on the art of subsequent generations interested in accessible content.

Ocean is one of several paintings from the mid-1970s in which bodies of water become metaphors for the emotional "drowning" that the artist was experiencing in his personal life. A chain-smoker, Guston was hospitalized in 1976 for exhaustion and, a few years later, he suffered a near-fatal heart attack. He ultimately succumbed to a second heart attack in 1980.

When Wayne Thiebaud first rose to national prominence in the early 1960s, he was usually linked to the Pop Art movement because the subjects of his paintings consisted largely of common foods or consumer items. His distinctive style, however, had more to do with the pictorial problems of orchestrating shapes and colors than with communicating anything in particular about popular culture. Using thick paint to define the surface of a cake, for example, he mimicked the very act of icing it, moving the brush along a cake's contours the way a baker would guide a spatula.

Thiebaud turned his attention to landscape in the late 1960s. Upon purchasing a home and studio in San Francisco's Potrero Hill neighborhood in 1972, he became inspired by the area's quirky and dramatically curving slopes. Although he initially painted outdoors from direct observation, he soon found that he could give his imagination freer rein by composing from memory in the studio. In this example, he continues his practice of defining surfaces with thick paint that follows the logical contours of a subject. At the same time, he exaggerates the severity of features such as curving arcs, the highway's sharp edge, contrasts between sunlight and shadow, and disparities in scale between the landscape and the seemingly tiny cars and homes that inhabit it. All in all, these details add up to a playful look at the precariousness of the hilly, earthquake-prone San Francisco landscape.

WAYNE THIEBAUD
American, born 1920
Potrero Hill, 1976
Oil on canvas
h. 36 in. (91.4 cm); w. 44 in. (111.8 cm)
Purchased with funds provided by the National Endowment for the Arts, The Brown Foundation, and the Sarah Campbell Blaffer Foundation, 78.301

MARK DI SUVERO
American, born 1933
Timber Tongs, 1977
Welded steel
h. 63 in. (160.0 cm); w. 42 in.
(106.7 cm); d. 46 in.
(116.8 cm)
Purchased with funds provided
by The Brown Foundation and
the Sarah Campbell Blaffer
Foundation, 78.796

Following a practice he began in the late 1950s, Mark di Suvero constructed this sculpture by combining a scavenged object—in this case a set of tongs once used for moving logs—with a form of his own creation, the metal planar structure upon which the tongs delicately rest. Influenced by the twentieth-century psychologist Carl Gustav Jung, di Suvero believes that there are dualities that can be observed throughout nature, such as geometric versus organic form or stability versus movement. These dualities are referred to in this work through a gentle balancing of opposites. The base of the sculpture, which is a stable, solid geometric mass, has been set in equilibrium with the tongs, which are kinetic (they can tilt or rotate), curvilinear, and wrapped around open space.

After earning a degree in philosophy, di Suvero was working in construction when he was injured in an elevator accident. During rehabilitation, he began honing his steel-working skills. Since the 1960s, di Suvero has been widely recognized for indoor and outdoor kinetic steel sculptures, many of which are monumental in scale.

In the late 1960s, Sam Gilliam became the first African American to earn national acclaim as an innovator in the development of abstract painting. At that time, Gilliam was staining his canvases with acrylic paint, a favored technique among fellow artists in Washington, D.C. He first experimented with folding and rolling the canvases to create vertical stripe configurations and hanging them on stretchers with beveled edges, so that they jutted outward from the wall. He then conceived the idea of suspending the canvases like draperies, completely free of any frames. His paintings thus became hybrids of painting and sculpture, with factors such as location or the pull of gravity determining a work's actual shape.

By the 1970s, Gilliam had moved on to other new ideas. Seeking to bring the thick surfaces of Expressionist painting into his work, he used a crusty paint made by combining acrylic paint with Rhoplex, a dense acrylic-based resin. One series of paintings was made through a process of deconstruction and reconstruction. After building up a thick surface on a large canvas and raking through it to create textured ridges, Gilliam cut the work into smaller sections, which he then reconfigured to form new paintings. In this example, three cutout horizontal bands are attached to a thin support to form the center of the composition. The bands are surrounded by a larger border, cut from an earlier painting, which serves as both a framing device and part of the finished image.

SAM GILLIAM
American, born 1933
Glow-Sprite, 1979
Acrylic and Rhoplex on canvas
h. 30 in. (76.2 cm); w. 40¼ in. (102.2 cm)
Gift of Elizabeth and Meyer Lifschitz in memory of Pearl and George Bronz, 97.6

DON EDDY
American, born 1944
C-II, 1980
Acrylic on canvas
h. 30 in. (76.2 cm); w. 30 in.
(76.2 cm)
Gift of Nancy Hoffman, 82.56

Don Eddy has at times been identified with a group of artists known as Photorealists, yet he has little interest in replicating the appearance of a photograph. Although Eddy bases each work on a black-and-white photograph, the paintings are in color, each painted with an airbrush according to a unique three-color system. Eddy begins by applying a layer of tiny circles all over the entire surface of a canvas in the color phthalocyanine green. He then adds a second layer in burnt sienna, and follows this with a third and final layer painted in dioxazine purple. The layered circles combine to yield saturated colors marked by rich reflections of light.

Essentially, Eddy is a philosopher whose paintings bring attention to the metaphysical connections among objects. Seeking to paint images that have personal meaning, he relied on memory and free association as he chose the objects for this painting during a ten-minute visit to a five-and-dime store. In selecting the toys in a quick and spontaneous fashion, Eddy believed that he would be drawn to objects that were important to him when he was a child. In preparation for the painting, he placed the objects in a cabinet with glass shelves and mirrored walls and photographed the collection from different views. In the final painting, objects and their reflections merge to create a spatial ambiguity. By giving objects and their reflections the same degree of precise rendering in the painting, Eddy implies that they are, in fact, equally valid realities.

Marcia Gygli King created this sculptural painting during a period when artists were breaking down traditional distinctions among mediums, and many were blurring the lines between conventional notions of painting and sculpture. This work, which has elements of both mediums, was inspired by the obsessive and monotonous activities of industrial laborers. In its process and formal vocabulary, however, it reveals King's interest in a new feminist aesthetic that was taking shape at the time, characterized by patterns like those commonly found in fabrics, quilts, wallpaper, and other formats traditionally associated with domestic life or the craft arts. The V-shaped pouch that dominates the composition evokes associations with female anatomy, which was also a popular subject among women artists at the time. The cantilever motif links the work to architectural traditions dating back to classical antiquity.

Throughout her prolific career, King moved freely between figuration and abstraction. Her later work includes expressive paintings of botanical subjects as well as allegorical narratives about difficult themes, including death and the foibles of being human.

MARCIA GYGLI KING
American, 1931–2011
Cantilever, 1980
Paper disks, bark, modeling paste
h. 72 in. (182.9 cm); w. 70 in. (177.8 cm)
Anonymous gift, 2008.7

DONALD LIPSKI
American, born 1947
Building Steam No. 91, 1982
Shovel, rubber tubing, wood,
plastic, nickels
h. 45 in. (114.3 cm); w. 17 in.
(43.2 cm); d. 7 in. (17.8 cm)
Purchased with funds provided
by Awards in the Visual Arts
and the Young Art Patrons,
85.3.5

In the 1970s, Donald Lipski began making sculptures and wall installations from common, everyday objects. Initially, he made little sculptures from tiny objects such as paper clips, rubber bands, and matchbook covers that he kept in a cigar box. For his first major installation, *Gathering Dust*, he pinned the miniature sculptures to the wall in a format that mimicked a mounted butterfly collection. In *Passing Time* and *Building Steam*, the two series that followed, Lipski increased the scale and range of his found materials. Always working intuitively, he would join together such unlikely partners as a crystal ball placed atop an intercom or a wilted Christmas tree enclosed by an aluminum walker. Over the years, he has worked on many scales and used a vast range of materials, including airplane wings, American flags, fruits or flowers housed in industrial glass tubing, candles, and tree trunks. He has also become widely recognized for public art installations such as *F.I.S.H.*, which was installed in 2009 along the San Antonio River Walk and can be seen from the river landing on the north side of the Museum.

Lipski believes that meaning in his art should be left to the minds of its beholders. In other words, the metaphors that are suggested by the juxtapositions of specific objects will vary, depending on each viewer's experiences and perspectives.

Loosely based on 1950s photographs found in high-school yearbooks, obituaries, and other media sources, César Martínez's *Bato* series presents a colorful cast of stereotypical characters known as *batos* or *pachecos*, who are associated with Latino neighborhoods. These characters are inspired by memories from his childhood years in the border town of Laredo, Texas. Seeking to focus solely on the physiognomic characteristics and fashionably hip teenage attire of his subjects, Martínez adopted a pictorial format that he admired in the work of the renowned photographer Richard Avedon, whose works present the figures from the waist or torso up, staring straight at the viewer. In spite of the fact that the young man in the high-school letter jacket wears sunglasses, his pose and poker-faced gaze are directed toward the viewer's space, as if he is about to engage us in conversation. The predominantly white abstraction that serves as a backdrop to the subject, painted in thick brush gestures, reflects Martínez's fondness for the Abstract Expressionist and Color Field painting movements that were popular in the 1950s and 1960s.

CÉSAR A. MARTÍNEZ
American, born 1944
Bato con High School Jacket, 1986
Acrylic on canvas
h. 64½ in. (163.7 cm);
w. 59½ in. (151.3 cm)
Purchased with Tom Slick Estate Acquisition Funds, 90.76.1

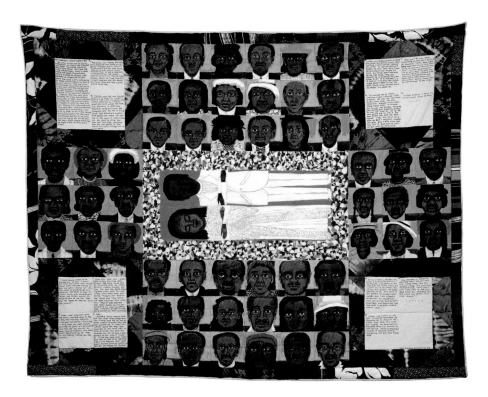

FAITH RINGGOLD
American, born 1930
The Funeral: Lover's Quilt #3,
1986
Acrylic on cotton canvas;
tie-dyed, printed, and pieced
fabrics
h. 57 in. (144.8 cm); w. 76 in.
(193.0 cm)
Purchased with the American
Art Acquisition Fund, 2006.7

The final work in a trilogy, this quilt uses text and images to tell a story of infidelity. The primary figures are Addy and the Reverend Luther, a deceased wife and husband who are shown in the center, surrounded by guests at their funeral. In the text at the four corners, a story narrated by Addy reveals conflicts between her love for her husband and her guilt over having slept with his brother on her wedding day. As a result of her indiscretion, she gave birth to her brother-in-law's twins, but never confessed to her husband. To complicate matters, her sister-in-law knew of the situation, but never said anything. In the end, Addy and Luther are killed in an automobile accident, just as the suspicious and angry Luther was about to coerce Addy into revealing her secret. With no simple resolution, the story raises open-ended questions about moral dilemmas relating to such topics as love and marriage, good and evil, and truth and deceit.

Faith Ringgold was a pioneer of the feminist movement of the 1970s, and her story-quilt narratives are characteristically told in a female voice. When Ringgold made her first quilt in 1980, she was assisted by her mother, who was an accomplished designer and dressmaker. By 1983, the artist recognized the medium's potential for storytelling and began incorporating text passages, thereby giving attention to both visual and verbal narrative. The patterning that frames the narratives owes a debt to traditional quilt-making and indigenous African art.

As a conceptual artist and one of the first graduates of the conceptual art program at the California Institute of the Arts, Valencia, Jack Goldstein worked in various genres, including performance art, experimental film and audio, painting, and sculpture. Often associated with a group known as the "pictures" artists because they found their ideas and image sources in mass media, Goldstein received considerable recognition in the early 1980s for his black-and-white paintings of imagery appropriated from photographs of natural phenomena, science, and technology. Around 1983, he focused his attention on outer space and began studying the computer-generated charts known as "tomographic maps" that appear in popular science magazines. The result was a series of paintings in which concentric bands of fluorescent color represent digital information received via satellite about the light and heat conditions of the universe. To stabilize the color intensity of the computer-derived configurations, Goldstein added geometric patterns, such as the strip of black circles and vertical bands at the painting's edges, to reaffirm the flatness of the painting as an object. He reinforced this idea further through his use of unusually deep stretcher bars, which call attention to the painting's physicality.

JACK GOLDSTEIN
Canadian, 1945–2003
Untitled, 1987
Acrylic on canvas
h. 84 in. (213.4 cm);
w. 108 in. (274.3 cm);
d. 6 in. (15.2 cm)
Gift of Peter R. Stern, 2008.22

ALBERTO MIJANGOS
Mexican, 1925–2007
Surrounded by Sound, 1988
Oil, acrylic, and mixed media
on canvas
h. 80 in. (203.2 cm); w. 80 in.
(203.2 cm)
Gift of Geary and Priscilla
Atherton, 88.103

Although Alberto Mijangos began as a figurative artist, he started painting abstractions in the late 1960s. Influenced by the Abstract Expressionists, who were known for building up layer upon layer of paint, Mijangos developed his own process of layering using a variety of materials. Characteristic of his paintings of the 1980s is a T-shirt or cross motif that has metaphoric associations with the sweat and toil of the laborer, as well as with the Christian cross. The title of the painting refers to the artist's belief that silence is actually filled with sound, and that the color red is associated with harmony. Although he was born in Mexico, in the 1950s Mijangos moved to San Antonio, where he was an active figure in the art world until the time of his death. In addition to founding what is now known as the Instituto Cultural de México en San Antonio, Mijangos greatly influenced a multitude of younger artists in his capacity as a teacher, mentor, and role model.

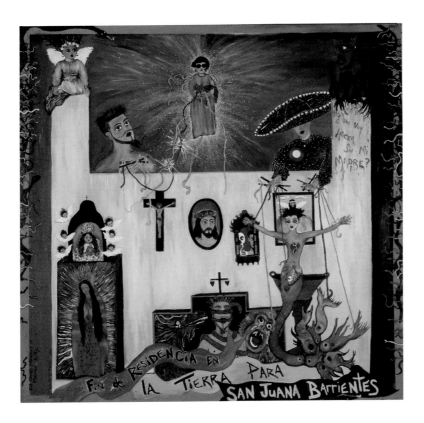

As a Latino and a gay activist, David Zamora Casas devotes his creative endeavors to exploring issues surrounding his multiple identities. Working primarily in painting and performance art, he employs a narrative format steeped in the traditions of theater and draws inspiration from cultural and family histories, as well as everyday experiences.

Inspired in part by the love poems of Pablo Neruda, this painting was conceived as a memorial to Jan Barrientes, the mother of a close friend of the artist. The composition combines elements of a colonial Mexican *retablo* (altarpiece) and a puppet theater, with the setting based on the artist's bedroom. Casas developed a complex iconographic scheme that pays homage to motherhood, lesbianism, and women in general, while also musing on life and death. At the upper left and right corners, respectively, are an angel and a gargoyle, which represent the dualities of good versus evil and light versus dark. At top center, the artist's friend appears as a divine figure holding a kitten, a reference to "Momma Kitty," which is her mother's nickname. Below her are two puppeteers, shown as a self-portrait of the artist at the left and a mariachi musician at the right. Other iconographic features include a dragon and a monkey, here symbols for sexuality; a Mexican *charro*, a reference to the supreme Aztec earth goddess; and the Virgin of Guadalupe, an enduring devotional icon in Latin American culture.

DAVID ZAMORA CASAS
American, born 1960
In Loving Memory of Momma Kitty, 1989
Oil on canvas
h. 80 in. (203.2 cm); w. 83 in. (210.8 cm)
Purchased with funds provided by Lenora and Walter F. Brown, 96.20

JAMES COBB
American, born 1951
Perishables 2, 1990
Oil on canvas
h. 34¼ in. (87.0 cm);
w. 64¼ in. (163.2 cm)
Gift of ArtPace, A Foundation
for Contemporary Art / San
Antonio
Gift to the Margaret Pace
Willson Collection of
Contemporary Art, 99.14

James Cobb's paintings reflect the way he sees the material world: as an illusion that appears always alive, energetic, and bustling with vitality. Inspired by the Dutch still-life tradition of *vanitas* paintings—depictions of skulls accompanied by the remains of gluttonous meals finely rendered as symbols of life's temporality—Cobb invented his own still-life compositions using a contemporary sensibility. In this example, various foods (a chicken drumstick, fish and fish bones, vegetables, all topped with large globs of brightly colored gelatin) merge to form a heaping pile of flowing lines and rich, sensuous colors, tempting our visual senses the way the aromas of a feast appeal to our taste buds. With the food infested with clusters of ants, the imagery is intended more as a metaphoric still life than as a literal representation. Simply put, the painting reminds us how easy it is to be seduced or repelled by appearances.

In his blackboard paintings, Vernon Fisher gives visual form to the interaction of his random thoughts, both conscious and unconscious. He is particularly attracted to the blackboard because it functions as a practical device for quickly scribbling ideas and notations, and also because one's marks can be erased and replaced with jottings of new thoughts. Additionally, blackboard erasures have a metaphoric value in that they often remain faintly visible, much like memories emerging from the past. In this example, Fisher has juxtaposed chalk drawings of mathematical notations, hybrids of human hearts, a whirlpool, a geometric cube, and, painted in shades of blue, a river landscape depicting the Rio Grande skirting the Chisos Mountains in western Texas. Collectively, these images represent the thoughts and pictures in the artist's mind that morph from one to the next in no logical order. Pictorial "landscapes of the mind" were first popularized in the early twentieth century by the Italian Metaphysical School painter Giorgio de Chirico. This subject was further developed in the 1930s and 1940s by Surrealist artists such as Salvador Dalí and Roberto Matta Echaurren.

VERNON FISHER
American, born 1943
Chihuahua, 1990
Oil, blackboard slate, chalk, and epoxy on wood
h. 71¼ in. (181.0 cm); w. 83 in. (210.8 cm); d. 8 in. (20.3 cm)
Purchased with Tom Slick Estate Acquisition Funds, 90.80

ÁNGEL RODRÍGUEZ-DÍAZ
American, born 1955
Círculos de Confusion (Circles of Confusion), 1993
Oil on paper on linen
h. 31⅞ in. (81.0 cm); w. 24 in. (61.0 cm)
Purchased with funds provided by Edward A. Fest, by exchange, 95.16

A native of Puerto Rico, Ángel Rodríguez-Díaz has held a longtime interest in issues of identity. When he moved to New York City in 1978, he experienced life for the first time as a member of an ethnic minority. Upon relocating to San Antonio in 1994, his concept of being "the other" shifted once again. As a Puerto Rican living within a city whose heritage and populace are predominantly Mexican, he now saw himself as a minority within the Latino community.

In his paintings, Rodríguez-Díaz has used a number of metaphoric devices, such as masks, mirrors, or demonstrative gazes and hand gestures, to question his place in the universe. In this self-portrait, painted shortly before his move to San Antonio, the artist creates an artificial mask with his hands and peers through his fingers with a questioning expression and furrowed brow. He shows himself only from the shoulders up, in front of a tunnel of golden light, and immersed within a field of suspended disks. This composition suggests that Rodríguez-Díaz, like all human beings, is connected to the larger expanse of the space-time continuum.

In this assemblage, Luis Cruz Azaceta combines painting with metal and found objects to memorialize the victims of the 1995 bombing of the Alfred P. Murrah Federal Building in Oklahoma City. On the wood support, he painted an explosive abstract pattern and included images of a severed leg and his own somber self-portrait. Metal scraps refer to the ruins of the destroyed building, while attachments include objects that could have been found in the rubble—such as shoes, stuffed animals, a toy car, and a baby doll. The wreckage is further alluded to in attached photos of old and broken mattresses and flowers. Throughout the composition, these various elements are tied together with caution tape, normally used by police officers to keep spectators away from crime scenes and disaster areas.

As a youth in Cuba in the 1950s, Azaceta witnessed shootings and bombings firsthand during Fidel Castro's overthrow of the government led by Fulgencio Batista. Since moving to the United States in the 1960s, Azaceta has addressed many social themes in his paintings and sculptures. Most notable are works devoted to raising awareness about the plight of the Cuban "boat people," the AIDS crisis, gang violence, and Hurricane Katrina.

LUIS CRUZ AZACETA
Cuban, born 1942
Oklahoma 4, 1997
Acrylic and enamel paint, photos, found objects, tape, plastic fencing, metal studs on wood
h. 48 in. (121.9 cm);
w. 293 in. (744.2 cm);
d. 20 in. (50.8 cm)
Gift of Ruthe and Benjamin J. Birdsall, Jr., and SAMA Contemporaries, 2009.13.a-b

ROLANDO BRISEÑO
American, born 1952
Black Hole, 2000
Archival pigment print
h. 36⅝ in. (93.0 cm);
w. 28⅜ in. (72.1 cm)
Gift of Dr. Raphael Guerra and
Sandra Castro-Guerra, 2004.10

For much of his imagery, Rolando Briseño uses a format that he identi-fies as a "tablescape," a variation of traditional still life that serves as a compositional device for articulating ideas about the enduring value of family and community. In this example, Briseño has utilized digital tech-nology to combine a number of symbolic images that represent various elements in the space-time continuum. In reference to the artist's own Latino heritage, the table setting is made up of traditional Mexican din-ner plates, silverware, and a checkered tablecloth, while the present day is alluded to at upper left by a common technological tool, a remote con-trol. Shown spinning in a circular motion, these symbols revolve around a green gravitational field that circumscribes a black hole, at the core of which is a chicken, a link in the food chain that has existed for centuries and thus transcends the specificity of a particular time or place. Human beings, also part of the continually evolving DNA chain, are represented as stick figures on the dinner plates. Taken together, these images sug-gest a hopeful view of the human spirit as a universal and powerful life force that is strong enough to withstand the threats to nature that lead to social, cultural, and environmental mutations, many of which have resulted from advances in technology.

Cecilia Paredes often uses her own body in her art as part of an ongoing examination of relationships between materiality and spirituality. In this photographic work, which was inspired by a poem about accepting death as a natural part of the life cycle, the artist shows herself lying facedown, sandwiched between a bed of leaves and taxidermic birds placed on her back. Through this staging, she symbolically affirms her place—and that of all human beings—as part of nature. The stuffed birds had been loaned to her by a taxidermist from the Museo de Ciencias Naturales La Salle Costa Rica, located in the town of San Jose, where Paredes lived and worked from 1998 to 2004. In many related works, Paredes has expressed her connection to nature by posing before floral wallpaper, with the wallpaper patterns painted on her body.

Paredes's approach to photography stems from traditions that originated in the 1970s with works by artists such as Cindy Sherman and Jeff Wall. Sherman was one of the first to create an extensive body of photographs in which the artist is a performer, and Wall introduced the light-box format, which has become an effective means for bringing cinematic theatricality to a photographic image.

CECILIA PAREDES
Peruvian, born 1950
El Sueño (The Dream), 2002
Cibachrome print on transparent paper, light box
h. 30½ in. (77.5 cm); w. 61 in. (154.9 cm); d. 4 in. (10.2 cm)
Purchased with the Mary Katherine Lynch Kurtz Fund for the Acquisition of Modern Latin American Art, 2008.2.2

VIK MUNIZ
Brazilian, born 1961
Bacchus Astride a Barrel, after Rubens (Pictures of Junk), 2006
Chromogenic print
h. 50 in. (127.0 cm); w. 40 in. (101.6 cm)
Purchased with the Mary Katherine Lynch Kurtz Fund for the Acquisition of Modern Latin American Art, 2008.5

Since the early 1990s, Vik Muniz has been practicing an art of illusion, making familiar images out of unconventional materials and then photographing the end result. In the past, he has created "drawings" or "paintings" out of such materials as wire, thread, or chocolate syrup. In other instances, he has shaped his imagery by drawing in soil, dust, or sugar. While the photographic image remains as the completed artwork, the composition being photographed is merely a prop in the process and is often reworked for another photo.

In creating this work from his *Pictures of Junk* series, Muniz enlisted the aid of Brazilian youths who, under the artist's direction, moved junk around the floor of a large warehouse. The images in the series are based on Old Master paintings of mythological deities. The source for this representation of Bacchus, the Roman god of wine, is a painting by the Flemish master Peter Paul Rubens (1577–1640). Muniz's version is filled with subtle references to his subject, such as wine bottles stored in an open refrigerator door.

DARIO ROBLETO
American, born 1972
The Pause Became Permanence, 2006
Ink-dyed willow and ash, hair lockets made of
stretched and curled audiotape recordings of
the last known Confederate and Union Civil War
soldiers' voices, excavated and melted shrapnel
from various wars, hair flowers braided by war
widows, homemade paper (pulp made from
soldiers' letters home sent by sea), lace and fabric
from widows' mourning dresses, colored paper,
silk, ribbon, milk paint, glass, typeset
h. 69 in. (175.3 cm); w. 26 in. (66.0 cm);
d. 26 in. (66.0 cm)
Purchased with funds provided by an anonymous
donor in honor of Nancy Brown Negley, 2006.16

Dario Robleto's art is concerned with collective histo-
ries and memories. This work is from a series about
the impact of the American Civil War on the loved
ones of soldiers who never returned home from bat-
tle. Their stories are told in texts inscribed on tablets
and taken from the obituaries of the last three Civil
War widows. A sense of loss and mourning is embed-
ded in the materials themselves, each of which has
been meticulously chosen for its integral role as part
of the content. Using alchemical processes as a sci-
entist or a magician might, Robleto reconfigures or
transforms these materials from one physical state
into another. Rather than play the audiotape record-
ings of soldiers' voices, for example, he has curled the
tape to replicate hair lockets that were commonly
placed at tombstones during the Civil War era. Paper
flowers were fabricated from paper that the artist
made from the pulp of vintage soldiers' letters that
were written during different wars. The artist's work-
ing method derives from a practice common to disc
jockeys, known as "sampling." In essence, Robleto
orchestrates and combines materials the way a disc
jockey mixes sounds.

AOCCDRNIG TO A RSCHEEARER AT CMABRIGDE UINERVTISY, IT DEOSN'T MTTAER IN WHAT OREDR THE LTTEERS IN A WORD ARE, THE OLNY IPRMOATNT TIHNG IS THAT THE FRIST AND LSAT LTTEER BE IN THE RGHIT PCLAE. THE RSET CAN BE A TAOTL MSES AND YOU CAN STILL RAED IT WOUTHIT A POR-BELM. THIS IS BCUSEAE THE HUAMN MNID DEOS NOT RAED ERVEY LTETER BY ISTLEF, BUT THE WORD AS A WLOHE.

SWEENEY

GARY SWEENEY
American, born 1952
According to a Researcher, 2006
Routed wood, paint, lettering
h. 25 in. (63.5 cm); w. 48 in.
(121.9 cm)
Gift of Laura and Jack
Richmond, 2007.14

With a strong interest in both the form and meaning of language, Gary Sweeney collects words and phrases as the source material for developing humorous conceptual art in several mediums, including painting, sculpture, photography, and site-specific installation. This mixed-media example was inspired by a newspaper column about the human capacity for discerning accurate meaning from misspelled words if the first and last letters of each word remain in place. In reading the text—mostly words with scrambled interior letters—viewers will discover that they are participating in the very activity that the text describes. To ensure that the work would remain light and playful in tone, Sweeney included a 1950s-style comic-book fatherly figure reading a newspaper. Sweeney is also a prominent figure in the arena of public art. Always whimsical in tone, his permanent site-specific installations can be found in cities throughout the United States, including San Antonio.

Originally trained as a lawyer, Franco Mondini-Ruiz turned to making art in the 1990s, a decade when artists across the United States were addressing issues of identity. The son of an Italian father and a Mexican American mother, Mondini-Ruiz grew up in San Antonio in a household filled with dialogue and conflict based on class, ethnicity, and varying cultural perspectives. This complex family dynamic echoed the cultural milieu of San Antonio during the artist's coming-of-age. For Mondini-Ruiz and others of his generation, there was a constant tug of war between the need to identify with one's heritage and the desire to pursue the American dream. In this assemblage sculpture made from everyday objects, the artist takes a whimsical look at cultural conflicts, such as those arising from what he considers to be a legally sanctioned separation between the United States and Mexico.

Like many of Mondini-Ruiz's sculptural objects, this example was first exhibited within a large installation based on Mexican botanicas, stores that sell candles, incense, religious statuettes, medicinal herbs, potions, and knickknacks. In the late 1990s, Mondini-Ruiz operated Infinito Botanica in San Antonio's Southside neighborhood. The Botanica offered fine art and spiritual objects, while also serving as a drop-in community center and artists' salon.

FRANCO MONDINI-RUIZ
American, born 1961
Legally Separated, 2008
Mixed media, resin, and vintage porcelain
h. 9 in. (22.9 cm); w. 10 in. (25.4 cm); d. 11 in. (27.9 cm)
Gift of Lori and Joel Dunlap, 2008.17.a-b

INDEX

CONTRIBUTORS

The following individuals made selections and contributed written entries for this *Guide to the Collection*:

SAN ANTONIO MUSEUM OF ART CURATORS

John Johnston—The Coates-Cowden-Brown Curator of Asian Art
Marion Oettinger, Jr.—Curator of Latin American Art
Jessica Powers—The Gilbert M. Denman, Jr., Curator of Art of the Ancient Mediterranean World
David S. Rubin—The Brown Foundation Curator of Contemporary Art

CONSULTING SCHOLARS

Richard R. Brettell—European Painting
Donna Corbin—European Decorative Art
Yuka Kadoi—Islamic Art
Lisa B. Reitzes—American Art
Virginia-Lee Webb—Oceanic Art

CREDITS

Detail photographs:

Page 2: *Cizhou Jar*, Chinese, 1279–1368 (see p. 74)

Page 6: *Portrait of a Woman*, Roman, early 2nd century AD (see p. 46)

Page 9: Don Eddy, *C-II*, 1980 (see p. 190)

Page 10: Joaquin Castañon, *San Isidro Labrador* (*Saint Isidore the Farmer*), 1866 (see p. 137)

Pages 20–21: *Sleeping Ariadne*, Roman, 2nd century AD (see p. 47)

Pages 54–55: *Door*, Iran, 19th century (see p. 63)

Pages 64–65: *Yen yen Vase*, Chinese, 1662–1722 (see p. 80)

Pages 96–97: William Adolphe Bouguereau, *Admiration*, 1897 (see p. 117)

Pages 118–119: *Processional Banner*, Guatemala, late 17th century (see p. 129)

Pages 150–151: Asher B. Durand, *Landscape, Haystack Mountain, Vermont*, 1852 (see p. 156)

Pages 176–177: Philip Guston, *Ocean*, 1976 (see p. 186)

Page 208: *Santa Teresa de Ávila*, Guatemala, late 17th century (see p. 130)